Masterpieces
of
ART

Masterpieces of ART

PAINTING FROM GIOTTO TO THE PRESENT DAY

A. N. HODGE

METRO BOOKS
NEW YORK

© 2008 by Arcturus Publishing Limited

This 2008 edition published by Metro Books by arrangement with
Arcturus Publishing Limited

Designer: Zoë Mellors
Consultant editor: Libby Anson
Jacket design: Elizabeth Healey

Metro Books
122 Fifth Avenue
New York, NY 10011

ISBN-13: 978-1-4351-0411-2
ISBN-10: 1-4351-0411-0

Printed and bound in China

1 3 5 7 9 10 8 6 4 2

CONTENTS

INTRODUCTION

This book was designed to map out a popular history of painting in the western world, from medieval times to the present day. Rather than focusing on the biographical details of individuals and their specific contributions, I have looked in detail at where artists were located in time, with which movements they were associated and who or what inspired them to work in the way that they did.

It is no straightforward task to present painting as a chronological history of styles and movements. The history of painting is not a neat, tidy affair. Labels are inconsistent and often overlap. Sometimes it is difficult to sort out exactly who belongs where and whether the fact that they belonged to a particular grouping at one point in their career was relevant to their later, and perhaps more mature, work. In some cases painters have been brought together here under one umbrella, not necessarily because they worked together or even had any contact, but because their work shares common themes and ideas. Rather than airbrushing out all the

imperfections, I hope that my idiosyncratic, narrative approach gives you a greater understanding of why, say, Vermeer worked in a particular style, as well as where he stands in the greater scheme of things.

Inevitably a book of this kind demands that choices be made; not every painter worthy of inclusion can be represented. The selection process is, of course, subjective and guided by personal taste. On that basis it may be possible to detect a bias towards living artists, as well as a celebration of the many women artists who are still excluded from most considerations of the 'Old Masters'.

I have tended not to rely upon any particular definition of what constitutes a painting. Hence, in this survey, I have considered painting in its widest sense, from the wooden tempera panels of the medieval painters to the diverse media applied to the canvases of contemporary practitioners.

Painting is an exciting medium and I hope this book demonstrates that it always has been. Although at times

painting has been knocked off course by photography, video, installation, sculpture and performance, in the end artists return to paint because in no other medium is it possible to experience the thrill of applying a brush to the surface or of squeezing paint from the tube as well as the visceral, intuitive process of creating an image from raw materials.

Currently, it seems that painting is as popular as ever, and that old hierarchical distinctions are largely meaningless. Without wanting to suggest that all contemporary painting is of a quality to compete with the very best of the traditional painters, there seems to be a visual richness about much recent work that relates to the past, while projecting firmly into the future.

Through knowledge of public collections I have tried to include as many images of accessible works as possible. Take time to go and visit the originals; there is simply no substitute for standing in front of a painting and really looking. There is no experience that can match the moment when you feel that a painting has really spoken to you: the moment which critic Jeanette Winterson so memorably described in her book, *Art Objects, Essays on Ecstacy and Effrontery* (Jonathan Cape, 1995), as when 'my heart flooded away'.

I hope that this book will appeal as a reference work to students, the general reader and artists looking to refresh their knowledge of the story of western art. The text here is really only the start and I hope that the book will inspire you to make your own links with the work of some of the artists presented. Reading about painting means starting to think seriously about painting – after a while you become more confident in your opinions and begin to see, for example, the connections between the paintings of Manet and Goya, or the equivalence between the emotional weight of a Rothko and a Caravaggio. The challenge for *The History of Art* has been to guide you to make these associations, as well as to inspire and inform.

A. N. Hodge, London 2007

THE ITALIAN RENAISSANCE
c1250–1550

In the late medieval period, from about AD 1,000, painting mainly took place in the monasteries. Here, monks would use gold leaf and a range of stylized imagery to illuminate manuscripts, while occasionally the walls would be decorated with some simple scene from the Bible. Most, if not all, of the imagery that was produced during this time was religious. There were no true portraits until the late Middle Ages, no real landscapes either and very little attempt to draw from life. Consequently, there were no painters of any real significance. There were sculptors in the 13th century in the cathedral cities of Strasbourg and Naumburg whose knowledge of the human body led them to make lifelike and convincing statues, but this was not true of painting. Painting was flat and lifeless.

All this changed with the arrival of Giotto in Florence. Not only did Giotto's work signal a complete break with tradition, but it had a far-reaching influence on subsequent generations of Florentine painters and hence on western art. Giotto created a window on the world the like of which had never been seen before. His figures were no longer stiff, cardboard cut-outs but had solidity and depth on both a physical and emotional level. With his gift for portraying a range of human emotions, Giotto was able to convey religious stories that were convincing, compelling and deeply compassionate. For the first time, the viewer could empathize with key characters in the narrative and the impact that this radical approach had on painting cannot be overstated.

Renaissance means 'rebirth' or 'revival' and central to its development in Italy was the rediscovery of classical antiquity by the cultural elite. By the time Giotto was painting the walls of small churches in Padua and Assisi in northern Italy at the beginning of the 14th century, the world around him was beginning to change. Trade routes into northern Italy had opened up new markets and prompted new networks of exchange both in terms of goods and ideas. With the new wealth and the rise of the merchant class, old certainties like the authority of the church were brought into question. Wealthy patrons emerged as the humanistic revival of the classical influence in arts and architecture began to gather pace.

1254	1297	1347	1430	1454
Birth of Marco Polo, explorer, who was to bring pasta to Italy from China	Magna Carta, confirmed by Edward I – entered English statute rolls as law	Bubonic plague in Europe; originated in India, 1332. 75 million deaths	Joan of Arc captured, taken to England. Later she was publicly burned in Rouen, France	Italy divided into five major regions: Venice, Milan, Florence, the Papal States and Naples

Masaccio was the next painter to come along and take up some of the artistic challenges posed by Giotto. It was not, of course, a relay race with the baton being handed from one artist to another – more a process that evolved against the increasingly rapid advances that were being made throughout the parallel worlds of science, literature, architecture, music, invention and discovery. For the first time, these parallel worlds began to converge – quite literally, with the discovery of one-point perspective. It was the architect Brunelleschi who developed the idea that to give a picture depth it was necessary for its lines to converge upon a single vanishing point. This in turn inspired Masaccio to experiment with rudimentary perspective in his paintings, giving his figures a monumental, sculptural quality and helping to build the illusion of real space.

Following on from Masaccio, other artists such as Uccello, Mantegna and Piero della Francesca took these experimental ideas one stage further, all the time adding to the technical knowledge of how best to create a convincing picture, or a mirror of reality. The period known as the High Renaissance – namely 1500 to 1520 –

was when the three great artists, Leonardo, Michelangelo and Raphael, were at the height of their creative powers. Florence was still the main centre of artistic activity, but by this time both Rome and Venice were starting to flourish. In Florence, Leonardo, in particular, developed fledgling scientific and mathematical concepts in a relentless intellectual pursuit that was part and parcel of his own artistic practice. Everything was there to be discovered, nothing could be taken for granted any longer.

Leonardo's *Mona Lisa* opened up the possibilities for a new way of looking at painting. Still probably the most famous portrait in the whole history of art, her enigmatic smile and soft features must have been shocking to a contemporary audience, brought up on a diet largely of stiff-featured and gold-haloed Madonnas. Michelangelo too, through the raw energy of his predominantly male nudes on the Sistine Chapel ceiling, was pursuing a vision that was to influence the way that the human figure was represented in art from that moment onwards. The quiet and subtle harmonies of colour and tone produced by Raphael were also admired and copied for centuries to come.

1492	1510	1513	1519	1544	1555
Columbus departed Palos, Spain in search of the Indies and discovered America	*Spain began settlements in Jamaica. Two years later in Cuba*	*Vasco Nunez de Balboa named large body of water as (the) 'Pacific'*	*Cortes brought Arabian horses to America from Spain*	*Sebastian Cabot published a map of the world with remarkable detail*	*First tobacco was taken from America to Spain*

GIOTTO AND THE EARLY FRESCOES

IT'S HARD TO KNOW WHERE TO begin when it comes to the history of western painting. There had been painters before Giotto, but what he achieved through his simple, timeless compositions was to set the whole of western art on an exciting new course, becoming something of a legend in his own lifetime. He produced works for the Pope and the King of Naples and is mentioned in Dante's *Divine Comedy*.

Giotto di Bondone (1267–1337) was the son of a Florentine farmer. Born into poverty, he was discovered by the painter Cimabue drawing the perfect likeness of a sheep on a rock. Giotto learnt quickly from his new master and, before long, was running his own busy workshop and accepting commissions to decorate the walls of religious buildings in Florence and other Italian cities.

Much of his work was done in fresco. This method of painting involves applying water-based pigment directly on to wet plaster; the paint and plaster then fuse together as they dry.

The technique had been used to decorate chapels and other religious buildings throughout Italy. Giotto's greatest achievement was the series of frescoes he painted inside the Scrovegni, or Arena Chapel, in Padua, depicting scenes from the lives of Jesus and the Virgin Mary. He also painted the St Francis of Assisi cycle for the Upper Church in Assisi.

But it was Giotto's contribution towards the development of the human figure within painting for which he will always be recognized. He broke free of the Byzantine tradition's use of stylized figures, giving the people in his paintings a much greater degree of realism. Look at any group of figures in a painting by Giotto and there is real emotion in their faces; he managed to depict a range of feelings – such as awe, sadness, suspicion, rage and jealousy – in ways that had never been seen in painting before. This creates a sense of compassion which helps to involve us in the unfolding drama.

There is also a great sense of movement in his closely observed narrative works. Hands remonstrate and flutter and figures bend and lean with a believable sense of space, weight and distance. Giotto shows a real feeling for colour too, particularly the way in which it interacts with light.

▶ THE RAISING OF LAZARUS, *1303* GIOTTO

Giotto's confidence in handling large groups of figures is shown here as Martha and Mary Magdalen implore Christ to bring their brother Lazarus back to life. In a moment of drama, Christ raises his hand over the bowed bodies of the two women with the stony landscape winding back in sharp relief.

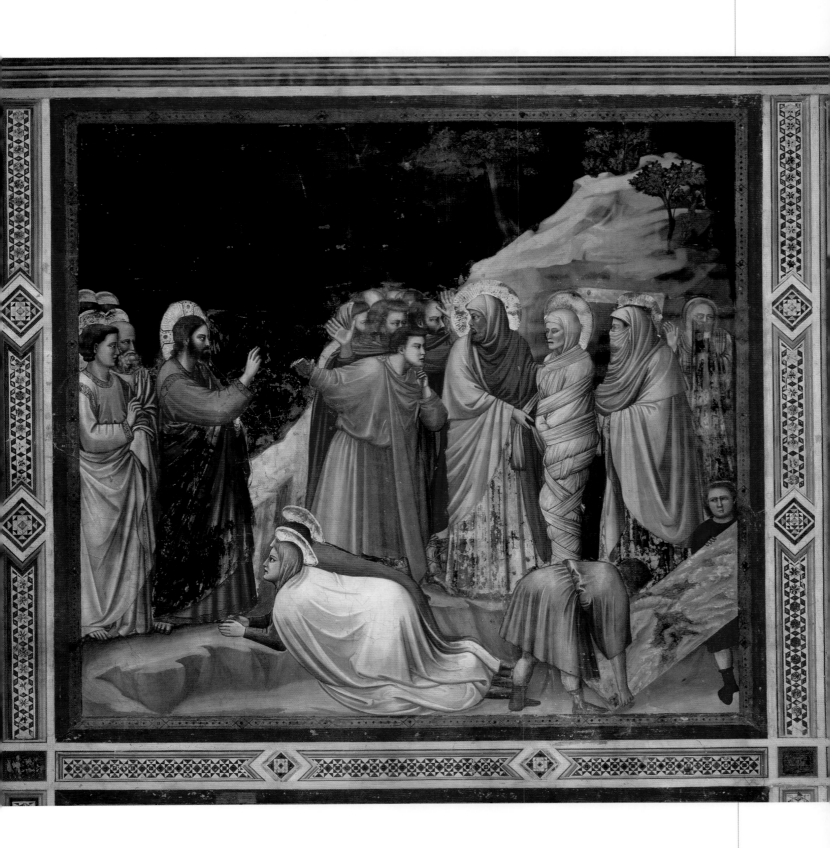

DECORATIVE ELEGANCE IN SIENA

F GIOTTO WAS THE MOST important painter in Florence for much of the 14th century, the painter Duccio di Buoninsegna (c1255–1319) was the principal painter to come out of Siena. The two Tuscan cities of Florence and Siena were artistic rivals at the beginning of the 14th century. The Sienese school was often seen as the more conservative of the two, with painting that emphasized the decorative qualities found in mosaics and illuminated manuscripts of the earlier Byzantine period. The Byzantine tradition, dating back to the Eastern Roman Empire, founded in AD 330, was primarily a religious art that emphasized a powerful orthodox vision through the use of symbols and stylized figures. Giotto, and to a lesser extent Duccio, developed a more naturalistic style that challenged this ritualistic convention.

Even today the medieval town of Siena is still dominated by its cathedral. For this, Duccio created the *Maestà*, a double-sided altarpiece with over 60 scenes, and it was installed there in 1311. Duccio infuses his narrative scenes with a new sense of life. There is real movement in his sacred figures – they are not simply stiffly arranged against a gold background.

Other important representatives of the Sienese school include Duccio's pupil Simone Martini (c1284–1344), and the brothers Pietro (c1280–1348) and Ambrogio Lorenzetti (c1290–1348). Simone Martini, whose work drew upon his master's brilliant colour and graceful line, was summoned to work for the French king of Naples and later for the Pope at his court in Avignon. The refined and courtly manner exemplified by the work of Martini dominated the arts across Europe at the end of the Middle Ages.

The brothers Lorenzetti were also probably assistants in Duccio's workshop, but while Martini painted with refined elegance, the brothers were influenced by Giotto and favoured an observational, narrative style. Ambrogio Lorenzetti painted *Good and Bad Government,* a fresco series for the Town Hall in Siena, between 1338 and 1340. This is an impressive and intricate work, displaying a hitherto unseen mastery of perspective in its depiction of small figures winding through the hilly streets of Siena.

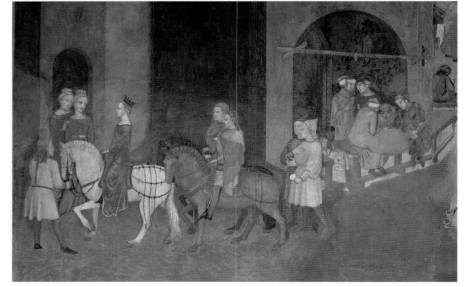

▲ ALLEGORY OF GOOD GOVERNMENT *(detail), 1338* LORENZETTI
This detail from the fresco in the Palazzo Pubblico Siena shows part of a street scene, featuring a bridal procession and the celebrations taking place at an inn. Lorenzetti's wall painting was designed to show the effects that both good and bad government can have on city and country.

▶ MAESTÀ *(detail), 1311* DUCCIO
This is the central panel of Duccio's most celebrated work, showing the Virgin Mary and Christ on thrones surrounded by angels and saints. Mary stands out from the rest of the group by virtue of her size and the intense ultramarine blue of her robe set against the richly gold-decorated haloes, clothes and throne.

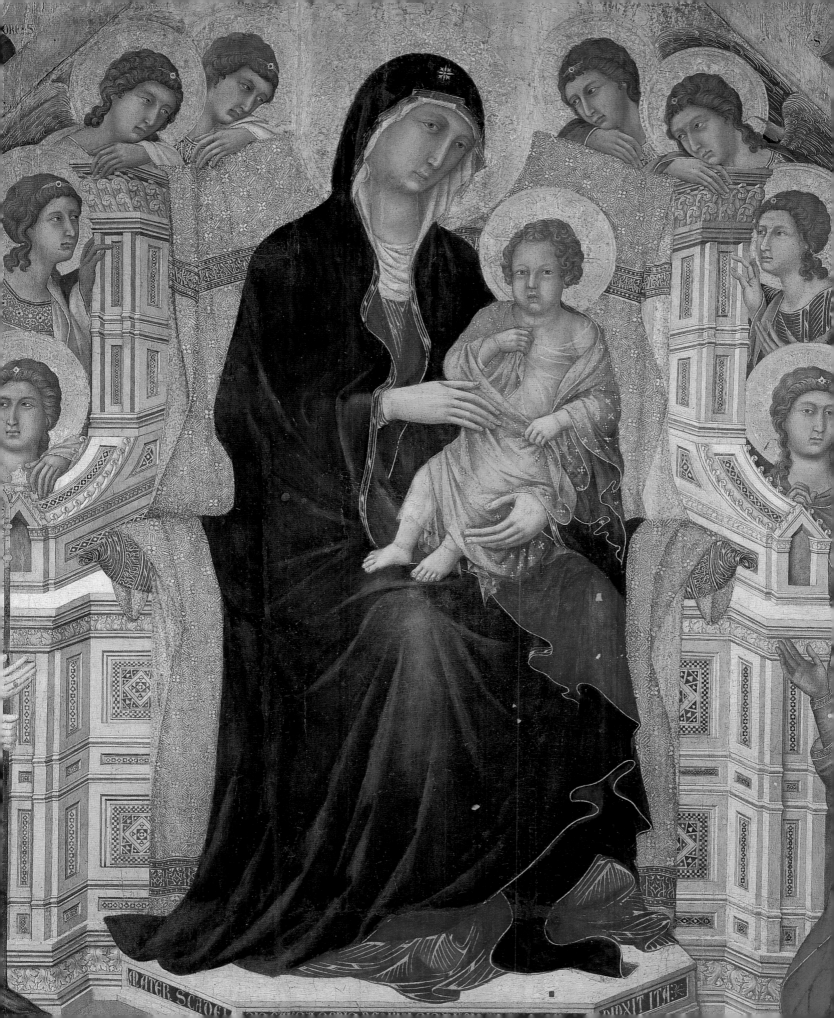

THE ILLUSION OF WEIGHT AND MODELLING

WITH HIS MANY PAINTERLY innovations, Masaccio (1401–1428) was one of the most important forerunners of the Italian Renaissance. Another Florentine artist, Masaccio's early life and training are not known, but from his earliest works there is clearly a rejection of the linear Gothic style of art that had flourished from the middle of the 12th century. Masaccio took up Giotto's concern with depicting believable human figures, but managed to go one step further by applying the rules of perspective that had been developed by his contemporary, the architect Brunelleschi. Masaccio also looked at the sculptures that were being created at the time by Donatello and was able to give the figures a solidity and volume that had never existed before in painting.

The Expulsion of Adam and Eve, c1425–8, a fresco from the cycle in the Brancacci Chapel in Florence, shows the full extent of Masaccio's extraordinary innovations with light, space and perspective. The bodies of Adam and Eve have a monumental, sculptural quality and seem to exist in three dimensions. Gestures and facial expressions are carefully highlighted by the light that falls from one source, with the shadows cast behind them helping to suggest volume. The composition is unified by the use of single-point perspective of the gates. With their heightened realism, austerity and directness, it is evident that Masaccio's paintings were not seeking to charm and please, unlike works produced by many earlier artists.

Fra Angelico (1387–1455), a Dominican friar who lived in a monastery at Fiesole near Florence, started out as a manuscript illuminator and there is a decorative, stylized element that can be seen in his early fresco work. However, in 1436, Fra Angelico was commissioned to decorate the friars' cells at the convent of San Marco in Florence with around fifty frescoes. While these were designed as direct expressions of the friars' faith, they also show a basic understanding of perspective and how figures recede in space. In the last decade of his life, Fra Angelico travelled to Rome to work on frescoes for Pope Nicholas V's private chapel in the Vatican.

◀ THE HEALING OF PALLADIA BY SAINT COSMAS AND SAINT DAMIAN, *1438–1440* FRA ANGELICO
St Cosmas and St Damian were twin brothers who practised medicine in Syria. This small painting, one of eight panels that originated from a Dominican monastery in Florence, shows the physicians carrying out a miraculous cure. The right-hand side shows St Damian receiving a gift for his healing powers.

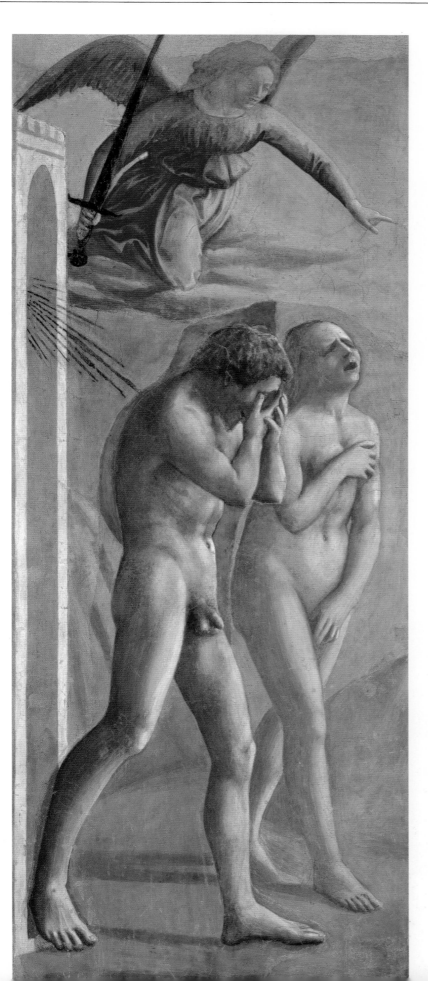

◄ **EXPULSION FROM PARADISE** *c1427*
MASACCIO

*Part of a cycle of frescoes painted by
Masaccio for the Brancacci Chapel in
Santa Maria del Carmine, Florence.
This dramatic depiction of the plight of
Adam and Eve broke new ground in
its realism due to the simplicity and
three-dimensionality of the couple and
their emotion-charged expressions.*

PERSPECTIVE AND FORESHORTENING

Masaccio and Fra Angelico had started to make use of single, or one-point, perspective. A number of other 15th-century Italian artists were also quick to exploit the new principles of linear perspective. This was the system where lines converge on a vanishing point, causing objects and people to recede in space. Linear or geometric perspective was developed by the architect Brunelleschi and remained integral to the idea of how painting best represented reality until the late 19th century.

Paolo Uccello (1397–1475), a Florentine painter apprenticed to the sculptor Ghiberti, became fixated with how to represent three-dimensional reality on the picture plane by means of perspective. Nowhere is this scientific obsession more apparent than in *The Rout of San Romano* (1454–7). These three panels, depicting the hostile territorial battle between the Florentines and the Sienese, were commissioned by the Medici family for their palace in Florence. This decorative, frieze-like work with its clashing lances and rearing horses presented Uccello with the opportunity to indulge his love of perspective.

Foreshortening, namely applying perspective to a single object or figure to create the illusion of projection or depth, first appeared on Greek vases c500 BC. The master of the foreshortened figure was the early Renaissance artist, Andrea Mantegna (1431–1506). Mantegna's adoptive father, Squarcione, was an archaeologist and painter, and he instilled an interest in classical sculpture and antiquities in his son. *The Dead Christ* (c1470), in which the viewer is positioned at Christ's feet, looking upwards at the truncated, cold body confined to the slab, is one of the most dramatic examples of a foreshortened body in the history of painting.

Piero della Francesca (c1416–1492) was influenced by the advances of contemporaries such as Masaccio and Uccello but, in addition to painting frescoes, he was an accomplished mathematician, writing treatises on geometry and the rules of perspective. However, to consider Piero della Francesca's works purely as examples of geometry, balancing space, scale and proportion, would be to do them a great disservice. Later paintings reveal his consummate skill in creating a serene, timeless and spiritual mood through the use of pale colours and soft, unearthly light.

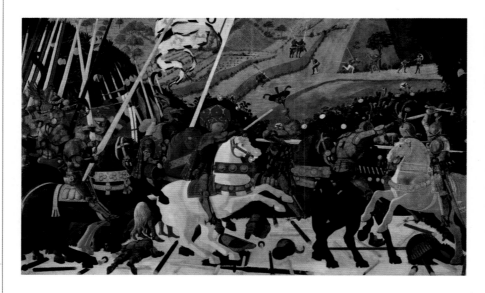

◀ THE ROUT OF SAN ROMANO, *1456*
PAOLO UCCELLO
The left-hand panel in a three-part series for the Medici palace depicting the conflict in which the Sienese were beaten by the Florentines. All the details in the work – from the carefully placed spears and lances to the tiny figures on the hillside behind – have been carefully placed to maximize the potential for perspective.

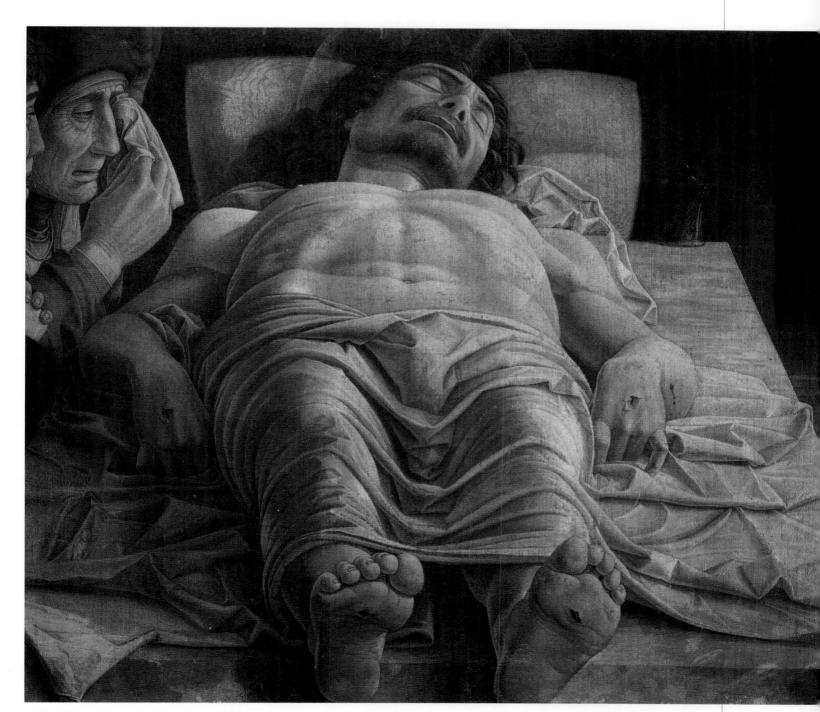

▲ THE DEAD CHRIST, *c1470* ANDREA MANTEGNA

In this portrayal of Christ, the Virgin and St John are shown weeping over his death. This is not an idealized portrait: the dramatic perspective of the foreshortened corpse, the holes in the hands and feet and discoloration of the skin lend it a realism belonging to the mortuary slab.

ALLEGORY AND GRACE

SANDRO BOTTICELLI (1445–1510) was born in Florence and spent most of his life in the city. For the most part Botticelli was unaffected by the drive towards realism that was so much part of his time; he rejected the new scientific discoveries, producing work that was quite distinct from his contemporaries. He trained under Fra Filippo Lippi, whose graceful frescoes were a model of refinement, and undoubtedly influenced the development of Botticelli's own delicate, linear style.

Botticelli had a real and unusual talent for drawing which led to commissions from patrons including the Medici family, who wanted him to paint subjects from classical mythology. The Florentine ruler, Lorenzo de Medici, took up an interest in paganism after meeting a group of Neoplatonists who had broken away from a conventional Christian view of the world.

This led Botticelli to produce his most famous pagan works, *The Birth of Venus* and *Primavera*. Both these paintings feature mythological scenes in which pale, elongated beauties, semi-clad in flowing drapery and with long, flowing locks, float against an unearthly backdrop. Botticelli is interested in the rhythmic line and the patterns of his idealized figures; he is by no means trying to convince us of their weight and substance. It is hard, however, to imagine the effect that Botticelli's Venus had on the public at the time. Here was an almost life-size naked woman, the like of which had not been seen in art before.

Botticelli's only significant trip outside Florence was a visit to Rome in 1481–2 when he worked on frescoes in the Sistine Chapel in the Vatican. He ran a busy studio and his supreme talent as a draughtsman meant that, at the peak of his career, his work was much in demand.

He also produced portraits and pen drawings to illustrate Dante's *Divine Comedy*. Following the death of Lorenzo de Medici, his work became more sober and intense and, when the crusades were at their height, Botticelli destroyed some of his earlier work which went against the religious feelings he had developed. Although he enjoyed great popularity in his lifetime, he died in obscurity.

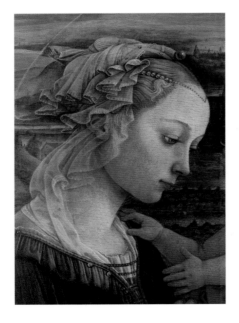

◀ MADONNA AND CHILD WITH
TWO ANGELS *(detail), 1465*
FRA FILIPPO LIPPI

An orphan, Fra Filippo Lippi was a monk whose talent for painting allied to the lure of a more worldly life eventually caused him to abandon the cloisters. Filippo Lippi is known in particular for his studies of the Virgin and Child, which, like this head of the Madonna, reveal good draughtsmanship and are often rich in ornamental detail.

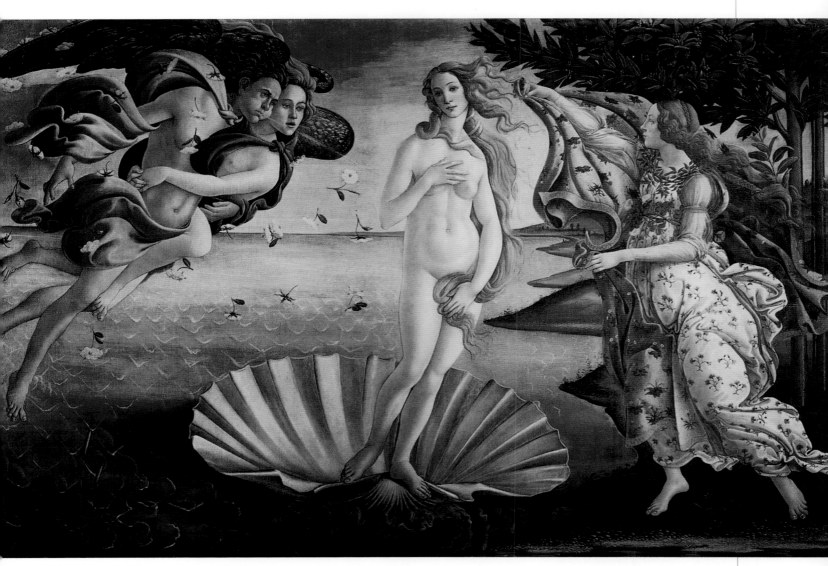

▲ THE BIRTH OF VENUS, *1485–86* BOTTICELLI

One of Botticelli's most celebrated works: Venus is blown ashore by flying wind-gods on a
seashell to be received by a nymph with a satin cloak amid a shower of roses. Thought to be
a celebration of spiritual beauty, this was nonetheless a pagan image produced at the height
of the influence of the Roman Catholic Church.

RENAISSANCE GENIUS, DRAUGHTSMAN AND INVENTOR

DURING THE PERIOD KNOWN AS the High Renaissance, when the greatest artists in the history of western art were at the pinnacle of their powers, one in particular stood out for the sheer breadth of his talent. Leonardo da Vinci (1452–1519) – draughtsman, painter, sculptor, writer, architect, scientist, musician, inventor – was regarded as the greatest of all Renaissance artists. His scattershot method of working, however, left behind many unfinished projects and a series of notebooks filled with studies of skeletons, clouds, flowing water and flowers, as well as observations on scientific subjects such as proportion, optics, geology and flying machines.

Like many Renaissance artists, Leonardo learned his craft as an apprentice to another artist, Verrocchio.

In this case, Verrocchio was so impressed by his pupil that he gave up painting altogether. From 1482, Leonardo spent 17 years in Milan working for the Duke of Milan, before returning to Florence where he painted the iconic *Mona Lisa* between 1503 and 1506.

The *Mona Lisa* is significant for a number of reasons. The pose – with the body at an angle, head turned forward – had not been seen before. The aerial perspective of the landscape, and the way it fades away into the distance, was also a notable advance.

Leonardo's real contribution to the history of painting, though, was what has become known as sfumato – from the Italian word for 'smoky' – namely the rendering of form by subtle tonal gradations, as seen in the soft features of *Mona Lisa's* face.

Leonardo left few authentic paintings, but greatly influenced contemporaries such as Correggio, Giorgione and Raphael. In playing with dramatic contrasts of light and shade, Leonardo prefigured the *chiaroscuro* effects that were to come to fruition in the Baroque period with Caravaggio and Rembrandt. His finely judged group compositions, where the figures often form a pyramid, are a defining feature of the High Renaissance style.

Leonardo created paintings of astounding beauty and realism, yet paradoxically he was mainly interested in solving problems of composition and pursuing a range of intellectual ideas. He joined the court of the French King Francis I in 1517, where his work was greatly appreciated and admired. He lived in France until his death.

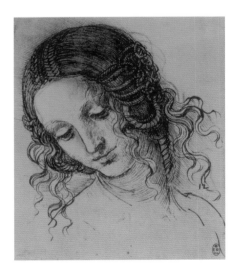

◀ STUDY FOR THE HEAD OF LEDA, *c1506* LEONARDO DA VINCI
In Greek myth, Leda is seduced by the god Zeus, who appeared to her in the form of a swan. Leonardo completed this drawing of Leda's plaited hair by drawing hatchings along the lines of the form, a technique he introduced into his drawings shortly before 1500.

▶ MONA LISA, *1503* LEONARDO DA VINCI
Vasari's biography of Leonardo da Vinci, published 31 years after Leonardo's death, identifies the sitter as Lisa Gherardini, the wife of a wealthy Florentine businessman. However, there is a resemblance to the artist himself, leading others to suggest that the Mona Lisa could be the portrait of a man or even possibly a self-portrait.

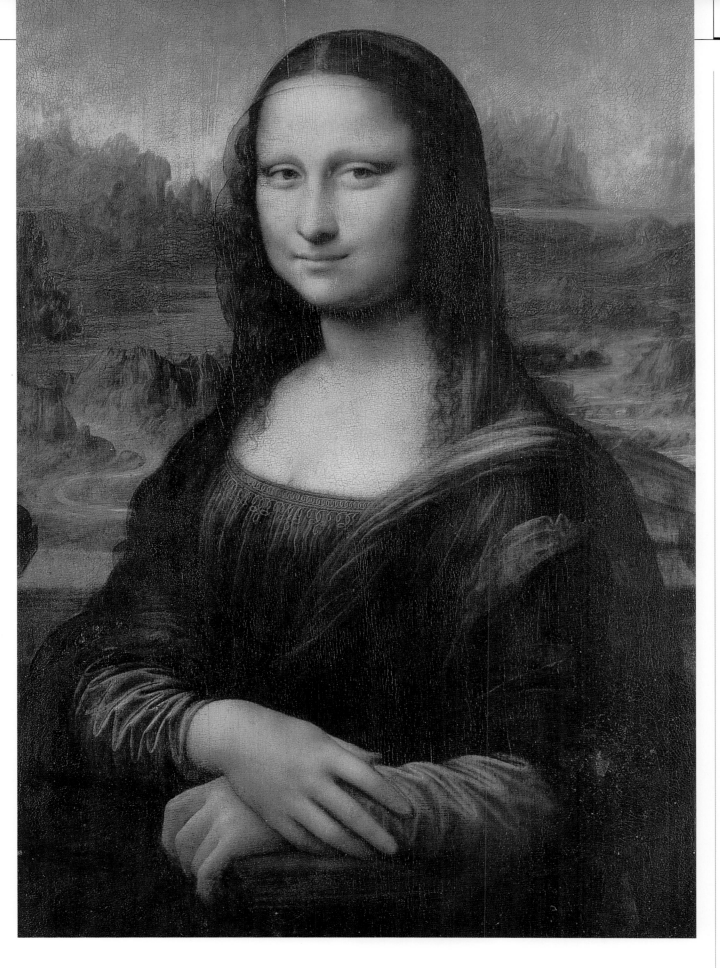

HUMAN BODIES WITH SCULPTURAL FORM

As a sculptor, painter, poet and architect, Michelangelo Buonarroti (1475–1564) was another hugely accomplished Renaissance artist. Twenty-three years younger than Leonardo, Michelangelo was raised in Florence. Here he trained briefly under the fresco painter Ghirlandaio, as well as receiving tuition in sculpture under the patronage of the all-powerful Medici family. His talent was recognized early on. Aged 19, after the death of his patron Lorenzo de Medici in 1492, Michelangelo left for Bologna, then lived in Rome from 1496, before resettling in Florence in 1501.

In the same year Michelangelo carved the marble sculpture *David* in Florence, embarking on a lifetime exploration of how best to represent the male form. Michelangelo mainly considered himself to be a sculptor and had to be coaxed into decorating the Sistine Chapel ceiling in the Vatican with frescoes. The chapel had been built by Pope Sixtus IV, but it was his nephew Pope Julius II who commissioned the work. *The Creation of Adam* (1508–12) forms the central panel of the chapel and shows God handing life to Adam and,

metaphorically, to the rest of Creation. Michelangelo's real contribution to painting can be seen in Adam's fully realized body, with its perfectly judged combination of strength and grace.

The first artist – and, many would say, the greatest ever – to specialize in depicting the male nude, Michelangelo devised a brilliant scheme for the Sistine Chapel ceiling. His complex design of interwoven scenes was painted as he lay on his back looking up at the ceiling over an exhausting four-year period. The series of narratives tell the biblical story from Genesis through to the life of Christ. *The Last Judgement* was completed separately for the altar wall in 1534. It is a monumental and astounding vision that earned its artist the title *il divino Michelangelo,* and ensured that his influence persists to this day. In his extraordinary dedication to the task of completing the Sistine Chapel commission and his willingness to trust his own innate genius, Michelangelo did more than any other artist to elevate the crafts of painting and sculpture to the status of Fine Arts.

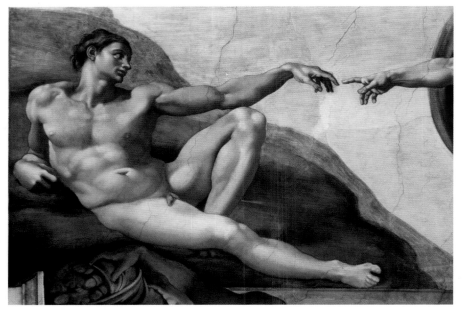

▲ THE CREATION OF ADAM *(detail), 1511* MICHELANGELO
*In this detail from the central panel of the Sistine Chapel ceiling, God's right finger is
separated from Adam's by the merest chink of light. The similar poses of God and Adam –
both their legs are in nearly identical positions – reflect the message of Genesis 1:27,
in which God was said to have created man in his own image.*

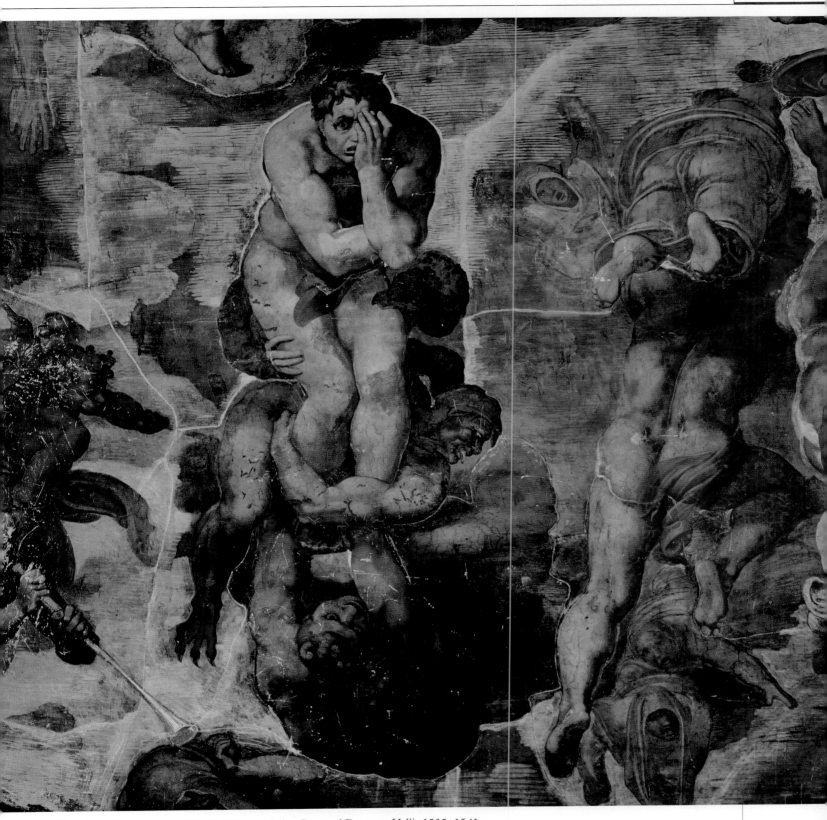

▲ THE LAST JUDGEMENT *(detail of Sinners Being Dragged Down to Hell), 1535–1541*
MICHELANGELO
*A nightmarish vision of the apocalypse in which bodies contort and writhe, with souls rising
and descending according to how Christ judges their fate. A huge work, it spans the entire
wall behind the altar of the Sistine Chapel and took six years to complete.*

BEAUTY AND CLASSICAL HARMONY

THE SON OF A PAINTER, Raphael (1483–1520, real name Raffaello Sanzio) was, along with Leonardo and Michelangelo, one of the three great masters of the Italian Renaissance. Younger than Leonardo and Michelangelo, Raphael moved from the small town of Urbino to Florence in 1504 where he studied their work, quickly realizing the extent to which these two were transforming the whole conception of painting.

In Florence, Raphael, like Bellini, was a painter of Madonnas or *Madonniere*. In these early paintings, the Virgin is shown as a tender, gentle figure, wholly immersed in caring for her baby Christ, with an idealized, harmonious landscape stretching out beyond. These works show a mastery of composition and have a serenity about them, presenting an untroubled vision of the world.

This perfect calm and sense of wellbeing are what separate the art of Raphael from the more intellectual approach of the other two great masters of the Italian Renaissance. Michelangelo was reputedly jealous of his younger rival's charming and easy manner, accusing him of stealing his ideas. But while Raphael's compositions and draughtsmanship might owe a lot to Leonardo and Michelangelo, it was really his rich feeling for colour and emotional harmony that constituted his unique contribution.

In 1508, Raphael decorated the papal apartments *Stanze* in the Vatican for Pope Julius II. *The School of Athens* on the main wall in the Stanza della Segnatura, with its many groupings of scholars in a great architectural setting, is the most famous of these frescoes. In his later years in Rome, Raphael also painted portraits noted for their subtlety and acute characterizations, as well as designing interiors for other wealthy Romans. His work displays a great sureness; in the compositions, dignity and grace combine with a sense of calm. Raphael's evocations of the classical Golden Age were to become the model for study in the academies.

His work was also a great source of inspiration to the great Classical painters of later centuries such as Poussin and Ingres. Reputedly, the papal court was grief-stricken on hearing of his early death from fever at the age of 37.

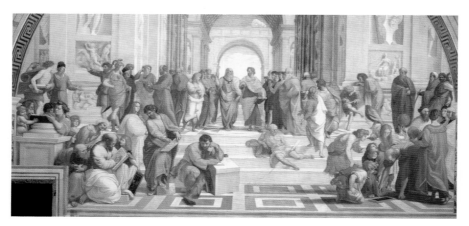

▲ THE SCHOOL OF ATHENS *(detail), 1509–11* RAPHAEL

A fresco forming part of Raphael's commission to decorate rooms in the Apostolic Palace in the Vatican. Plato and Aristotle are shown in the centre, engaged in philosophical debate, surrounded by a dynamic group of figures representing the various subjects that need to be mastered for classical learning such as astronomy, geometry and arithmetic.

▶ SAINT CATHERINE OF ALEXANDRIA, *c1507–8* RAPHAEL

A typical harmonious composition combining grace and a sense of calm, but made more dynamic by Saint Catherine's glance towards the heavens. She is depicted leaning on the wheel upon which she was condemned to die, but which was miraculously destroyed by a thunderbolt.

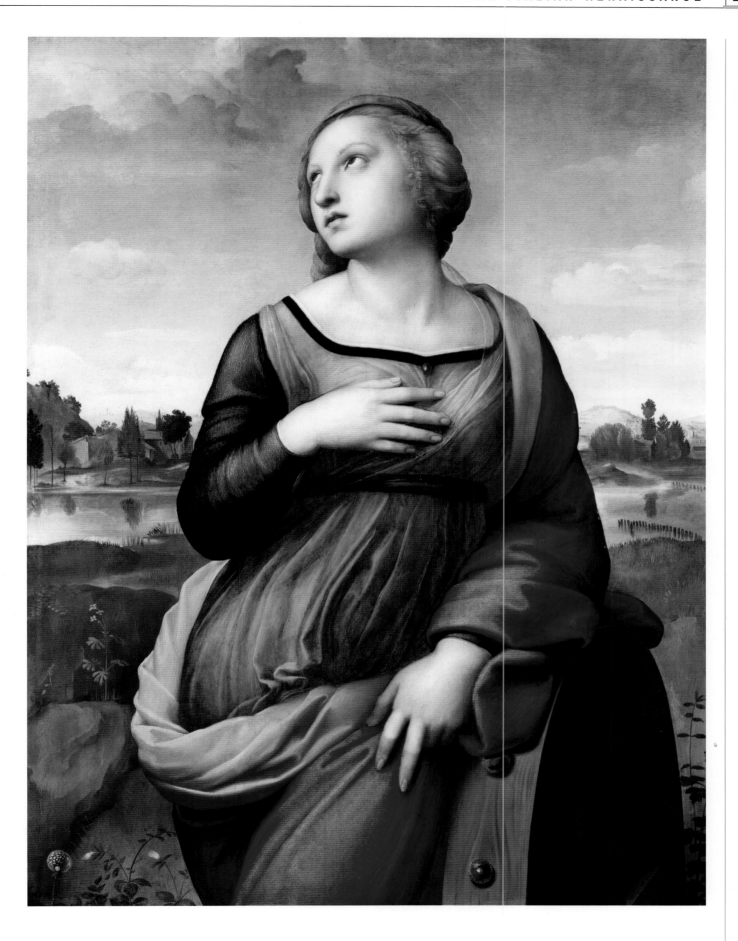

VENETIAN COLOUR AND LIGHT

WHILE THE SCHOOL IN FLORENCE was central to the great flowering of the Italian Renaissance, the school in Venice was developing some important innovations of its own. At the end of the 15th century, Venice was a powerful, independent city state and an important part of the trade route for pigments, spices and silks. One of the major influences in Venice in the late 15th century was the school of Padua, in particular the sculptural and three-dimensional effects achieved by the great master of perspective, the painter Andrea Mantegna.

At the same time, Antonello da Messina (c 1430–79) introduced the oil painting technique of Van Eyck to Venice. Messina had first come across oil paintings by the Netherlands artist in Naples, and used the technique to good effect in his own work – mainly portraits and religious works. Up until this point, Italian artists had mainly been working in tempera, a fast-drying medium in which the pigments are suspended in egg yolk. Oil paint by contrast was slow-drying and this had the advantage of creating a greater degree of realism, as artists were able to build up an image more slowly, layer by layer.

Messina passed his knowledge of oil painting on to Giovanni Bellini (c1431–1516), who was to become one of the most important artists of the Venetian school. Bellini adopted the technique of oil glazing and handed it on to his famous pupils, first Giorgione (1477–1510) and later Titian (c1488–1576). Bellini painted mainly religious themes, but he was quick to show an ability to create lyrical harmony between his figures and their setting.

Bellini's mature style impresses because of its high degree of realism and the subtle variations of tone and colour. In *The Doge Leonardo Loredan*, 1501–1504, Bellini shows the ruler of Venice as a w se, sensitive and dignified character. There hadn't been portraits which expressed such insight or feeling before. This Venetian feeling for light and colour is also to be found in the work of Giorgione, whose life remains an enigma. His highly coloured, atmospheric small paintings in oil, generally of non-religious subjects, were painted mostly for rich private collectors.

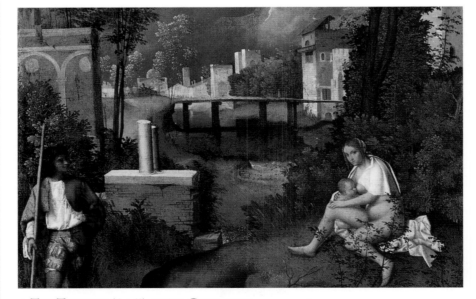

▲ THE TEMPEST *(detail), c1510* GIORGIONE
Art historians have long debated the significance of the enigmatic foreground of The Tempest, *with its stunted columns, a soldier and a semi-naked woman breast-feeding her child. In the background, a flash of lightning fills the picture with a sense of foreboding.*

▶ THE DOGE LEONARDO LOREDAN, *c1504* GIOVANNI BELLINI
Bellini's sensitive portrayal of the powerful ruler goes some way beyond mere flattery. Bellini uses his insight and skill to convey in the Doge's face a mixture of emotions – compassion, intelligence and confidence – from the minimum amount of information.

NORTHERN RENAISSANCE
c1400–1600

While the Renaissance was gathering momentum in Italy, there were also changes taking place in the Netherlands and Germany that signalled a new era for painting. While there is some evidence that artists from the northern cities of Gent, Antwerp and Bruges were aware of the great innovations in Italy, their work showed marked differences from that of their southern counterparts. In Italy, the Renaissance was inspired by humanism and a revival of classical antiquity; northern artists were less preoccupied with attaining ideal harmony and beauty than their Italian equivalents. Throughout the 15th century, the architecture in the North continued to look to the Gothic style of the previous century, which was characterized by pointed arches, rich ornamentation and vaulted ceilings. In painting, northern artists were slowly starting to break free of the Gothic tradition, rejecting the courtly elegance and overly decorative work that had hitherto been much in demand.

In the North the changes took place against a backdrop of religious reform and revolt against the Church. The revolutionary aspects of the Italian movement, such as the scientific discoveries of perspective or anatomy, interested northern artists less than an aspiration to reproduce the natural world in all its wonder. Northern Renaissance artists made extraordinary advances in naturalism; their paintings were a mirror of the world with every leaf, lock of hair and piece of velvet drapery replicated in exquisite detail.

The preferred method of the Italian artists was to use tempera, a medium in which the pigments were suspended in quick-drying egg yolk or a whole egg. For a long time, Jan van Eyck, the Netherlands artist, was generally credited with the discovery of oil painting. There is now some doubt over whether Jan van Eyck or his brother Hubert actually invented the technique, although it is widely accepted that they discovered that mixing pigment with linseed or walnut oil slows down the drying process. What is clear, however, is that Jan van Eyck was one of the medium's earliest practitioners, and that working on a wooden panel using glazes enabled him to produce oil paintings with a luminous brilliance that astonished his contemporaries.

1400
Geoffrey Chaucer, author of The Canterbury Tales, *died in London*

c1400–1425
Yong Le, 3rd Ming emperor, built the 'Forbidden City' in Beijing, using 200,000 labourers

1400–1500
In Venice Giovanni Spinetti produced the first piano, 'the spinet'

1436
Johannes Gutenburg invented moveable type. The first books were printed on rag paper

1444
Slaves were taken to Portugal from Africa for the first time

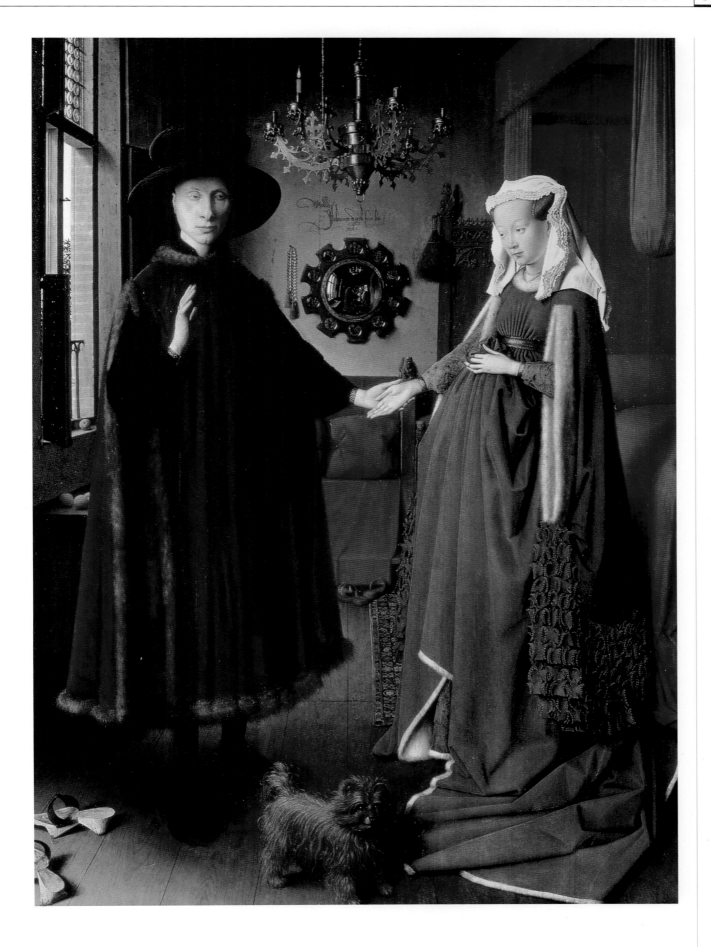

FOCUS ON RELIGION

THE NEW NATURALISM OF THE Netherlands, best shown in the intricate work of Jan van Eyck, began to attract attention and, by the mid-1450s, its influence was widespread. Other Flemish artists, such as Rogier van der Weyden (c1400–1464), Hugo van der Goes (1440–1482) and the German artist Matthias Grünewald (c1470–1528), worked almost exclusively with religious themes, using a naturalistic approach which gave their paintings a sharper sense of purpose and clarity than ever before. While there was a certain artificiality in Van Eyck's work – as if reality was trapped under glass – the paintings of some of these later Flemish artists are warmer, more emotional and humane.

Van der Weyden was one of the most influential artists of the 15th century. He was the official court painter to the Duke of Burgundy, Philip the Good, and his paintings were despatched to Spain and Italy, ensuring that his reputation spread wider. His work was celebrated for its close attention to detail and the expressive pathos that he managed to achieve through his moving depictions of important religious scenes. In large-scale compositions, like *Deposition* or *Pietà,* Van der Weyden organizes his group of figures in shallow pictorial space so that attention is focused on the grief etched on their faces.

This emotional intensity is also found in the work of Hugo van der Goes, who made large-scale paintings of religious scenes, including the *Portinari Altarpiece*, with its monumental figures gathered around the infant Christ. Other lesser-known northern artists made religious paintings, but few were as successful at combining the realistic detail found in the work of Van Eyck with the expressive power of Van der Weyden or Van der Goes.

The painter whose work articulated the darkest religious vision was Matthias Grünewald, a German artist who focused on themes of human suffering. His masterpiece, the altarpiece for the hospital church at Isenheim in Alsace, shows in brutal detail the agony that Christ suffered on the cross, his limbs contorted, his twisted body covered in lacerations.

◄ DEPOSITION, *c1435* ROGIER VAN DER WEYDEN

Deposition *focuses our attention on grief. The emotional charge of the painting is further heightened by the dramatic poses, especially that of Mary, whose swooning form echoes the broken body of her son.*

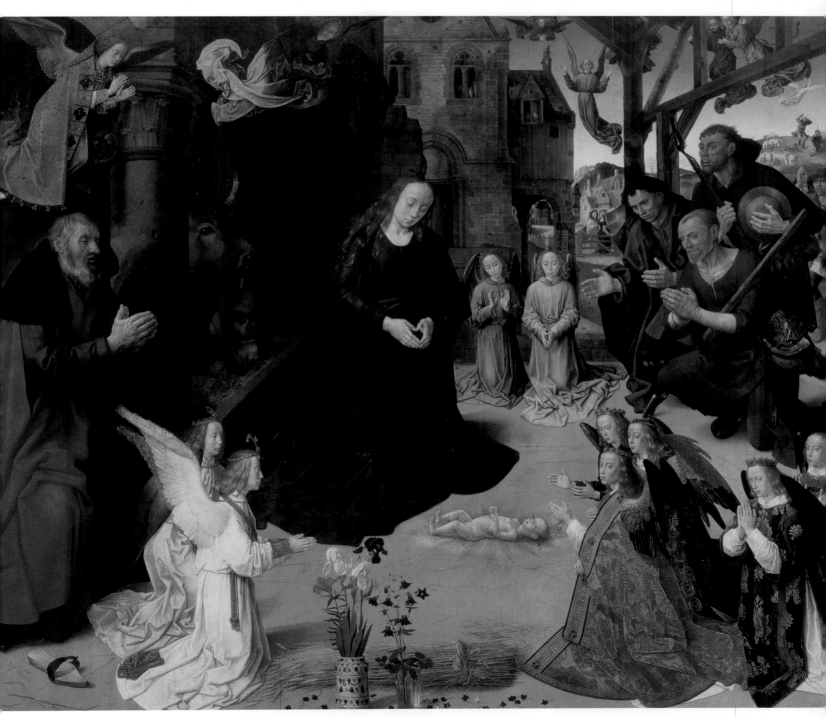

▲ THE ADORATION OF THE SHEPHERDS *(Portinari Altarpiece – central panel), 1476*
HUGO VAN DER GOES
Commonly thought of as his masterpiece, this large triptych of the Nativity was commissioned
by Tommaso Portinari, an agent for the Medici family, for the church of the Hospital of Sta
Maria Nuova in Florence. Van der Goes shows good organization of the groups of figures, and
there is keen observation in his depiction of individuals, particularly the awe-struck shepherds.

OBSERVATION AND OBSESSION

THE LEADING ARTIST of the northern Renaissance, Albrecht Dürer (1471–1528), was born in Nuremberg. His father was a goldsmith who taught him how to draw in silver point. As the line could not easily be erased, this method forced the artist to develop a superb linear technique. This sparked a dedication to close observation and exact rendering which was reinforced by other early influences. These included an apprenticeship in 1484 to Michael Wolgemut, the leading Nuremberg painter and illustrator of the day. Dürer learned the techniques of woodcut engraving from him.

Dürer enjoyed great success early on in his career and was swiftly acknowledged as Germany's leading artist for his draughtsmanship. His output was prodigious; he completed more than 200 woodcuts during his lifetime. From 1496 onwards, he made several trips to Italy where he was profoundly affected by the revolutionary changes taking place. Unlike many artists of the northern Renaissance, he studied artists such as Leonardo and Bellini, whose use of colour he particularly admired, and produced several oil paintings showing the Italianate influence. What is most distinctive about all of Dürer's work is its obsessiveness, revealing a relentless desire to expose the inner truth of the subject.

Dürer produced several self-portraits, which in itself was something quite new. The self-portrait of 1498 shows the artist as a dignified, confident traveller – ringletted, dressed in fine, noble garments and striking a pose before a landscape in which the ice-capped distant mountains recall his travels to the Alps. Dürer clearly saw himself as a Renaissance man; he was deeply curious about the whole intellectual background to the Renaissance movement and wrote treatises on the subject. Significantly, he was chiefly responsible for introducing the Renaissance ideas and achievements he discovered in the South to the North. Dürer's real fame lay, however, in his detailed graphic work – the etchings, woodcuts and watercolours – which demonstrate his unique ability to depict the world around him with scientific accuracy, as well as sensitivity and grace.

▶ YOUNG HARE, *1502*
ALBRECHT DÜRER
In this intense watercolour study, Albrecht Dürer paints a young hare from life. Young Hare is an exquisite example of both Dürer's extraordinary powers of observation and his ability to go beyond a mere depiction of nature to convey a sense of wonder and even awe.

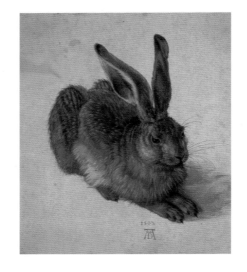

▶ SELF-PORTRAIT, *1498*
ALBRECHT DÜRER
This self-portrait of the artist at 26 is one of three that have been preserved. With his hair in ringlets, Dürer appears from the waist up, wearing elegant black-and-white attire that gives him something of the air of an Italian gentleman. Prior to this, painters had never been depicted with such poise and sophistication.

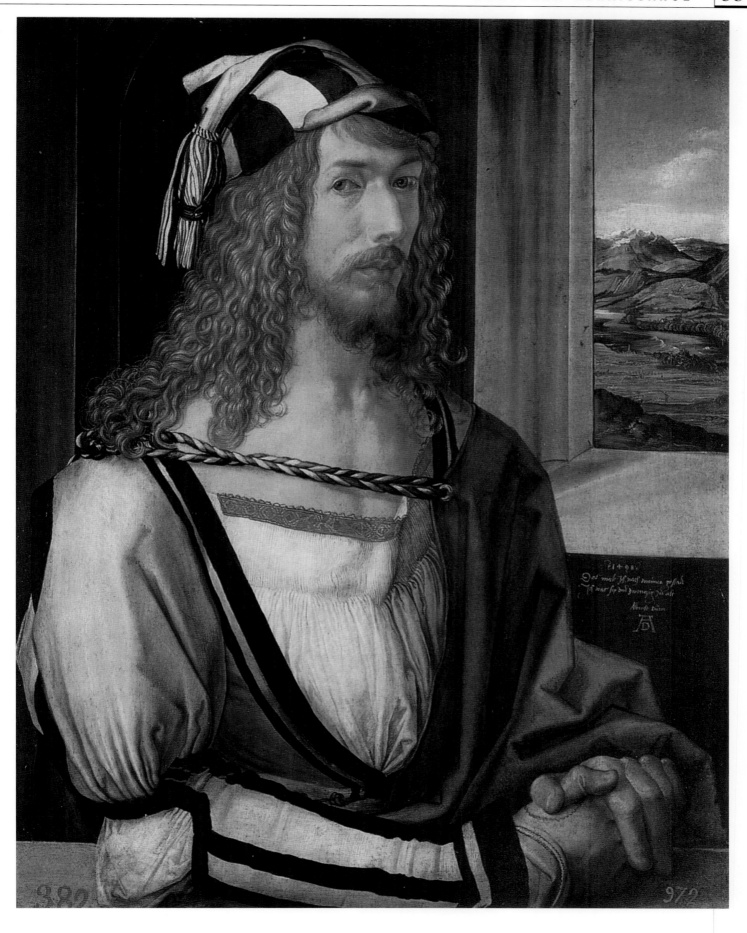

EARLY LANDSCAPES

UP UNTIL THIS POINT IN THE 15th century there had been no such thing as landscape painting. Prior to the Renaissance, the views on display were often heavily stylized with trees that looked like lollipops and steeply stepped hills that wove unconvincingly into the distance. For the first time, northern painters, in particular two German artists Lucas Cranach the Elder (1472–1553) and Albrecht Altdorfer (c1480–1538), started to look to the pine forests and rocky terrain of their immediate surroundings for inspiration. Both artists were part of the Danube School, a loose grouping of artists committed to exploring the German landscape.

Lucas Cranach the Elder was just one year older than Dürer, but his work does not show the same degree of unswerving concentration as the younger artist, although he too produced work with an amazing degree of naturalistic detail. While he did not produce pure landscapes, Cranach made the dark forests he grew up with an important feature of his work. Some of Cranach's nudes look contrived and awkward, although occasionally he managed to integrate figures more successfully into his rural settings.

Albrecht Altdorfer was not a traveller, unlike Dürer whose topographical watercolours of the Alps he much admired. However, he made frequent trips along the River Danube to make paintings in which the landscape is the only focus of attention.

In *The Danube Valley*, there are no people at all, just an enormous sweep of sky in which clouds are massing; the dense forest sits brooding, and there's a distant view of blue mountains. The overall effect is romantic and yet there's a subtle, almost imperceptible sense of foreboding. Here Altdorfer becomes the first real artist to understand the overwhelming, emotional impact of landscape. Other works show tiny figures dwarfed by nature, although in some epic battle scenes the overall effect is less expressive and more morally prescriptive.

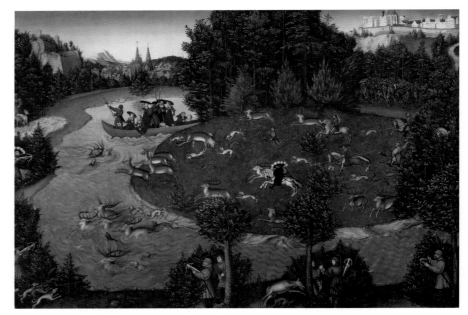

▲ THE STAG HUNT OF THE ELECTOR FREDERICK THE WISE, *1529*
LUCAS CRANACH THE ELDER
As court painter to the elector of Saxony, Cranach was duty-bound to provide the court with portraits of the ruler and his family as well as records of important occasions. This hunting picture records how stags were chased into the water to enable the court party to finish them off more easily.

▶ THE DANUBE VALLEY NEAR REGENSBURG, *c1520*
ALBRECHT ALTDORFER
In creating a landscape devoid of people or buildings and emphasizing the romantic qualities of light and space, Altdorfer was one of the first artists to understand the huge emotional power of pure landscape. Altdorfer became a citizen of Regensburg in 1505, and later a surveyor of the city's buildings.

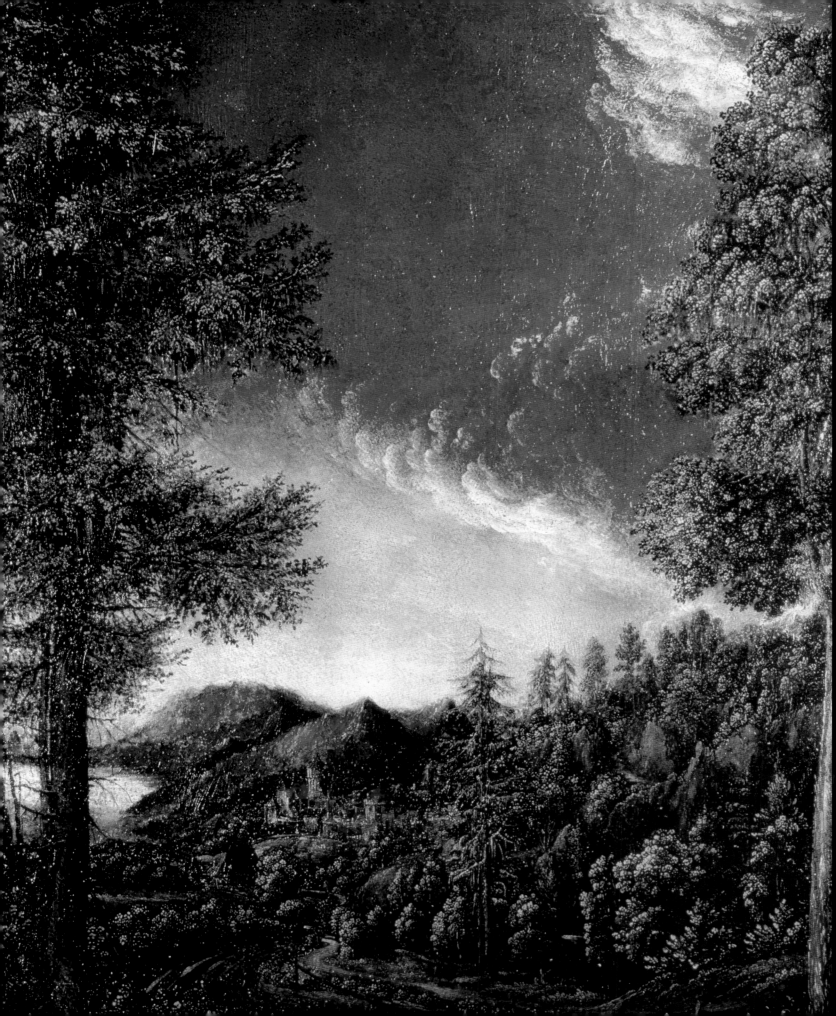

INVENTIVE FANTASIES

HIERONYMUS BOSCH (c1450–1516) took his name from his native Dutch town of s'Hertogenbosch. Details of his life are sketchy, although it is known that he was a member of a local religious brotherhood, a Catholic group working for the spiritual improvement of his town. He also designed stained-glass windows. If his religious beliefs were quite orthodox, however, the majority of his work certainly was not. If you look at Van Eyck and Van der Weyden, the two most influential painters in the Northern Renaissance, there is almost no similarity to Bosch. The only stylistic influence that can be linked to Bosch are the miniature stories found within medieval illuminated manuscripts.

Bosch's paintings present transcriptions of biblical scenes which he embellishes heavily with his own iconography of signs, symbols and allusions to expose the many temptations that are put before man and the fearful consequences that may result for the sinner. His work is both a remarkably profound comment on the human condition as well as an expression of the medieval worldview; this, with its pessimism and terror of hell, held sway until the Protestant Reformation took hold in the 16th century.

Unlike many of his contemporaries, Bosch didn't use underpainting, but painted directly on to the ground, relying on his skills with the brush. *The Garden of Earthly Delights* is one of his most important works, consisting of a series of four paintings on folding panels. The central panel depicts a seething mass of pale, slender, human bodies seeking gratification through sensual pleasure. These are not fully realized human beings but gothic types, whose purpose is to drive home the moral message. Bosch's extraordinary vision incorporates many elements of bizarre fantasy as half-human, half-animal creatures parade in a fantastical setting of imaginary buildings, parks and rivers.

Bosch's work was admired during his own lifetime and Philip II of Spain was an avid collector for a while after the artist's death. Bosch's crowded, energetic work undoubtedly influenced his contemporary, Pieter Bruegel the Elder. He was then largely forgotten until the 19th century, and rediscovered again in the 20th century by the Surrealists.

▶ THE GARDEN OF EARTHLY DELIGHTS, HELL *(detail – right panel), 1500* HIERONYMOUS BOSCH
Bosch's large triptych gives a detailed account of the creation of the world before and after man has succumbed to the seven deadly sins. In Hell, torments and horrors await all those who have transgressed and Bosch duly depicts figures distorted by avarice and gluttony, as well as a giant bird feeding on human flesh.

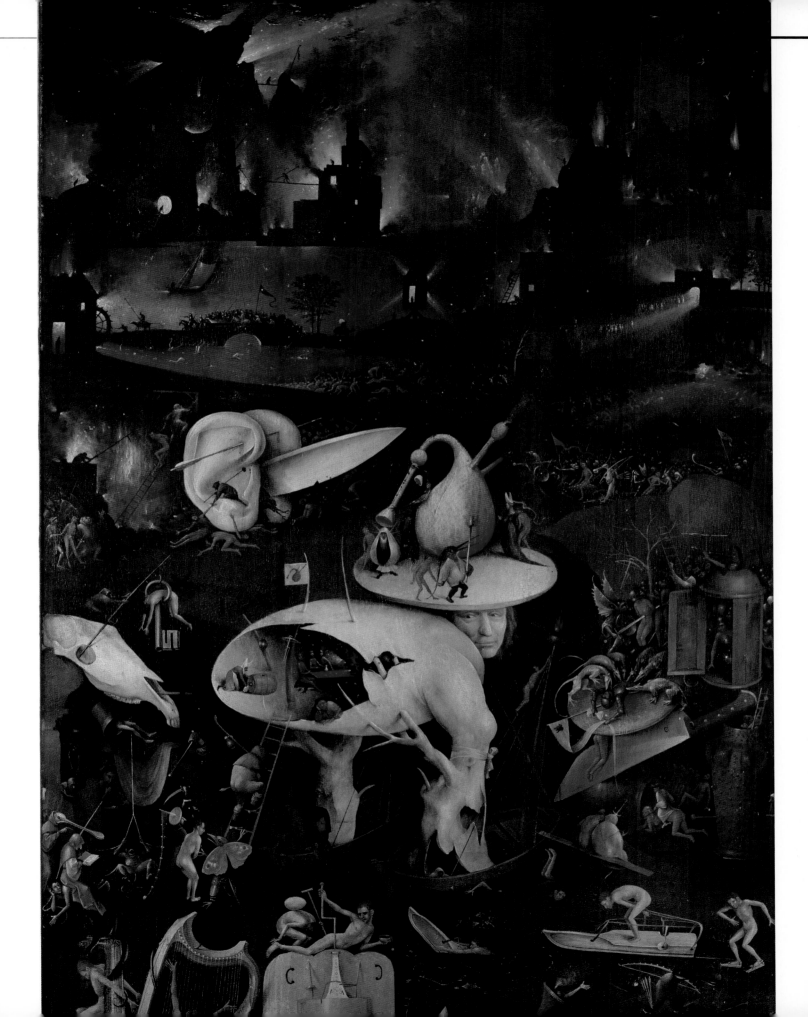

COURT PORTRAITS AND MINIATURES

THE PROTESTANT REFORMATION – inspired by the teachings of Martin Luther – provoked a crisis in the arts as Catholic imagery was denounced as 'idolatrous'. Protestants did not condemn all art – it was Catholic religious art they were mainly against – but it meant that there were suddenly very few, if any, commissions for painters. Some artists became redundant and many chose to pursue allied or, in some cases, unrelated occupations.

Hans Holbein the Younger (1497–1543) worked initially in his father's workshop in Augsburg, but left early in his career to live in Basel. By 1516, Holbein had started to paint portraits that were exquisitely rendered in the realist manner. Between 1517 and 1519, his style became noticeably softer, showing how the innovations of the Italian Renaissance were now filtering through to the North. By 1525, there was a great deal of unease and strife in Basel as the Reformation began to spread throughout Europe. Holbein decided to go to England and set sail with a letter of introduction to the King's Treasurer, Sir Thomas More, from one of his sitters, the Dutch scholar Erasmus.

Although King Henry VIII was committed to Protestant reform, there were openings in England – a country that had no history of artistic greatness – for a talented artist like Holbein. He painted a portrait of the More family; this was an important landmark as it was the first time anyone had painted a group portrait of a family at home.

On a second visit to England in 1532, he was introduced to Henry VIII and produced a series of outstanding court portraits, including one of the king with his third wife, Jane Seymour. A shrewd yet respectful eye meant that he steered a fine line between beautifying his subjects and exposing them warts and all; his dispassionate, non-judgemental style ensured that he retained his position as the leading artist in the Tudor court.

In later years Holbein turned to miniature painting (or limning), fashioning tiny portraits of his sitter's head and shoulders and picking out details with a fine brush. His only successor of any real note was the English miniaturist Nicolas Hilliard, who was appointed as limner and goldsmith to Queen Elizabeth I in 1562.

▶ THE ERMINE PORTRAIT, *1575* NICHOLAS HILLIARD
Ermine was the symbol of royalty and close inspection reveals that the animal is wearing a miniature gold crown around its collar. Elizabeth's dark bejewelled gown symbolically reinforces the gravity of the painting and its subject matter – her sword of state rests on the table beside her and stands for justice.

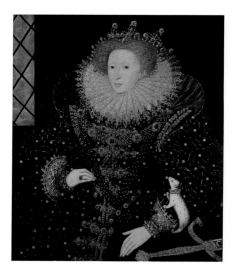

▶ PORTRAIT OF EDWARD VI, PRINCE OF WALES, *1538* HANS HOLBEIN
Edward VI became King at the age of nine and his entire rule was conducted by regents as he never reached maturity, dying at the age of 15. He was a gifted pupil and Holbein's portrait of the young boy with its serious expression emphasizes this introspective, academic side.

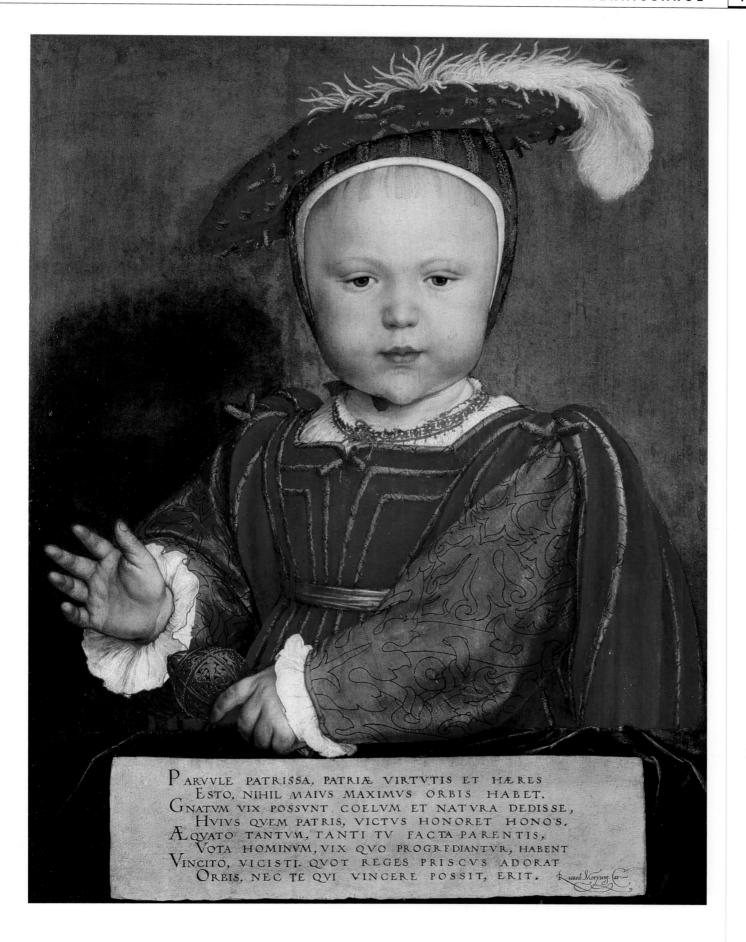

PARVVLE PATRISSA, PATRIÆ VIRTVTIS ET HÆRES
 ESTO, NIHIL MAIVS MAXIMVS ORBIS HABET.
GNATVM VIX POSSVNT COELVM ET NATVRA DEDISSE,
 HVIVS QVEM PATRIS, VICTVS HONORET HONOS.
ÆQVATO TANTVM, TANTI TV FACTA PARENTIS,
 VOTA HOMINVM, VIX QVO PROGREDIANTVR, HABENT
VINCITO, VICISTI. QVOT REGES PRISCVS ADORAT
 ORBIS, NEC TE QVI VINCERE POSSIT, ERIT.

CLOSE TO THE LAND

PIETER BRUEGEL (c1525–1569) was the last, and one of the greatest, of the 16th century artists from northern Europe. Many details of his life are uncertain, but he was born and lived in Antwerp. (He spelt his name 'Brueghel' until 1559 when he lost the 'h', but for some reason, long since forgotten, his sons clung on to the original version.)

His early works clearly show the influence of Bosch; the inventive distortions of the *Tower of Babel* are a particularly good example of his exaggerated fantasy style.

Bruegel was a highly educated, cultured man who had an extensive knowledge of myth and legend. He went on a two-year trip to France and Italy in 1552, but was largely unaffected by the quest for ideal classical form that he undoubtedly came across in Italy. He did, however, make detailed studies of the Alps on his journey home, and these form the basis for many of his later landscapes. On his return, he turned to the peasants and the countryside around his native Antwerp for inspiration, often adopting a disguise to mingle with the ordinary working people in their raucous celebrations. He became known as 'Peasant' Bruegel on account of his lively genre scenes which are at once affectionate and mildly satirical.

His real greatness lies in his depictions of landscape, in particular the series of landscapes illustrating the seasons of the year. *Hunters in the Snow (December/January)*, 1565, with its muted palette and frozen wastes, is an outstanding example, as it truly makes us feel what it was like to inhabit the physical world he portrays. Bruegel was fascinated by those who worked on the land and was keen to convey the differing relationships man had with the landscape, shown at times as overpowering and also capable of engendering feelings of great wellbeing.

During the last six years of his life Bruegel's style changed: his figures got bigger and there is a more sober and concerted attempt to illustrate proverbs and moral epithets. His work was much admired and there were many who tried to imitate him. Bruegel had two sons who became artists; Jan Brueghel (1568–1625), the second son, was the more successful, becoming renowned for his delicate flower paintings.

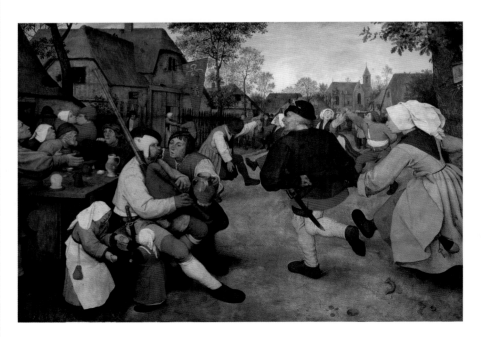

◄ PEASANT DANCE, *c1568*
PIETER BRUEGEL (THE ELDER)
Bruegel became known as 'Peasant' Bruegel on account of his paintings of local folk merrymaking, feasting, and working in the countryside. These genre scenes are works without malice, yet contain anecdotal details that reveal much about human nature. Note the lively interaction of the group around the table and the couple hand in hand in the foreground, rushing to join the dance.

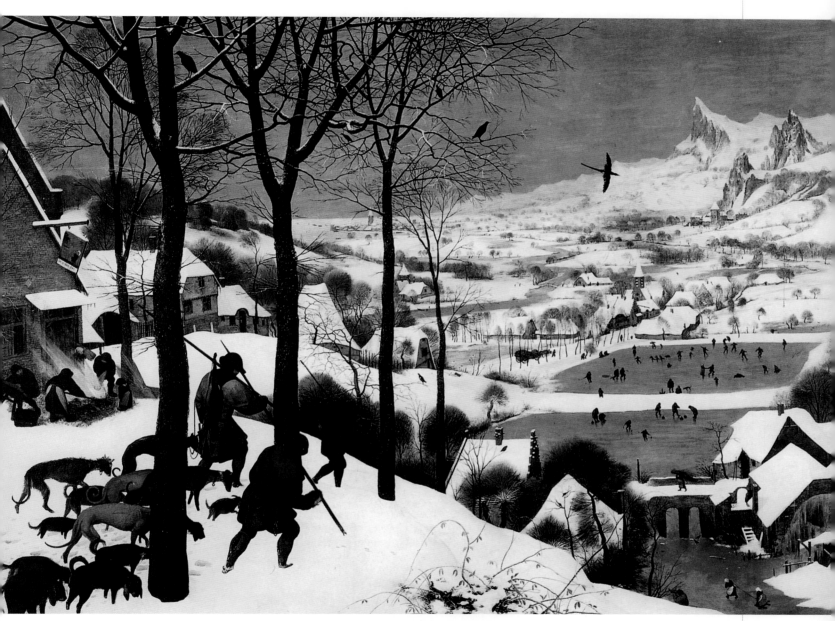

▲ HUNTERS IN THE SNOW (DECEMBER/JANUARY), *1565* PIETER BRUEGEL (THE ELDER)

From Bruegel's original group of paintings depicting landscapes and human activities through the seasons, only five have survived and, of these, Hunters in the Snow *is the best known. In this timeless scene, the countryside is in the grip of winter and the three hunters return with only a meagre rabbit in return for their efforts.*

THE BAROQUE ERA
c1600–1700

It was in Venice at the tail-end of the Renaissance that Titian first started to create an entirely new direction for painting with his loose, expressive brushwork and brilliant colour sense. This in turn was picked up by another Venetian painter, Tintoretto, whose grand compositions in churches with their exaggerated sense of space start to show the influence of Mannerism. Covering the period in art between the High Renaissance and the Baroque, Mannerism was primarily a linear style that distorted the human form in exaggerated and sometimes otherworldly settings. Tintoretto and El Greco were artists whose work featured some of the chief characteristics of Mannerism, including discrepancies in scale and harsh colour. But the style is best exemplified in Parmigianino, whose compositions were experiments in the distortion of space and the elongation of figures.

Then, at the start of the 17th century, at a time when most of Europe was facing great political, religious and social upheaval, a new type of art emerged. The Baroque style began in Rome and flourished particularly in Italy, Spain, Germany and Austria. The name Baroque was applied retrospectively to this particular style and has come to be associated with paintings with vigorous movement and emotional intensity. Baroque artists pushed forward the naturalistic achievements of the Renaissance in creating an ever more convincing illusion of reality, but went further in wanting to involve the spectator in the drama. These paintings were about substance – distilling solid, believable human beings out of light and shade and placing them on a stage where they could act out a human drama. Typically, works featured strong contrasts of light and shadow which enhanced the dramatic effect, rich colour and expressive gestures. The interplay of different diagonals on the picture plane also added a distinct sense of dynamism.

One of the greatest figures of the Baroque era was a sculptor – Gianlorenzo Bernini (1598–1680) – whose colossal marble sculptures and epic architectural designs exuded energy. At the same time, scientific advances such as those in astronomy, philosophy and physics, as well as the development of printing, were taking place against a backdrop of religious tensions between Catholics and Protestants. In response to the Protestant

1604
Cervantes finished the first modern novel, Don Quixote

1605
The first scientific description of the dodo appeared from Dutch botanist, Carolus Clusius

1614
John Napier invented logarithms to advance the field of mathematics

1614
The Church forced Galileo to recant after he suggested the earth revolves round the sun

1619
The first slaves arrived in British North America aboard a Dutch vessel

Reformation of the early 16th century, the Catholic Church embarked in the 1550s on a programme of renewal known as the Counter-Reformation. The Baroque movement took root in countries where Catholicism was revitalized by the Counter-Reformation. Following an agreement in 1609, the Netherlands was divided in two: the Protestant Netherlands (or Holland) and the southern Catholic Netherlands (Belgium and Flanders). Ruled by a Spanish archduke, Flanders became the stronghold of Catholicism in northern Europe, with Protestantism continuing to hold sway in Holland and England.

During the Renaissance, Florence and Venice were the key artistic centres in Italy, but during the Baroque period, Rome became the hub. In 1592, the great Italian painter, Caravaggio, moved from Milan to Rome, the destination of many other European artists at this time. Caravaggio was an unorthodox artist; he worked from real-life models with no preparatory drawing, often upsetting the priests who commissioned his work. By contrast, Rubens was a Flemish Catholic whose work and life were more ordered and caused less controversy.

Much admired for the way his works balanced passion and reason was the Flemish Baroque portrait painter Anthony van Dyck. In Spain, Baroque art was largely devotional in nature and Velázquez was its greatest exponent, producing his own inimitable, dignified vision of human reality.

It was the Dutch vision that came to characterize the era, with several artists contributing to what came to be known as the Golden Age of Dutch painting. Rembrandt, who lived and worked in Amsterdam, was the most celebrated of these artists, with a unique gift for producing portraits giving insight into his sitters. There was also a number of Dutch artists who looked to their immediate surroundings and produced either sumptuous still lifes or vital evocations of landscape.

Both Claude and Poussin in France were painting in the classical landscape tradition, although the emotional intensity of their work makes it part of the Baroque tradition. Towards the end of the 17th century, the Baroque gradually became more ornate and eventually gave way to the altogether lighter and more decorative style of Rococo.

1620	1666	1682	1683	1685	1690
The first pilgrims arrived at Plymouth Rock aboard the Mayflower	The Great Fire of London began in Pudding Lane, then destroyed four-fifths of London	William Penn began Pennsylvania as a 'Holy Experiment' based on Quaker principles	Vienna survived a gruelling three-month siege by the Turkish army	The Edict of Nantes, granting freedom of worship, was revoked, causing Protestants to flee France	William of Orange won the Battle of the Boyne, touching off three centuries of religious bloodshed

FREE EXPRESSIVE BRUSHWORK

TITIAN (c1488–1576) was the most important Venetian painter of the 16th century and one of the greatest and most versatile artists of the Italian Renaissance.

Born in the Dolomites, Titian went to live in Venice as a boy where he was first apprenticed to a maker of mosaics, before receiving training in Giovanni Bellini's studio. He then entered Giorgione's studio, thus ensuring the best schooling he could have had in Venice at the time.

Titian's first major commission was to complete three frescoes in Padua. Then, in 1516, after both his early mentors, Giorgione and Bellini, had died, he was appointed official painter of the Venetian republic. At this point,

Titian enjoyed a meteoric rise and became the favourite painter of wealthy intellectual circles in Venice.

His work was wide-ranging, encompassing portraits, religious subjects and mythological scenes. Although often reluctant to travel, Titian was inundated with offers from the rulers of Ferrara, Urbino and Mantua. His paintings tell us much about Italy's most powerful families of the time; he painted the young grandson of Pope Paul IV for example, as well as the infant daughter of the aristocratic Strozzi family. He first met Emperor Charles V in 1529 and was appointed court painter in 1533. He also worked for his successor, Philip II. Titian's stature was as great as that of Michelangelo, whom he finally met in

Rome at the age of 60 when Titian was invited to stay as a guest of the Vatican. He is believed to have lived until he was 90, when he finally succumbed to a plague epidemic.

Titian was a painter who revelled in his chosen medium. He applied oil paint freely, using fingers as well as brushes, anticipating the modern emphasis on employing materials in a direct, expressive manner. He developed his own technique, applying glazes and bright colours over an underpainting.

In a sense, light and landscape became his subject matter, his work exuding confidence and a great sense of wellbeing. His warm, rich palette has influenced painters and painting ever since.

▶ **A MAN WITH A QUILTED SLEEVE,** *c1510* **TITIAN**
An early work by Titian that was believed to be a portrait of the Italian poet Ariosto, but the sitter has never been firmly identified. Rembrandt used the portrait as a model for his own Self-Portrait at the Age of 34. *Note the extraordinary realism of the sleeve.*

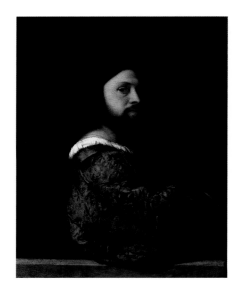

▶ **DAVID'S VICTORY OVER GOLIATH,** *1542* **TITIAN**
Commissioned for the ceiling of a church in Venice, Titian's David and Goliath is designed to be seen from below. The dramatic nature of the event is conveyed through the theatrical lighting and contorted poses, with the figure of Goliath seemingly about to topple down on us.

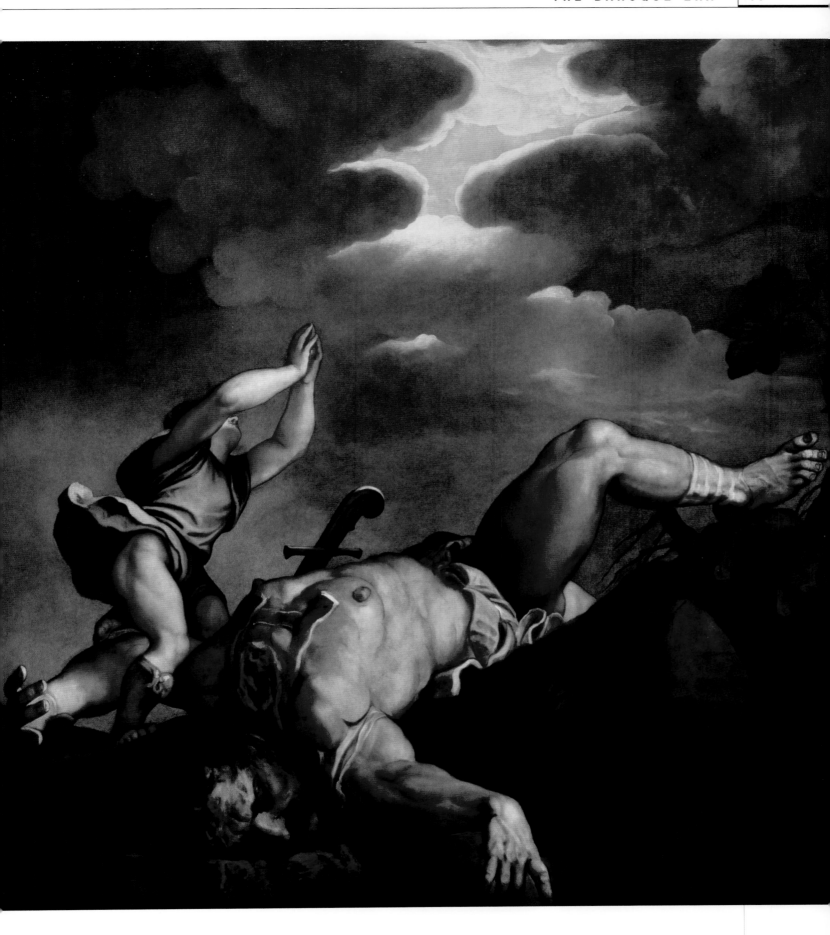

HEIGHTENED DRAMA AND TENSION

THERE WERE TWO other great Venetian artists in the latter half of the 16th century besides Titian. Their work tells us much about the city in which they lived and worked, as well as making for an interesting contrast in styles. Jacopo Tintoretto (c1518–1594) was one of Titian's pupils and it is said that the master was jealous of his talented pupil, who declared that his aim was to surpass the drawing of Michelangelo and the colour of Titian.

Tintoretto came from a relatively humble background; his father dyed cloth, and he lived all his working life in Venice where he painted mainly religious subjects and portraits. He worked hard for success and used all available means to secure commissions, including undercutting his rivals' rates.

Tintoretto often used a *maquette,* a small scale model, to help him plan his paintings. He positioned wax figures under artificial light to see how they affected the composition. His crowded pictures, featuring writhing, foreshortened figures, are full of movement and drama in the Mannerist style. In the mature works, his passionate vision produces a sense of suppressed excitement; it is as if something incredible is about to happen. His talent for storytelling emerges in his paintings for the Scuola di San Rocco, which depict the life of Christ in a dark and otherworldly light. El Greco's work clearly shows his influence.

Paolo Veronese (c1528–1588) was born in Verona, on the mainland territory of Venice. He was primarily a decorative painter whose flattering style played up to the vanity of the aristocratic Venetian families in the 16th century. He also specialized in religious scenes, set incongruously against opulent Venetian backgrounds.

Veronese was interested in dramatic narrative, conveyed with sumptuous colour and tone. His acute eye for the appearance of things and the way in which he managed to capture the luxurious surfaces of jewellery, silks and satins ensured his popularity.

Veronese's seemingly uncomplicated but powerful vision contrasted with the controversial approach of Tintoretto. However, in later years, Veronese faced an Inquisition tribunal to explain a number of 'irreverent and offensive elements' in his *Last Supper.*

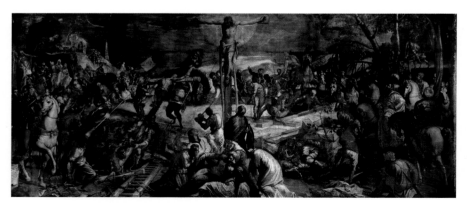

▲ CRUCIFIXION, *1565* TINTORETTO

Tintoretto's Crucifixion *in the Scuola di San Rocco is a vast dramatic scene in which the numerous spectators revolve around the central figure of Christ on the cross. Writing about* Crucifixion, *Henry James said: 'Surely no single picture in the world contains more of human life; there is everything in it, including the most exquisite beauty.'*

▶ THE WEDDING AT CANA *(detail), 1563* PAOLO VERONESE

At the wedding feast at Cana, Galilee (John 2:1–12), Christ first performed a public miracle, turning water into wine. In this detail focusing on the musicians, Veronese has used himself and his artist friends as models – Titian is dressed in red holding a contrabass and Veronese is in a white tunic with a viol.

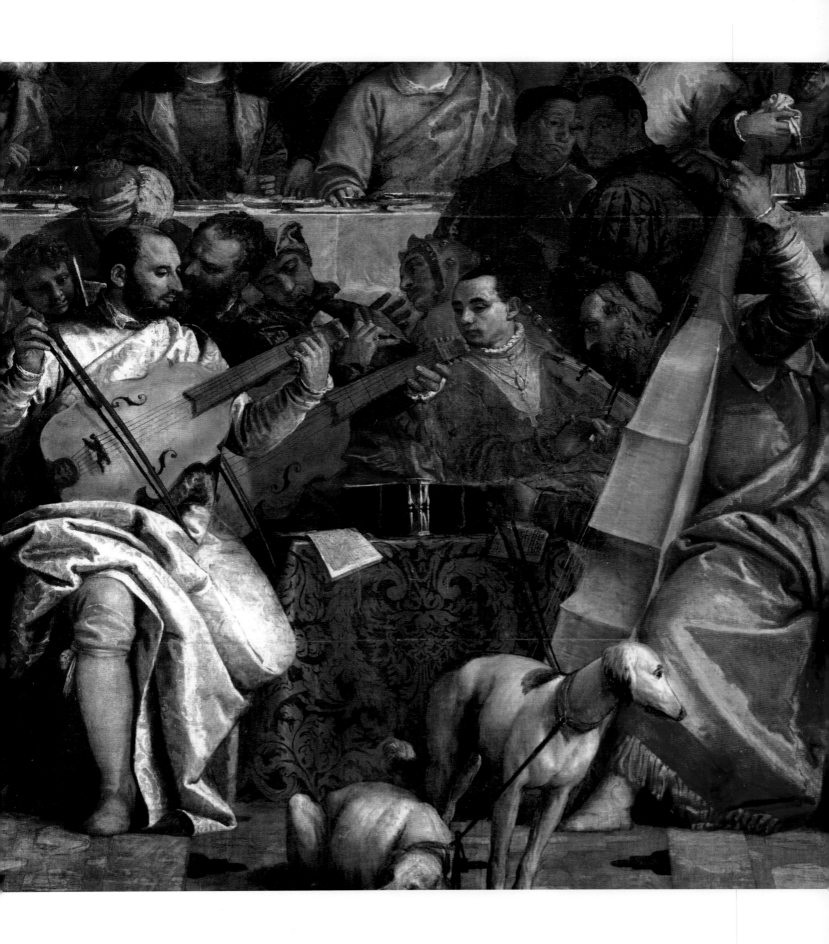

DISTORTION OF FORM

MANNERISM DESCRIBES an affected, self-conscious and contrived style that first appeared in painting, architecture and sculpture towards the end of the Renaissance period. A reaction against classical harmony, Mannerism relies on ambiguity and a search for new forms to produce compositions that feature distortion, ambiguous space and unnatural colour. The archetypal Mannerist is the painter Francesco Parmigianino (1503–1540).

Born in Parma, Parmigianino went to Rome in 1523 where he started experimenting to create his own idea of feminine beauty. The resulting distortions and elongations were not to everyone's taste and some denounced his work as too artificial. His later works include the much-celebrated *Madonna of the Long Neck* with the Virgin's unfeasibly long, yet gracefully tapering pale neck and shoulders.

El Greco (1541–1614, *né* Doménikos Theotokópoulos) was born in Crete. A wholly original and visionary painter, he was the greatest exponent of the Mannerist style. El Greco initially painted icons in the Byzantine tradition, but after moving to Venice in 1560, his work, with its harsh contours and dramatic light and shade, clearly revealed the profound influence of Tintoretto. Michelangelo also had a significant impact on his development.

By 1577, El Greco was in Toledo, Spain where he remained until his death. Here his mature style evolved; characteristically his paintings were composed of dynamic, elongated figures flickering eerily almost like flames. All the movement sweeps upwards towards the top of the painting; the light, rapid brushstrokes and acidic colour add intensity to an already fervid vision. It is believed he may have used mirrors and other optical aids to achieve some of these distortions.

The legacy of the Counter-Reformation meant that Catholic Spain was the natural spiritual home for someone with such intense religious beliefs. Toledo was a key Catholic city and El Greco was able to find wealthy patrons there as well as in Madrid, although he had little success in securing royal patronage. His strange, unique and forceful vision was much admired in the 20th century by the Expressionists.

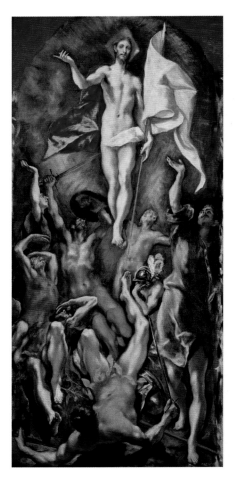

▶ RESURRECTION, *C1597–1604*
EL GRECO
In the Resurrection *panel, part of a three-level altarpiece for the church of the Colegio de Doña María de Aragón in Madrid, expressive distortion and intense drama are combined. In this, one of El Greco's most celebrated works, Christ bursts forth from his tomb and sucks the waiting figures upwards towards the heavens.*

▶ MADONNA OF THE LONG NECK, *1534*
FRANCESCO PARMIGIANINO
This strangely unbalanced composition, with its distortions of the Madonna's neck and shoulders must have confounded contemporary ideas of beauty and harmony. In The Story of Art, *EH Gombrich suggests that the intention was to show how a solution that was based not on harmony but discord could achieve an equally interesting and imaginative effect.*

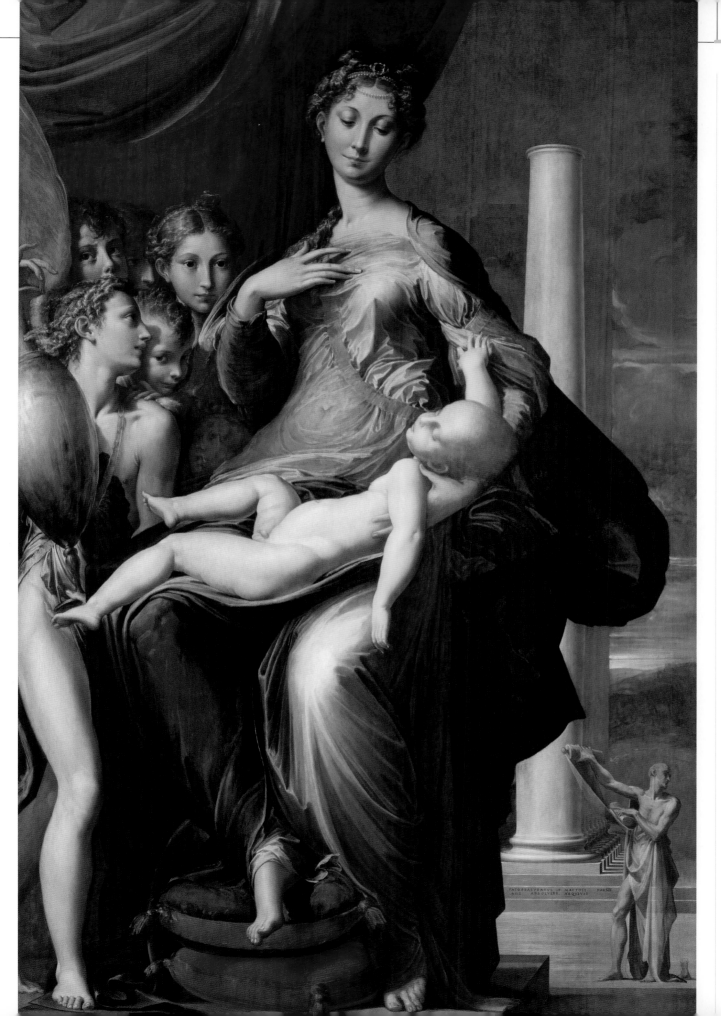

DRAMATIC LIGHT AND SHADE

BY THE START OF THE 17th century, Rome had become the main artistic centre in Italy, with Florence and Venice declining in importance. The Counter-Reformation had revitalized Catholicism in Italy and nowhere was this more evident than in Rome, the city to which the painter Michelangelo Merisi da Caravaggio (1571–1610) moved in 1592. At this point Caravaggio was still a relatively unknown artist with few commissions. However, all this changed in 1596 when he was engaged to paint frescoes for the Contarelli chapel. His *St Matthew* series caused a sensation and was condemned as 'vulgar and sacrilegious' by the clergy.

Caravaggio was a forceful and volatile character, capable of acts of violence. However, it is for his controversial working methods rather than his temperament that he should be remembered. In rejecting the Renaissance search for ideals, Caravaggio declared he wanted to study nature and chose ordinary working men and women as models. His method of painting directly in oils from models was revolutionary and led to another vital innovation, his use of *chiaroscuro,* or extremes of light and shade. His remarkable technique, with its concentration on dramatic gestures and down-to-earth realism, showed just how posturing the previous Mannerist style had been.

Caravaggio had influential patrons who protected him, but his naturalistic technique both offended and appealed to the Catholic clergy, because they feared that the dramatic impact of his work might help lure strait-laced Protestants back into churches.

Then, at the height of his success, he was obliged to flee Rome, having killed a companion in a brawl. He died, aged 37, from malaria.

Caravaggio's influence lived on particularly in the work of Artemisia Gentileschi (1593–1651) who met Caravaggio through her painter father. She had a turbulent start to her career, having been raped at 19 by her tutor. Her work has a similar dramatic quality to Caravaggio's, with figures emerging with great strength and vitality from the deepest shadows. Gentileschi painted five versions of the brutal biblical story of Judith slaying Holofernes, and it is hard not to interpret this as symbolic of a woman painter's determination to overcome adversity. Significantly, Gentileschi was the first female member of Florence's Academy of Art.

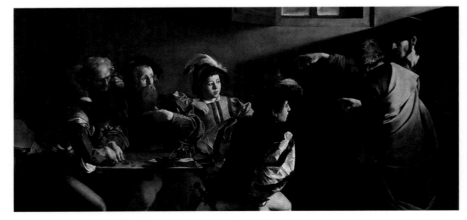

▲ THE CALLING OF ST MATTHEW, *1598* CARAVAGGIO
Caravaggio's first major church commission, this painting depicts the moment in the Gospel of Matthew when Jesus sees Matthew at his seat in the custom house and says to him, 'Follow me'. Pictured around the table in the gloomy interior are a group of impassive bystanders.

▶ JUDITH AND HOLOFERNES, *1620* ARTEMISIA GENTILESCHI
In the biblical story, Judith took her revenge on Nebuchadnezzar's general, Holofernes, for taking her hostage by decapitating him when he was drunk. Gentileschi painted this image of Judith several times. In this version, the violent act is portrayed in a dispassionate and unromanticized manner.

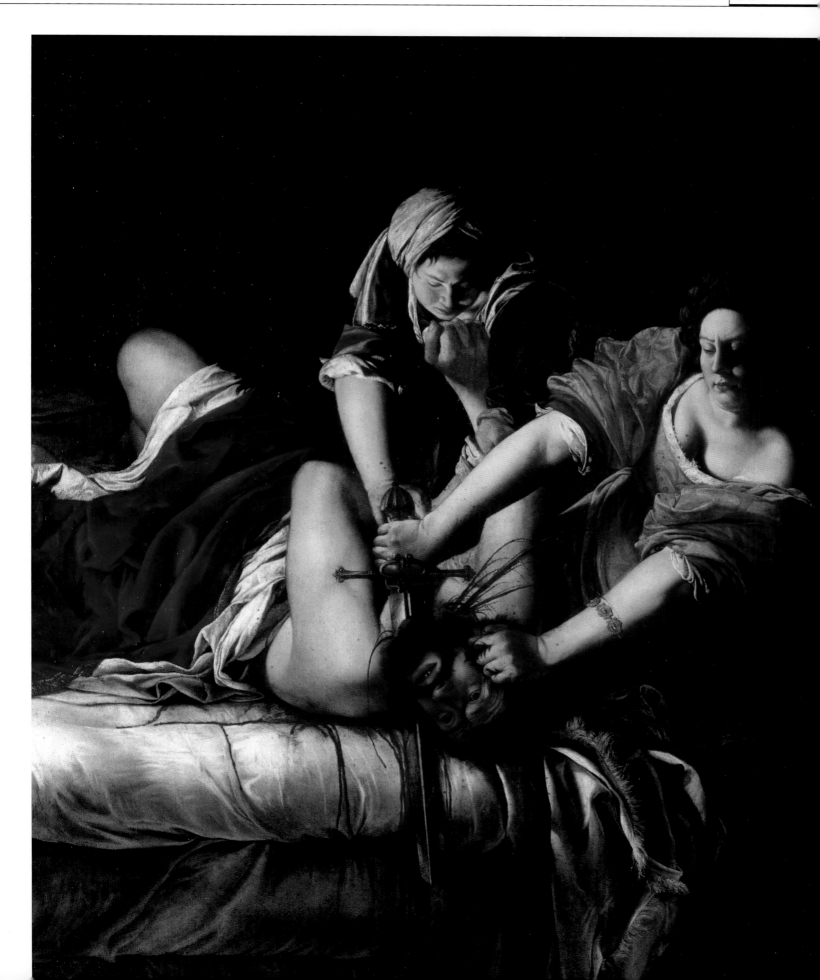

VOLUPTUOUS NUDES

BY THE 17TH CENTURY, Flanders was the main stronghold of Catholicism in an otherwise Protestant northern Europe. In 1609, an agreement separated Belgium and Flanders from the rest of the Netherlands in the North; the southernmost region remained under Spanish rule. Following the Counter-Reformation and the reassertion of the Catholic church in both Flanders and Spain, the two countries became a breeding ground for religious idealism.

It was against this background that Peter Paul Rubens (1577–1640) launched his career in Antwerp, the most prosperous city in Flanders. In 1600, Rubens went to Italy to study and travelled widely over the next decade. He visited Spain where he became friends with the Spanish master, Velásquez. A cosmopolitan and magnanimous man, Rubens took elements from many different sources, such as Michelangelo, the Venetian master Titian and Caravaggio, and fused them into his own style. Rubens exemplifies all that has come to be known by the term Baroque. His religious paintings contain outpourings of genuine emotion. There's a feeling for light and colour, as well as a clarity of purpose that suggests a deep sincerity and optimism.

Rubens spoke many languages and was regarded as a diplomat due to the many connections he managed to secure both at home and abroad. From 1609 to 1621, he was court painter to Albert and Isabella, rulers of the Netherlands, and after Albert's death in 1621, Rubens became an adviser and diplomat for Isabella. He also acted as a special adviser to Marie de' Medici, the widowed Queen Mother of France, and produced paintings for the Luxembourg Palace on the left bank of the Seine. In 1629, he visited the court of Charles I in England where his vigorous style was much celebrated.

His sizeable studio produced countless portraits, landscapes, religious and mythological scenes as well as altarpieces. Towards the end of his career, his brushstrokes became freer and he produced work in which the surfaces were incredibly well rendered. These include paintings featuring his well-known, voluptuous, fleshy nudes – a Flemish artistic convention equated with prosperity – which Rubens painted after studying classical sculptures. Rubens was a great influence on many painters, including Van Dyck, Watteau and, later, Renoir.

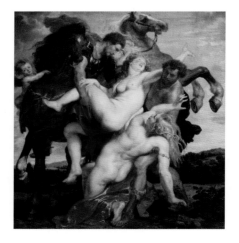

◄ **RAPE OF THE DAUGHTERS OF LEUCIPPUS,** *1616-17*
PETER PAUL RUBENS
In Greek mythology, Leucippus was the father of Phoebe and Hilaeira, who were abducted by two young men known as Castor and Polydeuces. With his warm tones, dramatic lighting and swirling composition, Rubens romanticizes the brutality implicit in the narrative and distances the viewer from its implications.

▶ **THE TOILET OF VENUS,** *c1613*
PETER PAUL RUBENS
Seen as the depiction of ideal female beauty in western art, Venus the goddess of love, entranced by her own reflection, was a commonplace subject in the Renaissance and Baroque eras. Rubens' Venus, however, gazes not at herself in the mirror, but at the effect that her beauty has upon the viewer.

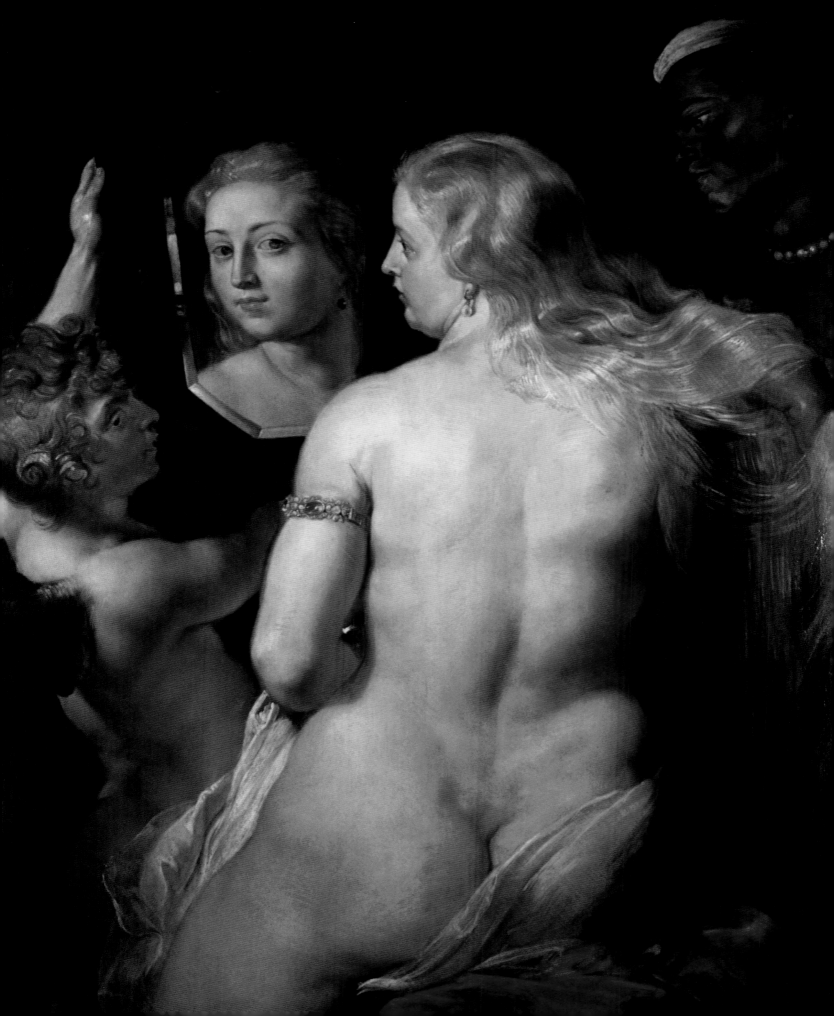

FRENCH NEO-CLASSICISM

WHILE MANY OF THE GREAT landscape painters of the 17th century were Dutch, two of the most important landscape artists of the time were French. Both Nicolas Poussin (1594–1665) and Claude Lorrain (1600–1682) were born in France but chose, like many of their contemporaries, to live and work in Rome. Both artists' work shows the strong influence of the classical tradition in Italy.

Nicholas Poussin left France for Rome in 1624 where he quickly secured important patrons. Poussin wasn't entirely impressed by the work that he saw there, rejecting the affectations of the Mannerists, but finding the naturalistic masters painting in the Baroque style too unrefined for his taste. Instead, Poussin chose to study Italian High Renaissance masters, particularly Raphael and Titian, along with antique sculptures. He also worked in the studio of the arch-classicist Domenichino.

Poussin came back to Paris from Rome in 1640, summoned by King Louis XIII and Cardinal Richelieu to supervise the decoration of the Louvre; he returned two years later and stayed there for the rest of his life.

Poussin was a supremely intellectual artist, believing that paintings should appeal to the mind as well as the eye. He imposed order on his smooth, highly finished, idealized landscapes using models of miniature stage-sets to help him perfect his compositions.

He brought a delicate and dignified approach to history and mythology, rejecting the emotional side of Baroque while bringing to it an austere, restrained classicism.

Claude Lorrain was a fellow inhabitant of Rome but more of an intuitive artist than the cerebral Poussin. Claude was known primarily for his masterly treatment of soft, golden light which he often observed first hand by painting outdoors. He used mythological and biblical stories as the basis for his compositions, but adapted these, drawing upon the countryside of Campagna around Rome for inspiration. Typically, his compositions feature a vista over low-lying countryside, with carefully placed antiquities and ruins helping to evoke an atmosphere of calm and nostalgia. Both Poussin and Claude dominated this genre in the 17th century and had many imitators, notably the Neo-Classical school in late-18th-century France.

▲ RINALDO AND ARMIDA, *1630* NICHOLAS POUSSIN

Poussin was interested in storytelling and the subject is from the Italian poet Tasso's baroque poem, Jerusalem Delivered' *(1580). The Saracen sorceress Armida is about to kill the Christian warrior Rinaldo, but love stops her from committing the deed. Instead, she takes him away to a magical island where he becomes infatuated with her.*

▲ A PASTORAL LANDSCAPE, *1677* CLAUDE LORRAIN

A late painting by Claude for the Roman aristocrat, Prince Lorenzo Colonna, who commissioned at least eight other works from the artist. Like many of his works, the tranquil mood of a group of people with musical instruments calmly enjoying the landscape evokes the pastoral amusements of ancient Rome.

CHARACTER STUDIES AND ROYAL PORTRAITS

DURING THE BAROQUE PERIOD portraiture became increasingly important. With the decline of religious authority, particularly in Protestant countries such as England and the Netherlands, powerful secular rulers wanted to stamp their authority by having their likenesses displayed for all to see. Flemish artists Rubens and Anthony van Dyck (1599–1641) painted images of these wealthy and powerful individuals dressed in their lavish robes. These were carefully designed to flatter, but often revealed much of the character within as well.

Van Dyck realized that portrait painting could be a passport to success in an increasingly secular age. After becoming chief assistant to Rubens, Van Dyck travelled extensively in Italy, painting portraits in Venice and Rome.

He returned to Antwerp, then finally settled in England in 1631 as court painter to Charles I. He made many portraits of the King, lending him an air of refined nobility and intelligence, while at the same time becoming the chief chronicler of the court and its elegant Cavalier style. Van Dyck received a knighthood in England and his influence on English portraiture has been profound and enduring.

Group portraits were produced in greater numbers during the Baroque period, particularly in the Netherlands. And one of the first painters to excel as a group portraitist was the Dutch painter Frans Hals (c1582–1666), a contemporary of Rubens and Rembrandt. Hals was also one of the first artists to use oils without underpainting, applying paint directly to

the ground. This gave his work a textural quality, the lively brushstrokes capturing the most fleeting of facial expressions. Hals' spontaneous, almost impressionistic style introduced a more informal note into portraiture in the 17th century. He painted people without idealizing them as Van Dyck had done.

The female artist Sofonisba Anguissola (c1532–1625) was also a significant painter of portraits and self-portraits. Born and trained in Lombardy, Italy, she was appointed court painter to Philip II of Spain in 1559 and was visited by Van Dyck in Genoa towards the end of her long career in 1623. Anguissola made much use of the half-length portrait, and was keen to search for an emotional truth behind her likenesses, which included several paintings of herself.

▶ CHARLES I, *c1635*
ANTHONY VAN DYCK
Van Dyck was court painter to Charles I and was knighted by him in 1633. He painted several different portraits of the King, including this one in hunting gear in which he worked hard to flatter the monarch through the dignified stance and elegant silk attire.

▶ SELF-PORTRAIT AT THE EASEL PAINTING A DEVOTIONAL PANEL, *1556*
SOFONISBA ANGUISSOLA
Sofonisba Anguissola's gender and social class meant she was restricted to making portraits of herself and members of her family. Because of this, she was able to develop a more intimate, informal style of portraiture, in which her largely female subjects were shown following a range of interior pursuits such as chess or painting.

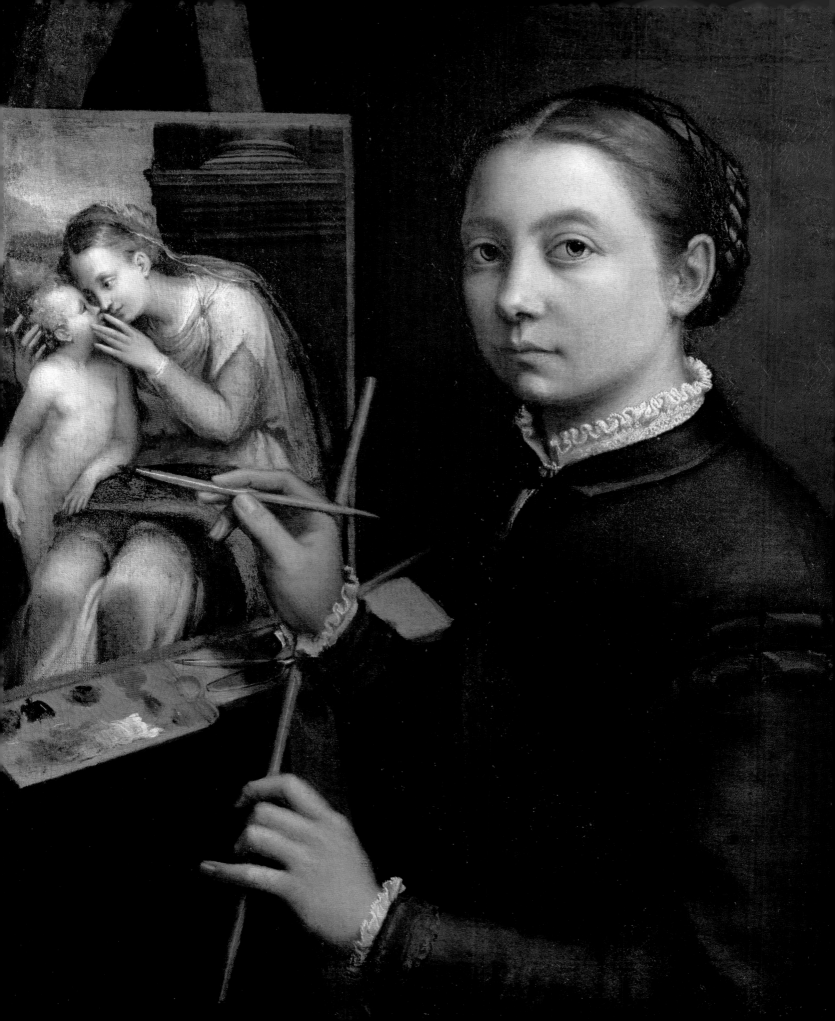

A Feeling for Humanity

The Spanish Hapsburg dynasty was marked by religious zeal and King Philip IV, like his predecessors Philip II and Philip III, ensured that devotion to Catholicism was maintained by means of the Spanish Inquisition. This meant that any artist producing work considered unorthodox or heretical could be subject to persecution by a specially appointed council. It was against this backdrop that, at the age of 24, Diego Velásquez (1599–1660) became court painter to Philip IV. Velásquez's early work showed the strong influence of Caravaggio with its dramatic light and shade and a strong streak of grim realism that was much admired in Spain. Even in his early religious paintings, Velásquez was developing a new naturalistic style in which the figures were based on real people rather than idealized types. From the time of his appointment as court painter to the end of his career, his paintings of Spanish royalty and life at the court are remarkable for the insight they give into the human condition.

Born in Seville, Velásquez trained under Pacheco. Early in his career, Velásquez made a type of genre picture known as a *bodegone* (literally Spanish for 'tavern'), which has come to mean a still life picture based on a scene from a kitchen. A celebrated example of this style is the dignified portrait of *An Old Woman Cooking Eggs*. At court, Velásquez primarily worked on portraits, but also continued to paint historical, religious and mythological paintings.

In 1628, following a visit to Spain by Rubens, Velásquez decided to visit Italy where his brushwork became more relaxed under the influence of great Venetian masters such as Titian. The 1630s and 1640s were a highly productive period. He produced many royal and court paintings in which he lent dignity to even the lowliest of the court subjects, including the jesters and fools.

In his final years in Madrid, Velásquez was made Knight of the Order of Santiago and painted some sparkling portraits of the royal family including the great group composition, *Las Meninas*. This complex essay in portraiture combines naturalism, atmosphere and insight into character and demonstrates Velásquez's ability to delve below the surface in search of real truths.

▶ AN OLD WOMAN COOKING EGGS, *1618* DIEGO VELÁZQUEZ
Painted when Velázquez was 18 or 19, this work is an insightful portrait as well as a remarkable example of his ability to paint everyday objects directly from life. The contrasting materials and textures and the play of light and shadow on the surfaces give the work an extraordinary realism.

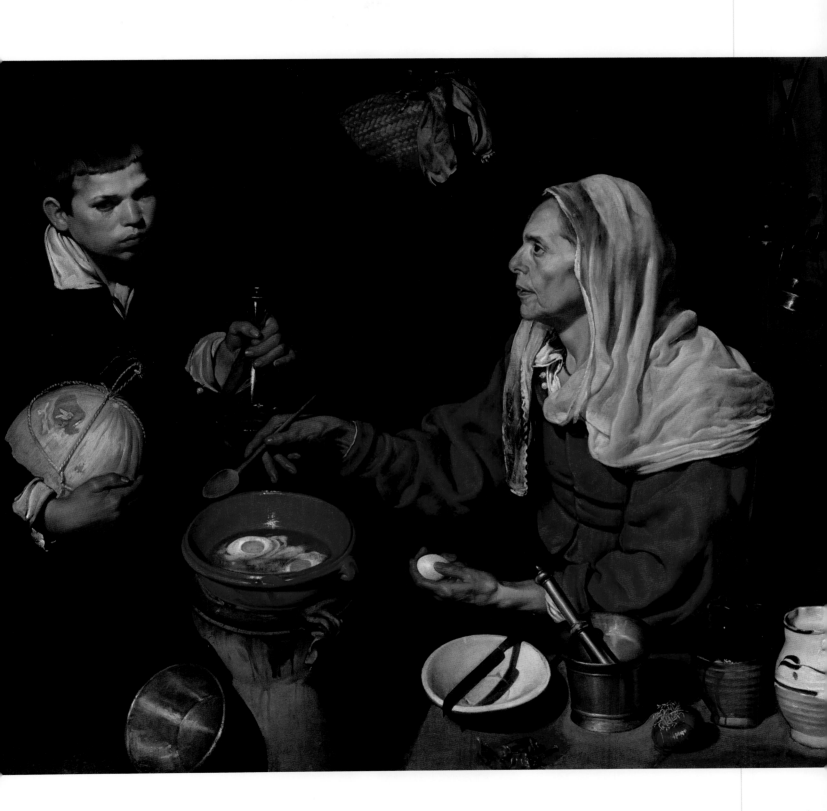

INNER TRUTH LAID BARE

WHILE RUBENS WAS based in Flanders, the greatest of all Dutch painters Rembrandt (Harmensz van Rijn, 1606–1669) was based in Amsterdam in the Protestant North. Here, churches had been stripped of all Catholic paraphernalia and, in painting, there was renewed emphasis on naturalism and an interest in ordinary, everyday things. Rembrandt was born in Leiden; he had a couple of early tutors, the most influential being Pieter Lastman, a Catholic whose taste for dramatic gestures and vivid lighting had an early impact on Rembrandt's developing style.

Rembrandt quickly decided to pursue a commercial career in Amsterdam where he soon attracted numerous commissions. His first, formal portrait in 1631 (of Nicolaes Ruts) established him as the leading portrait painter in the city. This was followed by *The Anatomy Lesson of Dr Nicolaes Tulp* in 1632 which, with its group of fully realized individuals gathered around a dissection, completely revitalized the group portrait. His success continued and, by 1639, he had earned enough to buy a large house.

From the 1640s onwards, following the death of his wife and mother, Rembrandt became more introspective and started to concentrate on religious painting. He eventually married his servant, Hendrickje Stoffels, and stayed with her for the rest of his life, painting many portraits of her. But after he turned his back on fashionable portraits, he got into financial difficulties from which he never quite recovered.

Human understanding and compassion are the hallmarks of his introspective and penetrating portraits. One of the first artists to specialize in the self-portrait, Rembrandt produced over 100 paintings and etchings of himself. His last, great self-portraits have an almost shocking ability to strip away all artifice to reveal a dignified, old man whose suffering is manifest in nearly every aspect of his face, but whose soft features betray no obvious signs of bitterness or regret.

The emotional depth of his work is equalled by his virtuouso technique. His paintings are built with layers of glazes and passages of impasto, leading one contemporary to remark that they looked as if they had been 'daubed with a bricklayer's trowel'.

There is a complete mastery of light and shade as well as a delicate softness which is entirely Rembrandt's own.

▶ WOMAN BATHING IN A STREAM, *1654*
REMBRANDT
The model for this dramatic portrait was probably the artist's common-law wife, Hendrickje Stoffels, with whom Rembrandt lived from about 1649 until her death in 1663. The painting is loosely handled and has the spontaneity of a sketch, appearing unfinished in parts, particularly around the edge of her robe.

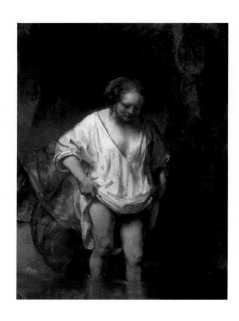

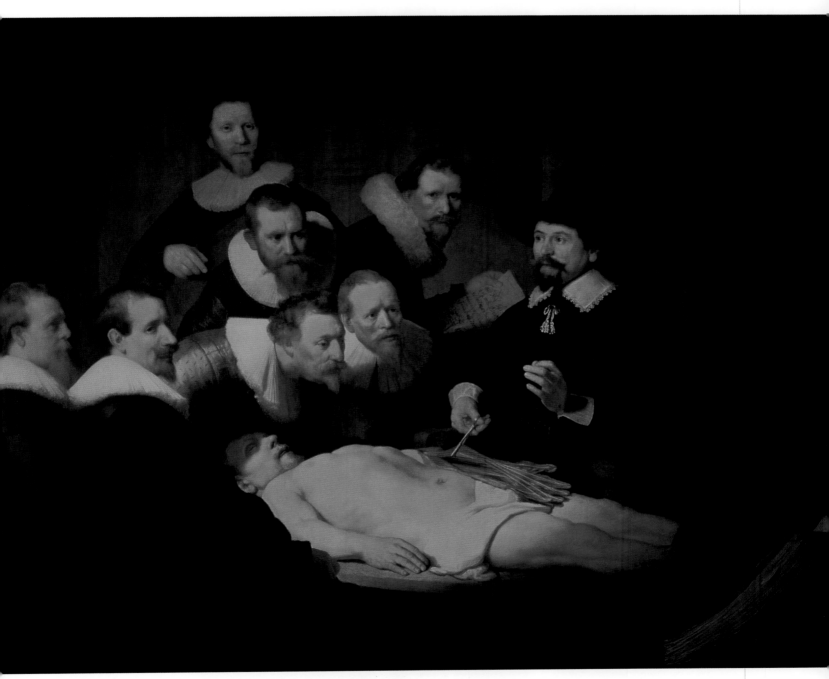

▲ THE ANATOMY LESSON OF DR NICOLAES TULP, *1632* REMBRANDT

Dr Tulp, of the Amsterdam Guild of Surgeons, explains to the assembled group of medics the muscle structure in the arm, having laid open a corpse's arm for the purpose. This carefully planned and well-thought-out composition was Rembrandt's first attempt in a series of group portraits he produced for the boardroom of the Guild of Surgeons.

STILL LIFE PAINTING

BY 1640, A NEW GENRE had been established in Holland, namely the still life. With religion waning in influence, the detailed realism of the still life appealed to the emerging Dutch middle classes who were now the principal patrons of art in the Netherlands. The convention was to have a table set against a blank and often dark background, with sparkling glasses, gleaming metal plates and the remains of a sumptuous meal as the outward symbols of wealth and conspicuous consumption. Paintings that contained symbolic reminders – such as a skull, a pocket watch or rotting fruit – of the transitory nature of life were known as *vanitas* and their popularity spread, along with the still life genre itself, to Flanders, Spain and France.

One of the earliest practitioners of the genre, Clara Peeters (1594–1657) was born in Antwerp at a time when the term 'still life' had not yet been coined. She produced what was termed a 'breakfast piece' on account of its depiction of plates of bread and fruit.

Willem Claesz Heda (1594–1680) and Jan Davidsz de Heem (1606–c1683) practised in the Dutch still life tradition with works that quietly responded to the beauty of the everyday. De Heem, who was born in Antwerp, concentrated mainly on elaborate floral arrangements, with the many different textures of individual flowers realized in exquisite detail. Rachel Ruysch (1664–1750) was another Dutch flower painter, whose meticulous flower and butterfly arrangements imply the fragile beauty of living things.

In Spain too there were some fine examples of still life painting. Juan Sánchez Cotán (c1560–1627) was a friar and an acquaintance of El Greco. His *Still Life with Quince, Cabbage, Melon and Cucumber* shows a dramatic arrangement of fruit and vegetables partly hanging from strings, one of five still lifes bought by King Philip III. Spanish painter Francisco de Zurbarán (1598–1664) was primarily a portrait painter, but the masterly still lifes he produced are some of the finest examples of the genre. His simple arrangements of domestic objects – in one composition, four simple pots and bowls are arranged in a line on the edge of a table or shelf – have a meditative, almost mystical beauty.

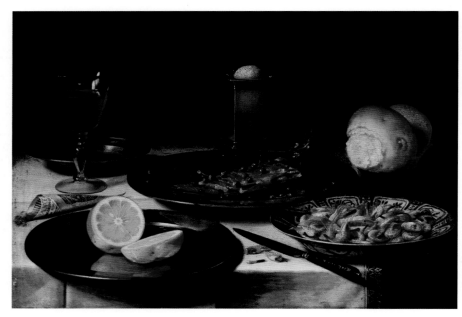

▲ A HERRING WITH CAPERS AND A SLICED ORANGE ON PEWTER PLATES, *c1620*
CLARA PEETERS
Peeters is the Flemish woman painter credited with introducing the Dutch type of 'breakfast piece' still life to Antwerp. Her meticulously rendered small-scale still lifes tend to avoid overlapping objects, and typically focus on arrangements of plates, goblets, items of cutlery, fruit and baked rolls, mostly set against a dark background.

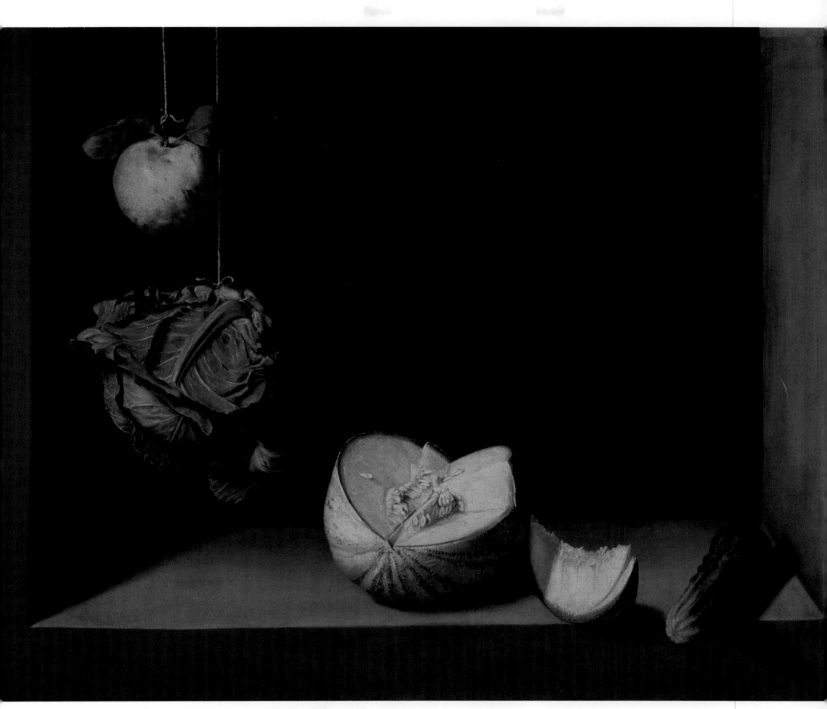

▲ STILL LIFE WITH QUINCE, CABBAGE, MELON AND CUCUMBER, *c1602*
JUAN SÁNCHEZ COTÁN

Following a simple recipe, Sánchez Cotán serves up a cut melon, a knobbly cucumber, a yellow quince and a leafy cabbage with loving detail. The cabbage and the quince are suspended on strings, a common way of preserving food in the 17th century. The clarity of the arrangement and the unusual light source provide the painting with an almost sculptural quality.

DUTCH LANDSCAPES

BY 1600, LANDSCAPE had become established as an autonomous genre. Landscape painting flourished in 17th-century Holland, partly because it was an expression of the pride the Dutch felt in their country after achieving independence from Spain. Jacob van Ruisdael (c1628–1682) is regarded as the greatest of all Dutch landscape painters, but he had many distinguished contemporaries including Jan van Goyen (1596–1656), Meindert Hobbema (1638–1709) and Aelbert Cuyp (1620–1691).

Dutch landscapes were essentially naturalistic yet not necessarily topographically exact, with certain details, such as the flow of a river, changed to suit a composition. Dutch artists were interested in the constantly changing quality of light, as well as depicting the various moods of nature. The landscapes almost always included human figures to reinforce the idea of man as an integral part of nature.

Jan van Goyen along with Salomon van Ruysdael (Jacob's uncle, c1600–1670) helped to establish the landscape school in Holland. Van Goyen visited France and travelled widely in Holland, using his sketches as the basis for calm, luminous and atmospheric compositions featuring river views and low horizons. Aelbert Cuyp was influenced by the Dutch artist Jan Both, who had been to Italy and from whom Cuyp picked up an Italianate understanding of light. Cuyp's views of the watery landscape around Dortrecht bathed in a soft, golden light led to his nickname, 'the Dutch Claude'.

Jacob van Ruisdael came to prominence in the late 1640s for his panoramic views of the low-lying terrain around Haarlem, his birthplace, now regarded as the home of Dutch landscape painting. Ruisdael painted every type of landscape – from beaches to winter landscapes – and quickly moved away from a soft, subtle tonal style to one that favoured strong, vigorous brushstrokes and dramatic contrasts of light and shade. There is a great emotional strength to Ruisdael's mature work, with dark skies, twisted, felled branches and rushing streams conveying the overwhelming and mysterious forces of nature.

Meindert Hobbema was a friend and contemporary of Ruisdael. His best-known work, the flat and ordered *The Avenue at Middelharnis*, continues to define the Dutch landscape tradition in the popular imagination.

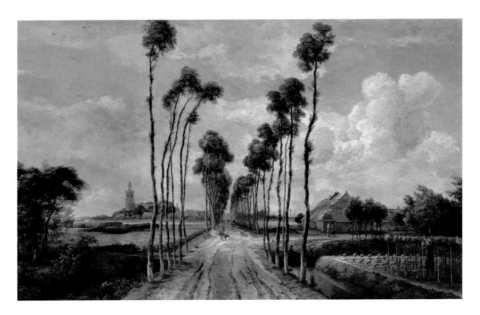

◀ THE AVENUE AT MIDDELHARNIS, *1689* MEINDERT HOBBEMA
This is a view of the Dutch landscape, featuring a straight dirt road lined with poplar trees leading to the village of Middelharnis in the distance. This ordered landscape has been created and maintained by mankind – deep ditches carry water to the surrounding orchards, while a man prunes the trees with a knife. The effect is simple but strangely impressive.

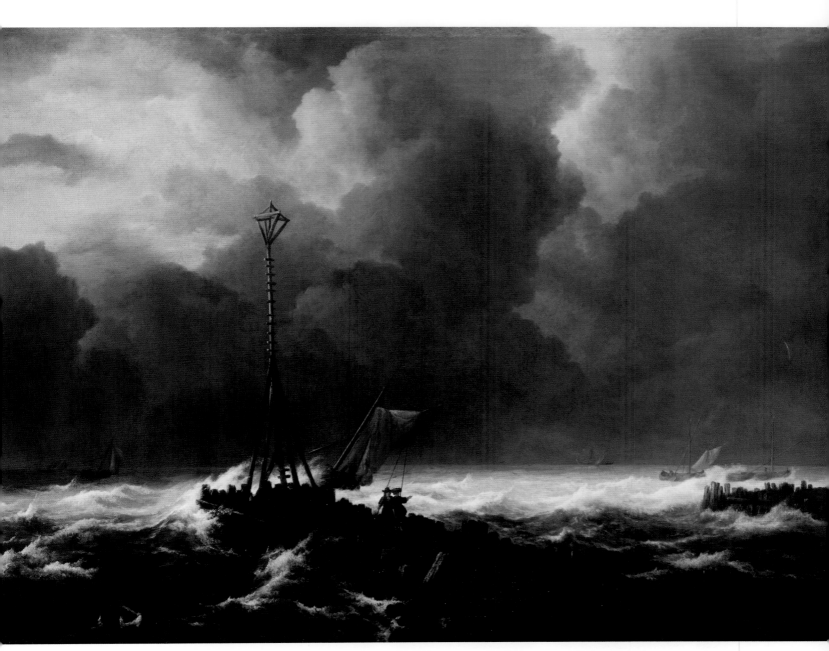

▲ A STORMY SEA, C1650 JACOB VAN RUISDAEL

Emphasizing the power and grandeur of nature, Ruisdael shows a rough sea in the grip of a powerful storm. Several boats are struggling towards the safety of the harbour. The drama is enhanced by the fact that two-thirds of the painting are taken up with the darkening sky.

DOMESTIC INTIMACY

THE DUTCH PRODUCED a succession of painters who all had their particular speciality, but there was no artist better at painting interior domestic scenes than Jan Vermeer (1632–1675).

Vermeer lived during the Golden Age of Dutch painting and is now regarded as one of the greatest painters in northern Europe, second only to Rembrandt. Unbelievably, he was almost entirely overlooked until the 1860s when he was rediscovered by a French art critic who particularly admired his unpretentious, direct realism.

Vermeer was born in Delft and it is thought that he spent all of his life there apart from one visit to the Hague in 1672. Most of his small genre paintings present domestic interiors and portray the 'middle classes'. There is a tremendous intimacy about these works; most show women caught up in various domestic or recreational tasks, either totally self-absorbed or self-consciously catching our eye.

In these compositions, Vermeer shows a masterly use of silvery light and colour – objects, drapery, furnishings and floors are all rendered with great clarity and with minute attention to surfaces and textures.

Above all, there is an air of serenity and contentment about Vermeer's best work that borders on abstraction; the viewer is drawn into a timeless world of simple, meditative calm.

To capture the exact light conditions and to help frame his compositions, Vermeer made use of a *camera obscura*.

Employing this simple darkened box with a lens on the side meant that he could make an image of his subject appear upside down on a blank canvas attached to the wall. The projected image could then be sketched in oils. X-ray evidence for this has been discovered underneath the layers of his finished compositions.

Pieter de Hooch (1629–1684) also worked in the School of Delft and produced a number of Dutch interior or courtyard scenes. With his work, there is a real sense of languid calm about the scrupulous arrangement of figures, for example, framed against a doorway; his paintings differ from those of his younger contemporary Vermeer since his vision tends to be less powerful and perhaps more parochial.

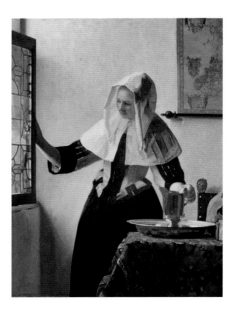

◀ YOUNG WOMAN WITH A WATER JUG, *c1662* JAN VERMEER
Vermeer mainly painted interior genre subjects and about half of these show solitary female figures engaged in ordinary, domestic activity. This interior is remarkable for its tranquillity and the subtle gradations of daylight falling through the window on to the objects on the table and the woman herself, in particular her headdress.

▶ THE COURTYARD OF A HOUSE IN DELFT, *1658* PIETER DE HOOCH
After beginning his own family in the mid-1650s, De Hooch switched his focus to domestic scenes and family portraits. While bringing everyday domestic life in Delft into sharp focus, it is the architectural details – the carefully framed courtyard, the through passage and the preponderance of red brick – that really stand out in this work.

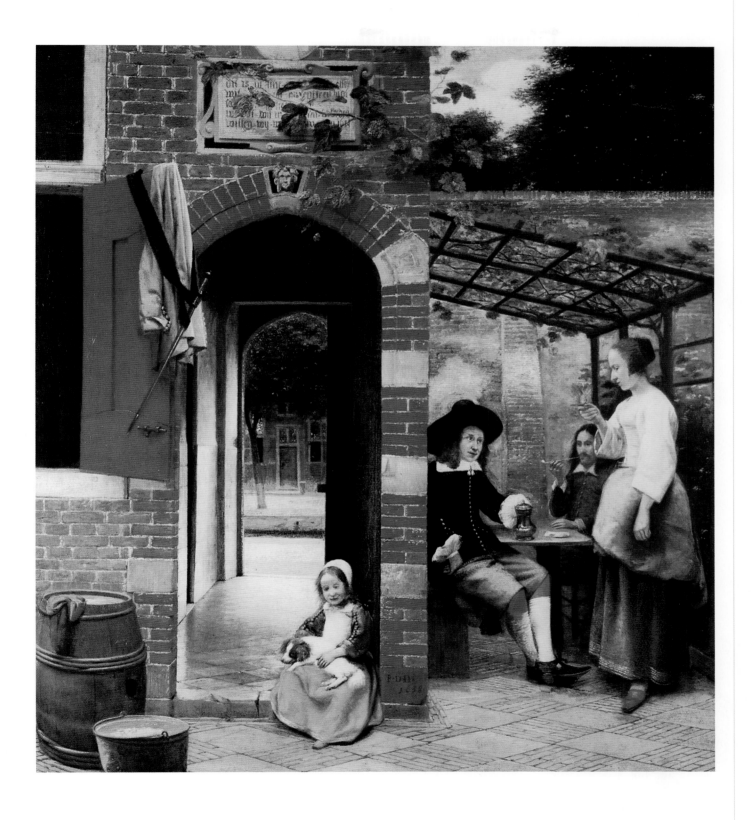

THE AGE OF ELEGANCE
c1700–1780

In painting terms, a line can be traced from the uninhibited, spontaneous marks made by Titian in the 16th century, through the wild, dark adventurousness of the Baroque era, to the start of something altogether lighter and frothier at the start of the 18th century.

This new style, favouring asymmetrical curves, decoration and frivolity, first captivated the French, then spread to Italy and other parts of western Europe. The style was known as Rococo, an Italian term derived from the French word *rocaille*, used to describe the shells that decorated grottoes in French gardens in the late 17th and early 18th century.

The 18th century was a time of great change in Europe. While the Church still played an important role in society, there were many, particularly in England and France, who rejected all forms of religious dogma and who challenged the absolute power of the monarchy. Radical developments in philosophy and science had opened up new possibilities, with the expansion of education to the middle classes leading to a growing emphasis on the idea of the individual as well as the power of reason. Living standards in Europe were on the rise, thanks to foreign trade and the colonization of distant lands. The general trend was towards freedom and change.

In 1682 Louis XIV had taken up residence in his extravagant palace at Versailles, where court life was conducted amid considerable grandeur. This did not stop him from succumbing to gangrene in 1715 and soon the Regent, his successor, introduced the Rococo fashion for lighter elements with more curves and patterns. The delicacy and playfulness of Rococo served as a riposte to the dogged empire-building of Louis XIV's regime. With its emphasis on personal and pleasurable pursuits, Rococo became well established, first in the royal palace and then throughout the upper echelons of French society.

In this context, the artist Antoine Watteau, who moved to Paris in 1702 to work with a theatrical costumier, was perfectly placed to capture the light-hearted, shimmering opulence of the new aristocracy. When Watteau died at the age of 37, he was immediately replaced as a chronicler of the fashionable set by Boucher and his pupil Fragonard,

1700
Triggered by a huge earthquake in California, a massive tsunami struck Japan

1707
The Act of Union led to the formation of the United Kingdom

1740
'Frederick The Great' of Prussia ended torture as well as granting freedom of expression

1749
The Bow Street Runners, an early police force, set up in London by novelist Henry Fielding

1755
The Great Earthquake of Lisbon killed over 70,000 people

both of whom made ornamental work with more charm than substance. Chardin was another French painter who worked alongside Boucher and Fragonard, but his work revealed a very different sensibility. Chardin's style was more modest; he was interested in painting the most humble objects and 'ordinary people', investing both with a simple dignity.

In England, Rococo was largely thought of as 'French taste'. William Hogarth embarked on a career as a satirist, producing paintings and prints showing the hypocrisy and immorality that he discerned in all walks of life. In painting, Rococo was also reflected in a love of nature and a rising interest in the landscape.

Artists such as George Stubbs and later Edwin Landseer turned to the animal world for inspiration. The 18th century was the golden age of portrait painting; suddenly it was fashionable for the wealthy to have their likeness hanging on the wall. Gainsborough and Reynolds represented the crème de la crème of the new portrait painters and both significantly contributed to advancement of the art – Gainsborough with his attractive English landscape backgrounds and Reynolds with his focus on the humanity of his sitters.

The Rococo style was readily received in the Catholic parts of Germany, Bohemia, and Austria, where it merged with the lively German Baroque tradition. In Italy, and particularly in Venice, Rococo found expression in the great allegorical compositions of Tiepolo – especially on ceilings and murals – and the precise perfection of the Venetian canal scenes produced by Canaletto. In Tuscany and Rome, painting still owed more to the Baroque.

However, the taste for empty luxury and decoration inevitably ran its course. In France, by the 1760s, the age of elegance was overtaken by that of reason and enlightenment. Rationalist thinkers and writers, predominantly based in London and Paris, believed that reason could be used to combat tyranny and ignorance to build a better world. One French artist in particular looked back to the classical age as a time of great freedom, heroism and balance. By the time of the French Revolution in 1789, the Neo-Classical paintings of Jacques-Louis David sounded the death knell for the excesses of previous years.

1757
General Clive defeated the Nawab of Bengal as the British established a foothold in India

1769
Sir Richard Arkwright patented a spinning machine as the Industrial Revolution raced on

1773
The Boston Tea Party – protestors dumped chests of tea in Boston Harbor in defiance of the Tea Act

1776
The Declaration of Independence: the statue of George III was torn down in New York City

1778
James Cook added Hawaii's islands to his discoveries. They were christened the Sandwich Islands

1780
A great hurricane killed 24,000 people in the Caribbean and nearly destroyed the British fleet

FRENCH ROCOCO

JEAN-ANTOINE WATTEAU (1684–1721) was born in Valenciennes, a town in north-eastern France that had only passed over to the French from Flanders six years earlier under one of the treaties of Nijmegen. Although there are strong links with Flemish art in his work, during his short life Watteau came to be regarded as one of the key French painters of the 18th century. More than any other artist, he helped to create the new mood of elegance and sophistication in French painting known as Rococo.

Watteau arrived in Paris in 1702 at a time when the classical art of Nicholas Poussin had passed its zenith. Until about 1708, Watteau worked with a theatrical designer Claude Gillot, who introduced him to the *commedia dell'arte,* a form of Italian pantomime based upon improvization and involving a set of stock characters such as harlequins and jesters.

After 1708, Watteau studied under Claude Audran at the Luxembourg Palace where he found inspiration in the vibrant, swirling figures that Rubens had produced in paintings for Marie de' Medici. Although Watteau was noted for his ability to place many figures in a composition, his groups of figures are not as energetic and robust as Rubens'. Watteau's style is altogether more poignant and delicate and, in time, he came to be regarded as the elegant epitome of the new Rococo spirit.

Watteau painted *fêtes galantes,* a term first used by the French Academy in 1717, meaning feasts of courtship. This new style applies to scenes in which a sociable group of fashionable people – elegantly attired musicians, actors and couples – are shown picnicking, laughing and openly indulging in courtship and flirtation.

What distinguishes Watteau from other painters who worked in the genre is the wistfulness that he creates in the faces of some of his protagonists. This not only serves as a reminder that happiness is not a permanent condition, but could also have been a reflection of the fact that Watteau suffered from tuberculosis for most of his life. His paintings certainly convey a gravity and sadness that separates his work from the more decorative painters of the Rococo, such as Boucher and Fragonard.

Watteau was a great colourist and used to apply colour directly on to his canvas, a method which inspired Delacroix and later the Neo-Impressionists, including Seurat.

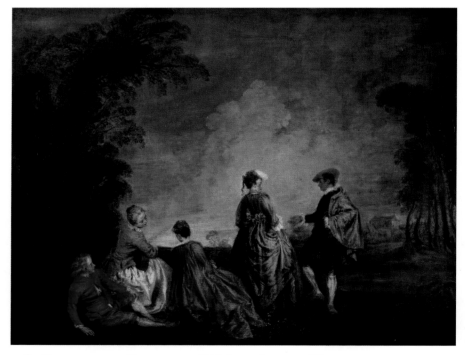

▲ AN EMBARRASSING PROPOSAL, *c1716* JEAN-ANTOINE WATTEAU
Watteau became famous as a painter of so-called fêtes galantes *in which members of the fashionable set are shown amusing themselves in the countryside. In* An Embarrassing Proposal, *a party of five are gathered under some trees: it is a casual flirtatious scene in which pleasure can be derived from the graceful gestures and lavish costumes.*

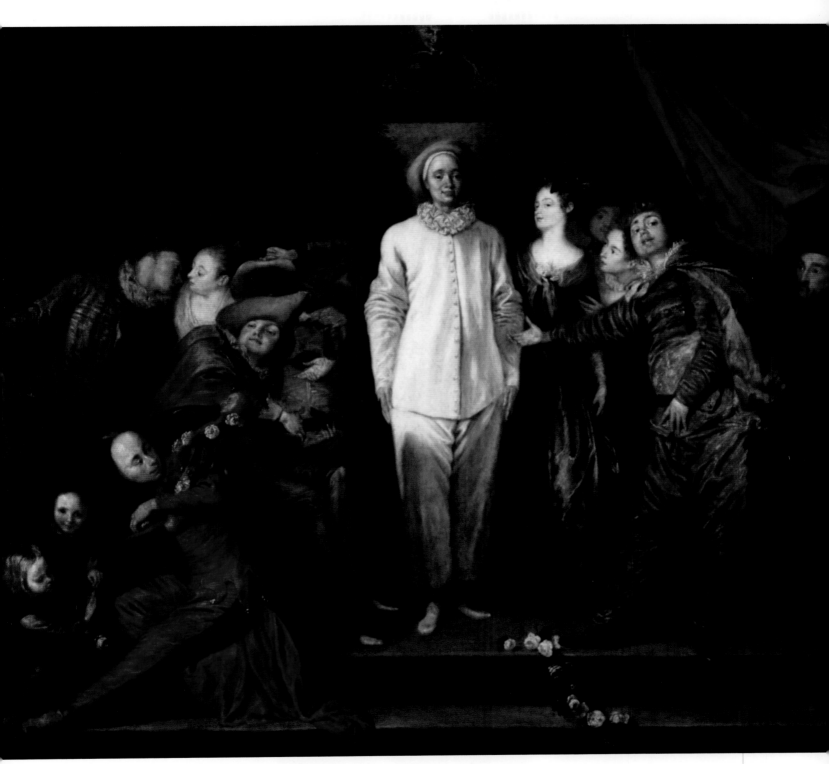

▲ Italian Comedians, *c1720* Jean-Antoine Watteau

This touching work was among Watteau's last paintings. Assembled on stage, possibly for a curtain call, is a troupe of popular Italian comedy actors (commedia dell'arte). The central, inert Pierrot, dressed all in white, looks vulnerable and it is thought that Watteau saw something of himself in the sad figure.

FRILLS AND FANCIES

If ANTOINE WATTEAU heralded the new spirit in French Rococo, then equally the work of both François Boucher (1703–1770) and Jean-Honoré Fragonard (1732–1806) best embodied the decorative elegance and frivolous charm most commonly associated with the new style.

Both of these artists made work that reflects the artificiality and superficiality of the French court in the middle of the 18th century, delighting in the luxuriousness of the costumes – the silk dresses, the powdered wigs, the ruffles and bows – and the fashionable surroundings. Each artist is easy to dismiss as embodying all that was frivolous about the age, but this would be to deny their superior technique as well as to ignore the fact that they

managed to capture the carefree spirit of the epoch for posterity.

The son of a Parisian painter and lace designer, François Boucher began his career making engravings from the pictures of Antoine Watteau. In 1727 Boucher went to Italy for four years and returned to enjoy a highly successful career at the French court, becoming the King's court painter in 1765. He was the favourite artist of the King's mistress, Madame de Pompadour, and painted her portrait several times. Boucher also worked as a decorative artist, devising elaborate schemes for the palace at Versailles and he completed opera designs as well as designing tapestries.

Like Watteau, Boucher painted *scènes galantes*, but injected his mythological and pastoral scenes with a much bolder

spirit, declaring that he preferred to paint from human life as nature was 'too green and badly lit'. His many portraits of fleshy nude women in provocative poses became his stock-in-trade until the public started to tire of them, feeling they lacked the necessary moral depth.

Jean-Honoré Fragonard was a pupil of Chardin and also of Boucher. From 1756 to 1761, he lived in Italy where he became familiar with the work of Tiepolo. He also visited the Tivoli gardens which became an important motif in his later work. Fragonard painted in the genres that were fashionable at the time: portraits, history and pastoral scenes set in the landscape. However, he achieved notoriety by specializing in painting love affairs conducted furtively in garden settings.

▶ YOUNG GIRL READING, *c1776*
JEAN-HONORÉ FRAGONARD
This study is one of several that Fragonard made of young girls, showing them deep in introspection. These works have an unfinished quality to them, having been painted very quickly with rapid, bold areas of bright colour. Fragonard used the wooden end of the brush to scratch and define the girl's ruffed collar.

▶ MADAME DE POMPADOUR, *1756*
FRANÇOIS BOUCHER
A full-length portrait of Madame de Pompadour, the elegantly attired mistress of Louis XV, reclining on a couch: here, Boucher focuses on the sumptuous fabric of the rose-covered dress, while pointing to the intellectual interests of this powerful woman through the inclusion of the book and the writing desk.

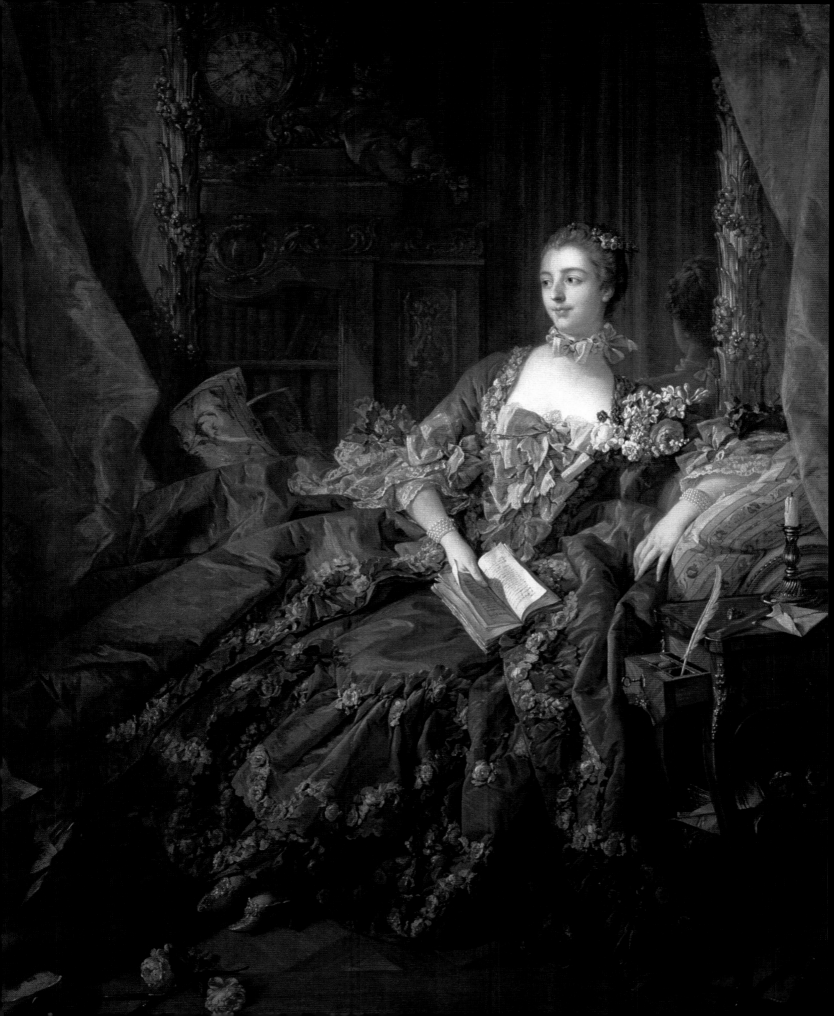

THE VENETIAN APPROACH

VENICE HAD NOT SEEN a great painter since Veronese in the 16th century. In the 18th century, painting in Venice was revived by Giovanni Battista Tiepolo (1696–1770), who came to be regarded as the most impressive exponent of the Rococo school in Italy. Tiepolo studied in Venice where he benefited from the city's rich artistic history, but soon moved on from painting in oils to designing enormous frescoes to decorate the ceilings and walls of buildings and palaces in Italy and elsewhere. Commissioned by patricians and merchant princes, these highly decorative compositions featured allegorical or

historical subject matter and were full of sparkling light and colour. In Germany and Austria in particular, there was great demand for these grand ornamental scenes and, in 1750, Tiepolo was invited to produce a monumental scheme of frescoes for the huge palace of the Archbishop of Würzburg.

In his youth, Giovanni Antonio Canal, known as Canaletto (1697–1768), worked in Venice and Rome as a theatrical scene painter with his father. Although Canaletto's paintings are imbued with the Rococo spirit, his particular type of well-ordered Venetian landscape painting eventually led to a renewed interest in classicism.

Canaletto became known as a *vedutista*, a painter of views, focusing on the canals and architecture of his home town. He was a master of perspective and his topographical compositions are packed with rich detail. Venice was rapidly becoming a centre for art in Europe. Wealthy travellers, in particular those from Britain, delighted in his work and bought his Venetian views to take home as souvenirs.

Canaletto's brilliant naturalistic technique portrayed the pomp and ceremony of many state occasions, as well as scenes of everyday life in which he captured the texture of old buildings reflected in the warm Venetian light.

▲ THE PIER SEEN FROM THE BASIN OF SAN MARCO (*detail*), *c1730-35* CANALETTO
Characteristic of Canaletto's views of Venice, this painting features the Doge's Palace, the Piazza San Marco and, in the background, the dome of the church of San Marco. The gondolas in the foreground bring the scene to life and help to create pictorial depth.

▶ OLYMPUS, *1761*
GIOVANNI BATTISTA TIEPOLO
Tiepolo was the last of the great Venetian painters commissioned to adorn and glorify some of the great buildings of Europe. In this oil sketch for the ceiling in St Petersburg, Tiepolo portrays the heavens and the earth as a wondrous cosmic vision in which an assemblage of floating mythological and allegorical figures fall and rise.

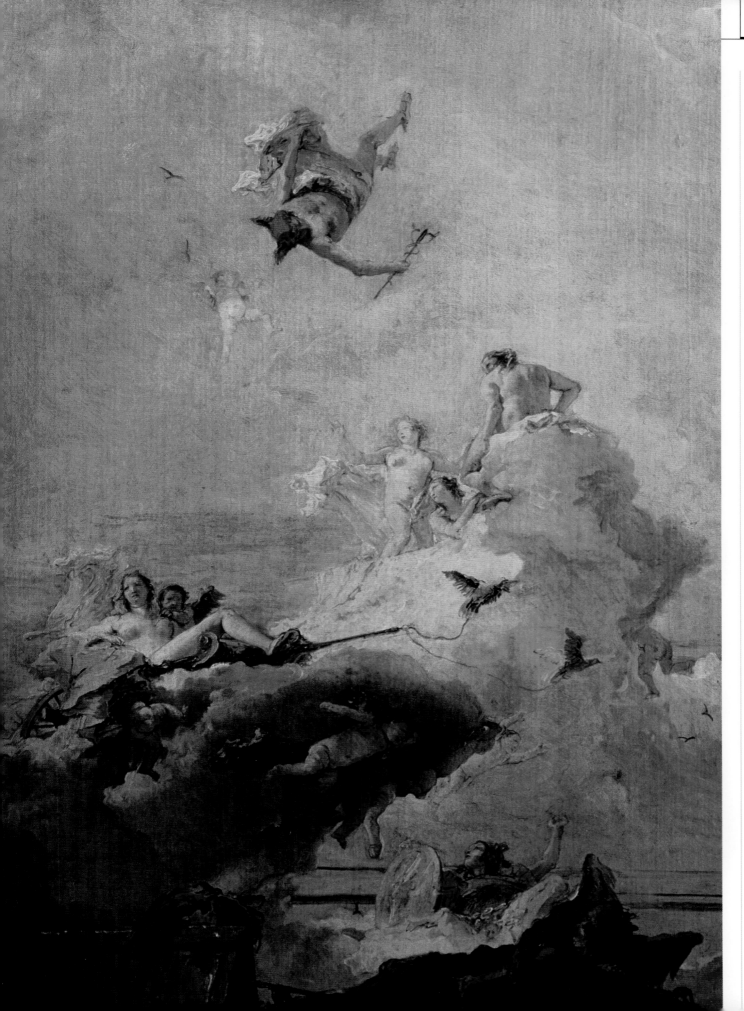

SOCIAL SATIRE

WILLIAM HOGARTH (1697–1764) was born in London, the son of a Latin teacher. Due initially to the popularity of his prints and paintings satirizing contemporary society, he became the most internationally renowned painter in Britain of the time. In commenting on the manners and mores of 18th century life, Hogarth tapped into a British taste that was perhaps more documentary than aesthetic, since the British tended to favour portraits of themselves and their land, or views of the foreign places they visited. Hogarth's influential vision appealed to the expanding middle classes who, freed from the control of the Church and aristocracy, liked to think of themselves as being above the social abuses and immoralities that Hogarth exposed in his melodramatic tableaux.

However, Hogarth was not only concerned with highlighting immorality, he was also vehemently opposed to the frivolous, fashionable excesses of Rococo painting, intending his studies of the seamier side of life to be seen as a critique of the pampered elegance of his French and Italian counterparts. He was a staunch nationalist and saw himself as upholding sensible British values against a wave of foreign affectation and vanity.

Hogarth trained as an engraver and became familiar with European paintings by looking at engravings. Apprenticed to English painter, Sir James Thornhill, Hogarth married his daughter in 1729, eventually inheriting an academy that became the forerunner of the Royal Academy. His first works consisted of small groups and conversation pieces. In 1731, he produced *The Harlot's Progress*, the first of his storytelling series of paintings from which he produced sets of extraordinary engravings, including *The Rake's Progress* and *Marriage à la Mode*. These were hugely popular and were endlessly reproduced, which meant that they could be enjoyed by a wider public and that Hogarth could be independent of rich patrons. In 1753, his tract, *The Analysis of Beauty*, was published, setting out his theory about the line of beauty in the shape of an 'S' being intrinsic to the structure of a composition.

Hogarth's ability to read character provided uncompromising insights into the human condition. Combined with lively, spontaneous brushwork, his observations prove his considerable talents as a portrait painter.

▲ THE RAKE'S PROGRESS, 'THE ARREST', *1735* WILLIAM HOGARTH

This monochrome engraving is plate four in a series of eight from Hogarth's original paintings showing the decline and fall of spendthrift Tom Rakewell. After squandering his money, Rakewell is dragged from a sedan chair outside St James' Palace, London and taken first to Fleet Prison and then on to Bedlam, the lunatic asylum.

▲ FRANCIS MATTHEW SCHUTZ IN HIS BED, *1755–60* WILLIAM HOGARTH
This unusual image of Francis Schutz (distantly related to the royal family) shown vomiting into a pot was intended as a moral warning to those who over-indulged. The direct and uncommonly frank portrait was altered in the early 19th century by some of Schutz's descendants to show him reading in bed.

SIMPLICITY AND STILLNESS

JEAN-BAPTISTE-SIMÉON CHARDIN (1699–1779) was born into the Rococo age, but his own work was very different from the ostentatious and exuberant style of his pleasure-seeking contemporaries. The son of a court craftsman, Chardin had impeccable Rococo credentials, having restored decorations at Fontainebleau and briefly tutored Fragonard. Largely self-taught, Chardin lived and worked in Paris all his life. Here, he quietly pursued a naturalistic style distinct from the lavish landscapes or elegant portraits that were so fashionable at the time. By contrast, Chardin looked around him for inspiration, initially making small-scale paintings of animals and fruit in the Dutch still life genre. In 1728, *The Skate,* one of his still lifes, was praised by the French writer, Diderot, for its realism, and earned Chardin a place at the French Academy.

Chardin expanded his largely domestic, intimate vision to include portraits of a single figure, quite often a servant, most commonly engaged in a household task. These delicate and unaffected genre paintings avoid sentimentality by focusing directly on what the artist saw, and as such are straightforward portrayals of the dignity of labour.

Despite swimming against the prevailing frothy tide, Chardin's modest nature and unpretentious talents were recognized within his own lifetime. His genre paintings were made popular by engravers; in 1740, he was presented to Louis XV who bought some of this work, and he became the official hanger of work at the Paris Salon in 1761.

Chardin had a rare ability to record the perfect moment of a gesture or look; his compositions appear to be frozen in time, giving them significance beyond the merely everyday or the purely representational. His brilliant technique allowed him to build up texture and subtle tonal contrasts. Courbet and Manet were influenced by him; Van Gogh and Cézanne were also among his admirers.

▲ THE SKATE, *c1728* JEAN-BAPTISTE-SIMÉON CHARDIN
The realism of this unusual composition of a skinned skate, a gleaming black pitcher and a tense, frightened kitten treading on oysters astonished Chardin's contemporaries and earned him a place at the French Academy. Proust likened the delicate structure of the fish to 'the nave of a polychromatic cathedral'.

▶ THE SCULLERY MAID, *1738*
JEAN-BAPTISTE-SIMÉON CHARDIN
In Chardin's quiet, thoughtful study, a scullery maid cleans a pan in a waist–high barrel. There is no running water and she wipes it with straw first, as water, like bread, was a very valuable commodity in the 18th century. The empty copper cistern is the vessel in which the water has been hauled from the river.

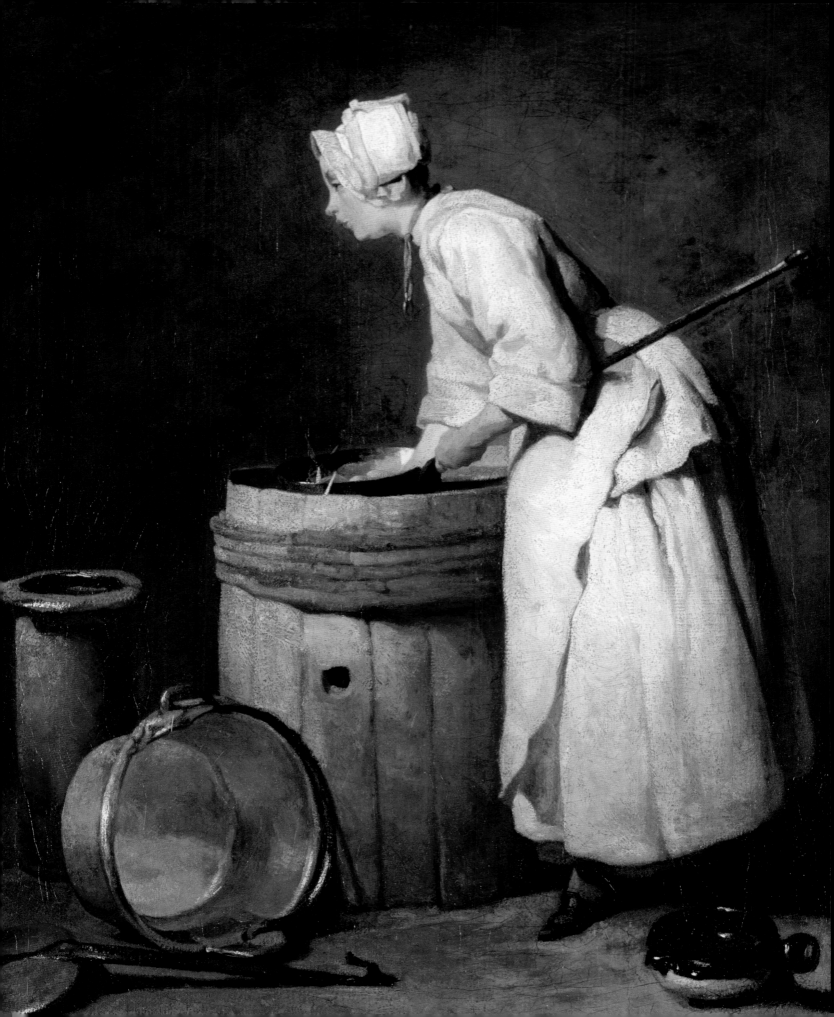

CAPTURING ANIMALS

A NEW MOVEMENT known as Neo-Classicism began in the mid-18th century, before the Rococo style had finally disappeared. The Neo-Classical spirit was an attempt to return to the simple, dignified art of classical Greece while conveying serious moral ideas such as honour and patriotism. British artists in the mid-18th century working predominantly with landscape started to favour more formal, controlled compositions as a way of conveying the elegant ease of the English aristocracy. George Stubbs (1724–1806) used his fashionable parkland vistas primarily as a backdrop for his paintings of animals.

Stubbs, whose first love was anatomy, decided to specialize in painting horses, which proved an astute move as this meant he stood apart from most 18th-century landscape artists. At the time, stock breeding was becoming increasingly popular and this helped to foster a taste for animal painting. Stubbs' paintings of horses revealed his deep knowledge of the equine form, which he conveyed with amazing accuracy and lyricism. There's a subtle energy and ease about his compositions, which sometimes feature groups of people, but more often depict noble beasts in precise anatomical detail, either individually or together in the landscape.

Stubbs had wealthy patrons and painted top racehorses for their owners. He also produced portraits of a host of other wild creatures that he observed in private menageries, including lions, giraffes and monkeys.

The precocious talent of Sir Edwin Landseer (1802–1873) led him to first exhibit at the age of 12 at the Royal Academy in 1814. Younger than Stubbs but equally conversant with anatomy, Landseer applied a less sophisticated treatment to his animal subjects, typically lending them human characteristics in order to tell a story, or convey a moral. The favourite artist of Queen Victoria, he also modelled the lions below Nelson's Column in Trafalgar Square, London.

French artist Rosa Bonheur (1822–1899) also painted animals, a genre that had hitherto been completely dominated by male artists. Bonheur's highly successful career was partly supported by the anatomical drawings that she made on the dissecting table, or out in the fields. Despite her conservative views, Bonheur led a radical life and disguised herself as a man to visit the horse market in Paris, since women painters were discouraged at the time. Her *Horse Fair,* of 1853, was the largest animal painting produced to date.

▲ THE HORSE FAIR, *1855* ROSA BONHEUR
This energetic and powerful painting of horses being paraded by their handlers is a smaller version of Bonheur's much larger original, Horse Fair, *which was 16 feet long. Bonheur believed in direct observation of nature but, to attend the all-male horse market in Paris, she had first to disguise herself in men's clothing.*

▲ A BAY HUNTER, A SPRINGER SPANIEL AND A SUSSEX SPANIEL, *1782*

GEORGE STUBBS

George Stubbs studied anatomy, and this painting of a horse and two spaniels reveals the
detailed realism that he managed to master in his paintings of animals. The background,
an 18th-century pastoral landscape, adds a note of lyricism to the scene.

THE ART OF CAREFUL CALCULATION

PORTRAIT PAINTING in Britain in the middle of the 18th century displayed an equal mixture of Rococo and Neo-Classical tendencies. The Neo-Classical spirit was most obvious in the grand, heroic portraits of Sir Joshua Reynolds (1723–1792), the leading academic painter of his day, who also painted genre paintings of allegorical subjects.

Reynolds was initially apprenticed to a second-rate portrait painter, Thomas Hudson, in London. He visited Europe between 1749 and 1752, studying the Old Masters and spending two years in Rome perfecting his technique. By 1760, he was the most fashionable portrait painter in London. His portraits have a classical dignity stemming in part from his great interest in Renaissance art and antiquity; he also painted sentimental portraits of children. His attempts at producing allegorical and history paintings in the grand style were less successful. His was a carefully calculated art that favoured reason over the romantic and the noble and sublime over the particular. Reynolds was the first president of the Royal Academy when it was founded in 1768, and in his career he did much to raise the standing of fine arts in Britain. It is thought he painted around 3,000 portraits in his lifetime.

Thomas Gainsborough (1727–1788) was also a founding member of the Royal Academy, but he displayed a lyrical approach in sharp contrast to the academic classicism of Reynolds. Gainsborough closely studied the portraits of Van Dyck and, after he discovered that he could easily capture a likeness of his clients, he suggested that they pose for him on their country estates. In this way, Gainsborough was able to indulge his great love of painting the landscape, while fulfilling the demands of his patrons.

Unlike Reynolds, Gainsborough did not travel widely. But he did move to London in 1774 where he painted the family of George III, and in 1783 he toured the Lake District. His landscapes, with their free and spontaneous brushstrokes, show a genuine feeling for nature, which led painter John Constable to remark: 'I fancy I see Gainsborough in every hedge and hollow tree.'

Swiss painter Angelica Kauffmann (1741–1807) was also a founder member of the Academy and a close friend of Joshua Reynolds. Kauffmann came to England to secure work, establishing herself as a fashionable, decorative portrait painter who also painted historical subjects. Nicknamed 'Miss Angel' by Reynolds, she was also a friend of Goethe and her life was the inspiration for a number of books.

▲ MASTER BUNBURY, *1780–81* JOSHUA REYNOLDS
A young boy sits under a tree in a wooded landscape looking intently ahead of him. Charles John Bunbury was the son of Reynolds' friends – Catherine Horneck and caricaturist Henry Bunbury – and he was nine when this affectionate portrait was painted. Bunbury became an army officer and died at the age of 26.

▶ CONVERSATION IN A PARK, *c1746* THOMAS GAINSBOROUGH
This early work by Gainsborough is a conversation piece – a genre of informal portraiture that began in the 1720s showing figures in a more spontaneous manner than had been the case up until then. Here, a young aristocrat is shown courting his female companion who, with her face turned away, appears to be unresponsive to his attentions. The romantic theme is enhanced by lush wooded background.

REVOLUTIONS
c1780-1900

The European movement known as Neo-Classicism started in the 1760s as a reaction against what remained of the Baroque and Rococo styles, and stood as evidence of the desire to return to the perceived purity of the arts of ancient Greece and Rome. The discovery of ruins at Pompeii in 1746 had fed a growing interest in antiquity. German archaeologist Johann Winckelmann's book, *Reflections on the Painting and Sculpture of the Greeks,* published in 1755, which stressed the noble simplicity of Greek art, was extremely influential in the development of the new movement. Neo-Classicism was everything that Rococo was not: sober, controlled, high-minded and moralistic.

In contrast to Rococo, Neo-Classical paintings eschew pastel hues and softness; instead, they opt for sharp colours and chiaroscuro. In France Jacques-Louis David's Neo-Classical paintings often make use of Greek elements to extol the French Revolution's austere virtues. David was followed by Jean-Auguste-Dominique Ingres, whose meticulous portraits and paintings of women bathers are supreme examples of the Neo-Classical style.

From the middle of the 18th century, momentous events were taking place in Europe and the rest of the world. In 1789, the French Revolution tore its way through France. In America, the War of Independence took place, a colonial struggle against Britain, with 13 colonies declaring independence in 1776. Revolutionary fervour was on the rise, which inevitably meant that rationalism took a back seat. By the end of the century, there was a reaction against the sterile, academic disciplines of Neo-Classicism.

In the revolutionary era, there was a transformation in the way that the artist was perceived. The artist became a romantic figure, a visionary, whose art was capable of expressing the very depths of his or her soul; even in the renewed response to nature, the emphasis was on the artist's subjectivity.

For a while, Neo-Classicism and Romanticism co-existed side by side. Neo-Classicism started in the middle of the 18th century but was in decline by the early 19th century; Romanticism didn't become a fully fledged movement until the 1780s and it continued until the mid-19th century.

1780
Pennsylvania became the first US state to abolish slavery (for new-borns only)

1783
Beethoven's first printed works published; the Mariinsky (Kirov) Ballet was founded

1789
The Bastille was stormed, marking the beginning of the French Revolution

1793
Louis XVI and Marie Antoinette were executed and France's Reign of Terror began

1799
The Rosetta Stone was discovered in Egypt, leading to the deciphering of hieroglyphics

Romanticism began as a literary and philosophical movement (although it was not called by this name until much later). The term comes from 'romance', a prose or poetic narrative favouring heroism that originated in medieval times. In contrast to Neo-Classicism, Romanticism favoured wildness and expression, individuality and unbridled creativity. It was full of raw emotions, ranging from longing and awe to fear and horror, and an uprising against rationalism.

In the revolutionary age, for the first time in the history of western art, artists became truly individual and idiosyncratic figures, looking wherever they wanted for inspiration – suddenly any topic or subject was considered worthy of painting. This inquiring, independent spirit was fostered by the heroism and rebelliousness of the age. The Spanish painter and etcher Francisco Goya was one of the first to explore radically different subject matter, the bloody executions of the Spanish resistance by French troops.

Romanticism in Britain was embodied in the work of Constable and Turner, whose paintings showed new, but widely differing, approaches to landscape. William Blake and Samuel Palmer took Romanticism in a slightly different direction, working primarily in watercolour to express their intense imaginary and visionary experiences. With their emphasis on dramatic colour and emotive subject matter, French painters Théodore Géricault and Eugène Delacroix best defined the sensibility of French Romanticism. Caspar David Friedrich, Turner's contemporary in Germany, was arguably the greatest Romantic of them all.

In Britain and France, Romanticism created a climate which looked to rural life in the belief that those who worked the land possessed an honesty and dignity uncorrupted by the towns and cities. Painting directly from the local landscape, Constable tapped into this – as did the new realism and sincerity found in the work of Millet and Courbet in France. By contrast, in expressing his own subjective feelings, Corot's landscapes came closer to the work of the Impressionists. At the end of the 18th century, reflecting this new mood of earnestness, the Pre-Raphaelite Brotherhood aimed to make work that evinced some of the truth and gravity they perceived in early Renaissance art.

1805	1806	1825	1826	1834	1848
Lord Nelson defeated the French and Spanish fleet at Trafalgar but was fatally wounded	*Goethe published the first fragment of* Faust	*The first railway, from Stockton to Darlington, was opened by George Stephenson*	*Samuel Mory patented the internal combustion engine*	*Charles Babbage invented the 'analytical engine', the proto-computer*	*Karl Marx and Friedrich Engels published* The Communist Manifesto

THE HORRORS OF WAR

FRANCISCO JOSÉ GOYA Y LUCIENTES (1746–1828) was the most important and original artist of his time, but his talent developed slowly and it was not until he was in his thirties that the full extent of his genius became apparent. Initially influenced by the German Neo-Classicist Anton Mengs, Goya's early work shows something of Meng's majestic style, but as Goya's paintings developed, there was a greater affinity with the emotional and expressive appeal of Velásquez and Rembrandt. Goya studied their work – along with that of Gainsborough and Reynolds – to produce his own portraits which reveal an acute ability to penetrate inside the mind of his sitter. This insightfulness, coupled with a real feeling for beauty, brought him to the attention of the Spanish court.

Goya became court painter to King Charles IV in 1779; he rapidly discovered that court life was ostentatious, pleasure-seeking and full of intrigue. His portraits of the Spanish court are candid, gently mocking the vanity and avarice that he found, yet trying not to cause too much offence, since he was mindful of retaining his position. In 1792, an illness left Goya deaf, and this brought about a further, very dramatic change in style as he devoted himself to a series of small, morbid paintings.

In December 1807, Napoleon Bonaparte marched his troops across Spain and took Madrid. In response Goya painted a pair of dramatic paintings of the moment when the French shot Spanish hostages on 3 May 1808. He subsequently produced other paintings and engravings that were critical of the horror and stupidity of war. This was an entirely new and revolutionary subject for painting.

Goya was a prolific graphic artist and pioneered a new printing method, *aquatint,* which allowed for shaded patches of tone rather than lines. Like his paintings, his illustrations do not fall into any known genre but represent his personal visions of witches and disturbing apparitions.

Goya enjoyed a long and successful career and was a great inspiration to many artists, including Delacroix, Manet, Daumier, Kollwitz and Picasso. He was a hugely inventive, reflective and, at times, tormented artist who single-mindedly pursued his own dark vision. In 1818 he moved into a house outside Madrid where he painted a series of murals known simply as his Black Paintings, full of dark invention and nightmarish images.

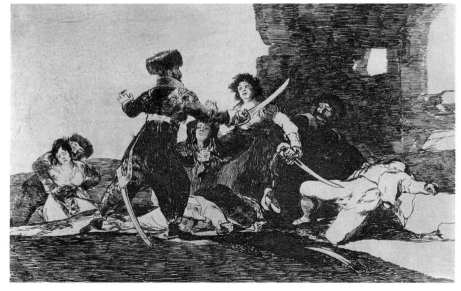

▲ DISASTERS OF WAR, NO 19: THERE IS NO TIME NOW, *1810–1814* GOYA
In this series of etchings representing the horrors of the Napoleonic invasion of Spain, Goya shows that acts of brutality were committed by both sides. French soldiers brutally tortured the Spanish, who found their own cruel ways of responding, leading Goya to reflect on the futility of war.

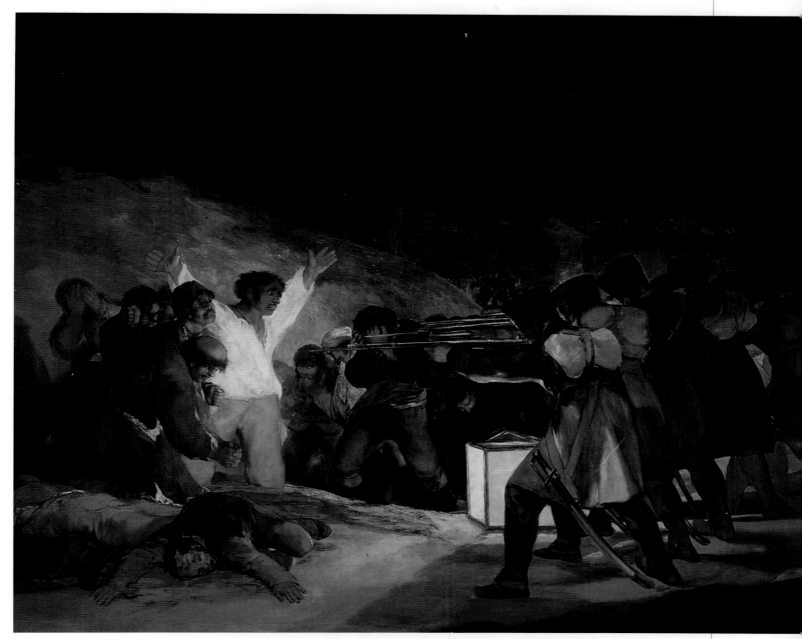

▲ THE THIRD OF MAY 1808 *(detail), 1814* GOYA

A detail from Goya's portrayal of a moment in the Spanish war of liberation when innocent civilians were shot by the invading Napoleonic troops. The drama unfolds at night; the lamp picks out the innocent central figure dressed in a white shirt who stares straight down the barrels of many pointed guns.

COOL LUCID COLOURS

THE PRINCIPAL INTEREST OF Jacques-Louis David (1748–1825) as a child was drawing and there is a strong linear quality that runs through all of his work. David trained in the Rococo tradition – he was distantly related to François Boucher – but it was in Rome that his mature style first emerged. He won the Prix de Rome in 1774 and spent the next six years there, inspired by both the ancient sculpture and the work of Nicholas Poussin to develop his own particular classical style.

Back in France, David quickly developed into the leading figure of Neo-Classical painting. The style marked a return to cool, lucid colours away from the pastel hues of Rococo.

There was an emphasis on drawing, which meant that form was sharply delineated and subject to strong contrasts of light and shade. His work gave new expression to the themes of heroism, honesty and devotion to duty that encapsulated the prevailing national mood. Overall, the style favoured an austerity and restraint that, in turn, recalled the purity that was felt to belong to the art and antiquities of the ancient classical world.

David was elected to the Academy where his sense of colour and line and his academic compositions were much admired. By the time of the French Revolution in 1789, David, who as a friend of Robespierre was actively involved and sympathetic to its aims, was regarded as the painter of the Revolution, and made three paintings featuring martyrs to the cause. In 1794, David was imprisoned in the Bastille; his ex-wife eventually interceded on his behalf and secured his release. In 1798, once Napoleon had come to power, David became his propagandist and painted a series of portraits that glorified the Emperor and his exploits.

It is, however, for his early portraits, including those of famous society people, that David is largely remembered. These have all the cool grandeur of classicism; his bodies are like marble statues from the ancient world, with the contours of each one picked out in sharp relief. Gerard, Gros and Ingres were among his many pupils.

▶ THE DEATH OF MARAT, *1793*
JACQUES-LOUIS DAVID
One of the defining images of the French Revolution shows the assassination in the bathtub of the radical writer, Jean-Paul Marat, an act carried out by Charlotte Corday, a woman with opposing political views. Although both the pose and the golden light idealize Marat, in real life he was believed to have a skin disease which meant he sought comfort in regular baths.

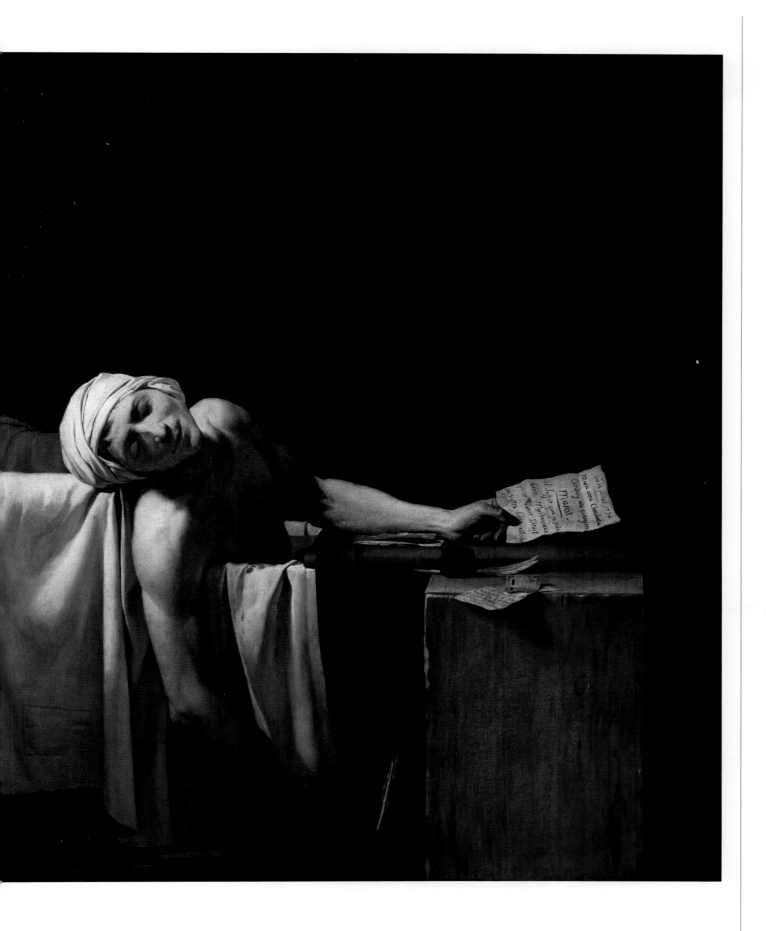

VISIONARY ROMANTICISM

THE ENGRAVER, PAINTER AND POET William Blake (1757–1827) was one of the most extraordinary figures of the Romantic period. As a child he claimed to have seen a tree filled with angels, 'bespangling every bough like stars'. Blake went on to develop an intensely personal art which drew upon a range of literary, mythical and biblical sources to expound a unique and mysterious vision.

Born in London, Blake was first apprenticed to an engraver and made studies of London churches, before studying briefly at the Royal Academy Schools. Here, however, he was not interested in painting in oils, neither was he concerned with the academic work of Sir Joshua Reynolds or what the Academy stood for. A supporter of the French and the American revolutions, Blake turned his back on organized religion, believing that only artists were in touch with divine inspiration. In every way, Blake was the archetypal Romantic – individualistic, solitary, and out of step with the rational thinking that had become so influential in the second part of the 18th century. Imagination and the creative process were what interested him; his art was a means to express the very intense nature of his revelatory experiences.

Blake mainly painted in watercolour. From the 1780s, he printed his own illustrated poems, both text and image, and then, with his wife, hand-coloured each print. He went on to make relief prints, using coloured inks, and sometimes retouching in paint. His dramatic compositions are immediately recognizable – the muscular nude figures show the inspiration he derived from studying Michelangelo. At the same time, his figures are ethereal and unearthly, often surrounded by balls of light. Blake enjoyed very little success in his lifetime, although the Pre-Raphaelites championed him after his death.

Swiss-born artist and writer Henry Fuseli (1741–1825) painted some key works of the Romantic era in which he combined themes of horror, mystery and tortured sexuality. Fuseli was a close friend of Blake's and aspired to an art that was sublime; specifically, he was interested in showing the grandeur and violence of nature.

Samuel Palmer (1805–1881), the landscape painter, printmaker and etcher, was one of Blake's disciples and, like Blake, experienced visions as a child that led him to make highly wrought, visionary paintings, charged with feeling and a sense of other-worldliness.

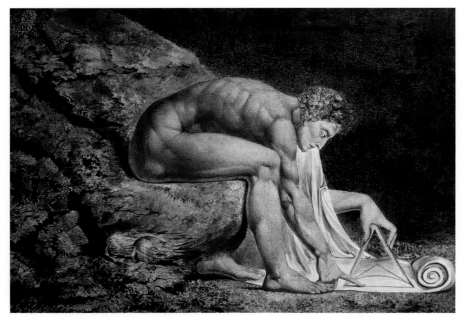

▲ NEWTON, *1795* WILLIAM BLAKE

Blake's vision of Newton suggests that he had tunnel vision and could only explain things by using sterile mathematical formulas. This is one of a series of large colour prints in which Blake painted the design on to a flat surface and then created the print by pressing a sheet of paper on to the wet paint. He then finished the design in ink and watercolour.

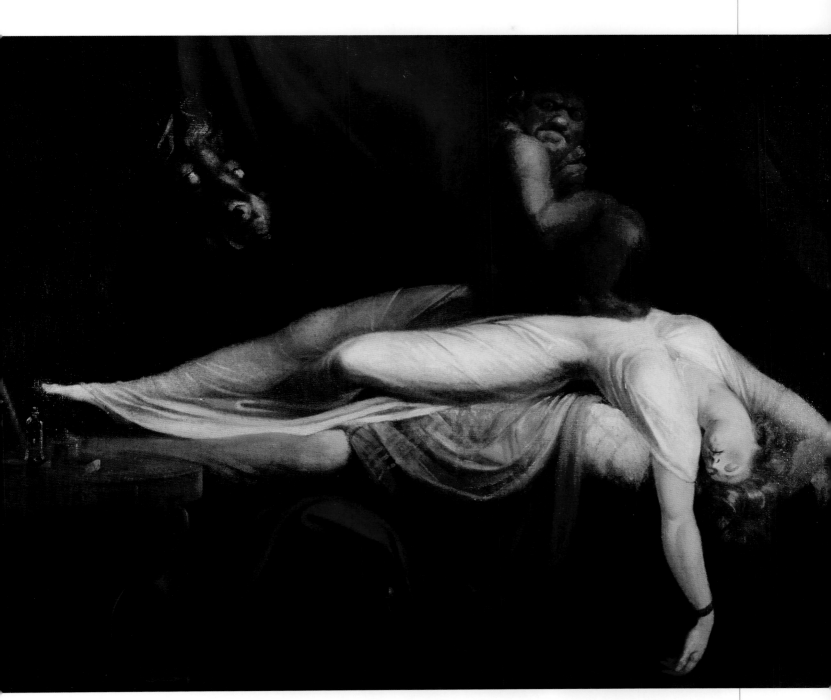

▲ THE NIGHTMARE, *1781* HENRY FUSELI

Fuseli painted two versions of this notorious picture, the first of which was exhibited at the Royal Academy in 1781. The wild-eyed stallion thrusting its head through a slit in the curtain, the supine figure of the young woman and the gnome-like figure seated on her pelvis combine to give the painting a distinctly erotic overtone.

LIGHT AND SPACE

JOSEPH MALLORD WILLIAM TURNER (1775–1851) was, with John Constable, one of two outstanding painters of the British School in the 19th century. Both of them specialized in landscape and both belonged to the English Romantic tradition that had started with Thomas Gainsborough. What set Turner's work apart from other Romantics was that he gave full rein to his imagination, producing poetic work that at times came very close to abstraction.

Turner was born in London and his precocious talent for drawing secured him a place at the Royal Academy Schools. From 1792, he began to undertake sketching tours, developing topographical drawings and watercolours of views and the landscape. Turner was a hugely productive artist, his sketchbooks, drawings and watercolours forming the basis for later oil paintings. Turner produced a wide range of landscape work, from the more formal, earlier historical compositions – which show the influence of Dutch 17th-century marine painters – to the later, semi-abstract works in which luminosity and atmosphere predominate.

Between 1802 and 1830, Turner made repeated trips abroad to study the landscape. The mountains and lakes of Switzerland and the canals of Venice, for example, were the inspiration for many oil compositions. After 1830, Turner's brushwork became freer and more expressive. He used a palette knife and rags in addition to brushes and his colour became increasingly radiant, characteristically featuring a palette of bright yellows, blues and pinks. Turner prepared the surface of his canvases by smoothing them with a white oil ground and then applying thin pale washes which he built up in subsequent layers. As a sense of place became secondary, light became his real subject matter; John Constable remarked that late Turners were 'painted with tinted steam'.

Turner, like Goya and Blake, was something of an isolated genius who was not fully appreciated in his lifetime; many found his later paintings too abstract for their taste. However, he was championed by John Ruskin, the influential critic whose treatise, *Modern Painters*, did much to enhance Turner's reputation. In painting light, Turner greatly influenced the Impressionists, especially Monet and Pissarro. He is buried next to Sir Joshua Reynolds in St Paul's Cathedral.

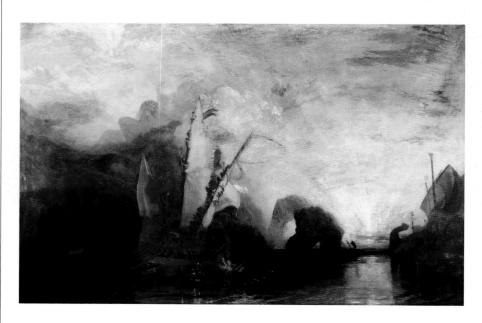

◀ ULYSSES DERIDING POLYPHEMUS, *1829* JOSEPH MALLORD TURNER
A depiction of high drama on the open sea from the Greek myth in which Ulysses escapes on a huge galleon, having blinded the one-eyed giant Polyphemus. What appears to really interest Turner here, though, is the spectacular sunrise with the scorching light reflected in the swirling sky and sea.

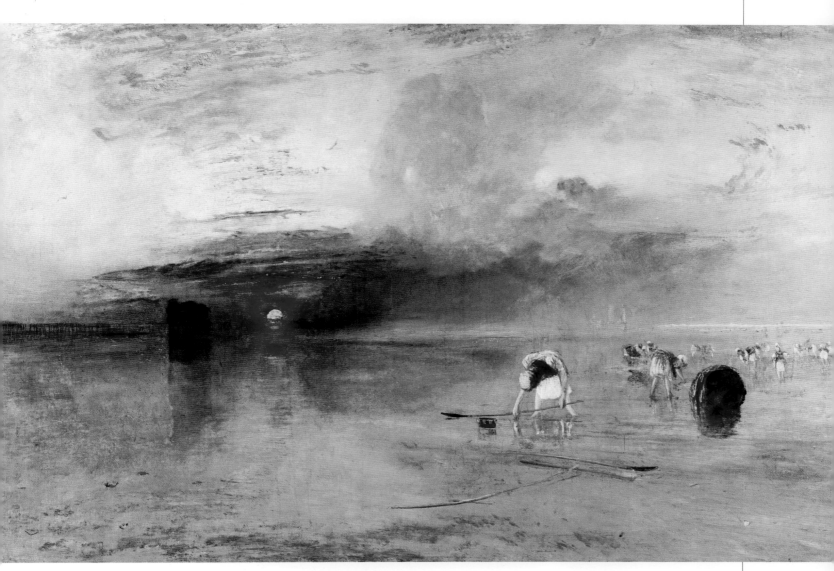

▲ Calais Sands, Low Water, Poissards Collecting Bait, *1830*

Joseph Mallord Turner

Set against a brilliant sunset, a group of women hunch over the sand collecting the bait.
The vitality is largely conveyed through luminous colour and bold, expansive brushstrokes.
In this scene, Turner pays homage to his contemporary Richard Bonington, who also produced
large landscapes of the French coast.

SKETCHES FROM NATURE

I F TURNER'S ROMANTICISM reveals itself in a poetic intensity, the paintings of John Constable (1776–1837) are equally lyrical, but take a more prosaic subject as their starting point. Constable loved the ordinary and the familiar, taking great pride in painting the Suffolk countryside where he was born and lived for most of his life. There is an immediacy to his work which broke new ground in dispensing with the classical notion of idealized landscape, focusing on the reality directly in front of him.

The son of a prosperous mill owner, Constable went to the Royal Academy School in his early twenties, but did not find success until his forties. Constable developed his own style over time, after initially looking to Gainsborough and other 18th-century landscape artists, who, he later felt, were too concerned with prettifying nature and altering their compositions to suit the conventions of the day. Valuing energy and truthfulness, Constable wanted to let nature speak for itself, without altering or trying to improve on it in any way.

His paintings were based on sketches done outside, using pure colours laid rapidly with a brush. He also made numerous small studies of skies, trees and clouds which were not necessarily part of a large composition, but were records of weather, colour and light conditions, generally with notes scribbled on the back. These enabled him to replicate the atmospheric effects in the larger, finished paintings that he executed in his London studio.

He made full-size sketches which he described as his 'six-footers' – on account of the fact that they were six feet wide – and which show his lively handling of paint. He exhibited *The Hay Wain* at the Paris salon in 1824, winning a gold medal. Constable could be said to be a painter of the particular rather than the general. In his words, 'no two days were alike, nor even two hours; neither were there ever two leaves of a tree alike.'

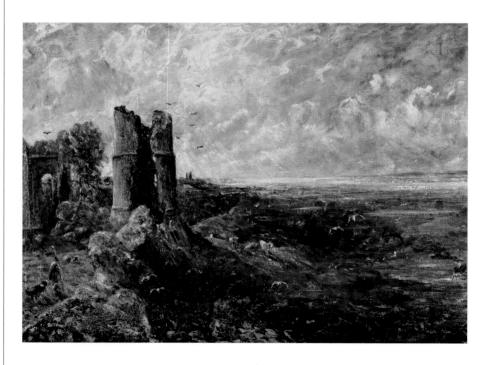

◀ SKETCH FOR HADLEIGH CASTLE, *1828* JOHN CONSTABLE
This expressive six-foot sketch was an essential part of Constable's working method as it allowed him to try out ideas before resolving them in the finished oil painting. Constable visited Hadleigh after his wife's death in 1828 and, it seems, the remote, ruined castle resonated with his feelings of loss and loneliness.

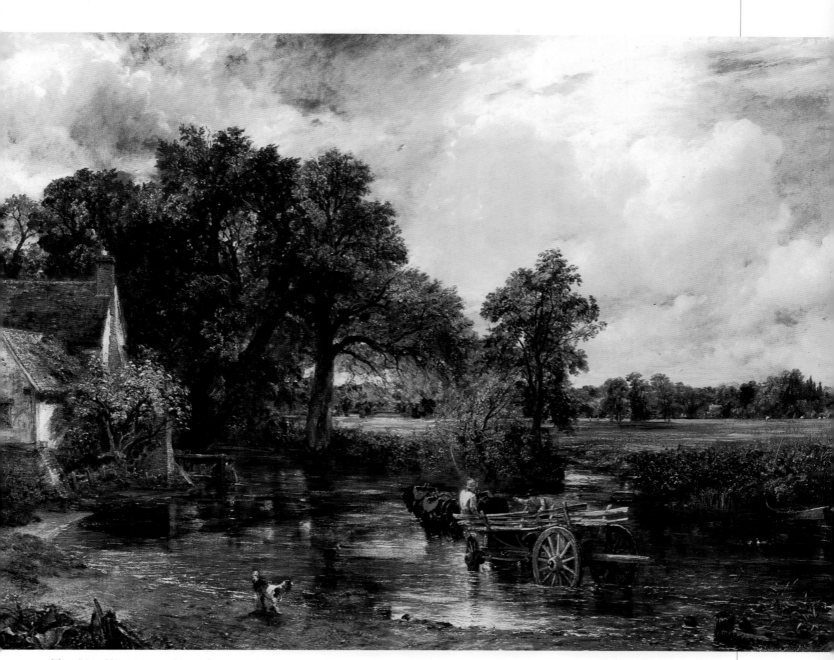

▲ THE HAY WAIN, *1821* JOHN CONSTABLE

This Suffolk scene near Flatford on the river Stour focuses on a horse-drawn cart known as a hay wain, with a group of haymakers beyond in the distance. Constable first made sketches of the scene in the open air, but the final painting was created in the artist's studio in London.

MYSTIC LANDSCAPES

CASPAR DAVID FRIEDRICH (1774–1840) was the most important visual artist of the Romantic movement in Germany, although his work was virtually forgotten at the time of his death and only rediscovered fully in the 20th century. Romanticism came to fruition in Germany, France and Britain in the early 19th century, with many artists looking to the landscape as a way of conjuring up mood and atmosphere. Landscape for Friedrich was a way of conveying powerful emotional feelings; he saw a religious and symbolic importance in nature that he wanted to communicate. Friedrich himself realised that his work was not, as it was in Constable's case, about 'the faithful representation of air, water, rocks and trees… but the

reflection of the soul and emotion in these objects'.

Friedrich trained at the Copenhagen Academy in Dresden between 1794 and 1798 and then settled permanently in Dresden. Romanticism in Germany flourished in Dresden and there Friedrich met other artists, including the poet Goethe. Initially he worked in sepia wash and pencil, but switched to oils in 1807. Although he turned his hand to other subject matter, Friedrich always returned to landscape, in which he often included ruins and solitary figures, showing these lone individuals as insignificant before nature.

Friedrich's paintings have an almost disturbing clarity, as a result of the fact that they are painted with such meticulousness. His foreground forms,

such as a sharp crag, or a rock, or a tree, are startlingly accurate and sharply delineated, whereas the background stretch of mountains or sea is often swathed in mist. This helps to reinforce an overall sense of contemplation – the mood is generally calm and optimistic. Light, too, is highly significant in his paintings with the particular time of day – dawn, sunset or twilight – imbued with significance. There is a concern also with the aspect of Romanticism known as 'sublime', a new aesthetic concept that developed in the 18th century, focusing on the grand passions stirred in man when confronted with the wildness and vastness of nature. Friedrich's intriguing, detailed and atmospheric paintings foreshadow the work of the Pre-Raphaelites in the late 1840s.

▶ CHALK CLIFFS IN RÜGEN, *1818* CASPAR DAVID FRIEDRICH
Friedrich made several paintings based on his sketches and studies of scenic places, like the cliffs on Rügen, Germany's largest island, and the areas of outstanding natural beauty around Dresden. This symbolic work, with its balanced composition, is a meditation on the awe-inspiring qualities of nature.

POETIC VISIONS

WHILE ROMANTICISM WAS coming to prominence in Europe at the beginning of the 19th century, a poetic movement known as *ukiyo-e* was the dominant art form in Japan. *Ukiyo-e* means 'pictures of the floating world', a term which describes a genre of Japanese woodblock prints and paintings produced between the 17th and the 20th century. The art of *ukiyo-e* reflects the transient pleasures of everyday life and makes use of imagery drawn from popular idols of the time such as actors and courtesans.

Katsushika Hokusai (1760–1849) was the leading exponent of the Japanese art of *ukiyo-e*. Born in Edo (now Tokyo), Hokusai was the son of a mirror-maker who learned wood engraving before training under a painter named Shunsho. Hokusai had various disputes with his master regarding work methods and left in 1785. He then went on to develop a method of woodblock printing that focused on a range of everyday subject matter, including birds, women and aspects of the landscape. *Ukiyo-e* was an important and dominant art movement in Japan because it was easy to mass-produce and thus affordable, while showing people going about their lives without idealization.

After studying European art and how perspective could be used in a picture, Hokusai concentrated primarily on landscape. Altogether he made over 30,000 drawings, mostly book illustrations made by the block printing method. His most famous block print is *The Wave*, although in his sixties and seventies he also created and published the equally influential woodblock prints, *The Thirty-Six Views of Mount Fuji*, between 1826 and 1833.

Ukiyo-e had a huge impact on the western world. In the middle of the 19th century, many foreign merchants visited Japan bringing with them many western influences, including photography and printing techniques. Japanese art was taken back to the West, where it became a source of inspiration for many European artists such as Monet, Degas and Klimt. Hokusai died at the age of 89 and left many followers.

Ando Tokitaro Hiroshige (1797–1858) is another Japanese artist of the *Ukiyo-e* school who adapted block printing to express his poetic vision. Typically, Hiroshige's prints feature landscape subjects in which small figures are shown journeying across bridges or along old roads or planting rice in the field. Hiroshige's colourful and graceful work was also a powerful influence on the Impressionists.

▲ MOUNT FUJI FROM OWARI, *c1831* KATSUSHIKA HOKUSAI

Hokusai created The Thirty-Six Views of Mount Fuji *when he was in his seventies. The series presents very different views of the distinctive cone-shaped mountain at different times of year. In it, he experiments with both eastern and western techniques, and simplifies the formal elements of composition, colour and line.*

◀ OHASHI,
SUDDEN SHOWER
AT ATAKE, *1857*
ANDO
HIROSHIGE
*A print from his
series,* One
Hundred Famous
Views of Edo, *this
is Hiroshige's last
great achievement,
which he kept
working on right
up until his death
in 1858.
Comprised of 118
prints, it is a
tribute to his
native city of Edo,
and makes wide-
ranging references
to its history,
customs and
legends.*

PORTRAITS AND NUDES

JEAN-AUGUSTE-DOMINIQUE INGRES (1780–1867) studied under the great Neo-Classical master Jacques-Louis David at his studio in Paris. David was 32 years older than Ingres, but the younger man was greatly influenced by the seamless rigour of his teacher's cool, classical style. The early work of Ingres harks back to the golden age of the Renaissance, and in particular the meticulous, harmonious world portrayed by Raphael, whose paintings he much admired. Ingres developed a superb linear style which, in time, was harnessed to produce works that revealed an astonishing degree of sensuous beauty, which could be seen as slightly at odds with his Neo-Classical intentions.

After winning the Prix de Rome in 1801 with a Neo-Classical history painting, Ingres embarked on a four-year scholarship, eventually spending 17 years in Rome altogether. From 1820 to 1824, he was in Florence and then returned permanently to France, where his work had little in common with the Romanticism of French contemporaries such as Delacroix. Although Ingres worked as a history painter and made works that were ambitious in scale with classical themes, these paintings are less compelling than his more intimate work, which includes lively portraits and a series of bathers, or *odalisques*.

Ingres began painting his *odalisque* series in 1807. These portraits of naked women surrounded by rich fabrics, including turbans, heavy drapes and luxurious bed linen, portray a world full of languorous, sensual indulgence. He particularly focused on women's backs as he wanted to show the naked form as a perfect example of classical linear grace. Despite being an artist dedicated to the classical ideals, Ingres displays in these works an overt physicality seemingly at odds with his more learned precepts.

Élisabeth Vigée-Lebrun (1755–1842) was also a French Neo-Classicist, who made work that, in some aspects, was not altogether typical of the genre; her strong contrasting colours are more suggestive of the Baroque. An aristocrat, she supported the monarchy and made portraits of Marie-Antoinette before she was guillotined in 1793. After exile in Italy and London, she returned to Paris in 1805, where her graceful and charming paintings were much admired.

▶ PORTRAIT OF COUNTESS GOLOVINE, *1797-1800* ÉLISABETH VIGÉE-LEBRUN
This portrait of the wife of a wealthy count was painted in Moscow after she was forced by scandal to flee from St Petersburg in 1796. Vigée-Lebrun described her as 'a charming woman … who drew very well and composed delightful love songs that she sang while accompanying herself on the piano'.

▶ THE BATHER OF VALPINÇON, *1808* INGRES
Ingres devised this particular way of representing the female body – nude and seen from behind – while studying at the French Academy in Rome. In choosing not to represent the woman's face, Ingres gives no hint of her personality, but rather forces the viewer to confront the eroticism of her voluptuous curves.

HISTORY AND DRAMA

THE FRENCH REVOLUTION of 1789 upset the old social order in France and meant that the grand, elegant Neo-Classical ideals to which David and Ingres aspired no longer reflected the reality of an increasingly mobile and fragmented society. If Neo-Classicism harked back to the culture of antiquity, Romanticism was firmly located in the modern world with none of the Neo-Classical's concern to stick with 'appropriate subject matter'. Both Eugène Delacroix (1798–1863) and Théodore Géricault (1791–1824) were great Romantic artists who made paintings containing subject matter that was emotionally highly charged. Ironically, Delacroix never accepted the Romantic label, insisting that he was a pure classicist.

Delacroix and Géricault received a classical training and first met as students of the Neo-Classical artist, Guérin. The elder by eight years, Théodore Géricault was born in Rouen, the son of wealthy parents. He lived a short but intense life, making radical work that forced his contemporaries to confront the grim reality of human suffering and death. He was fascinated by morbid subject matter. His paintings reflected, for example, the poverty he observed on a trip to London in 1820, where he also came to greatly admire the work of John Constable. Horses also figure repeatedly in his work and, whether they are engaged in battle or racing, reveal a characteristic Romantic preoccupation with drama and heightened emotion.

After Géricault's death in 1824, Eugène Delacroix was regarded as the true leader of the French Romantic movement. Delacroix, too, visited London where he also noted English landscape painting. He was inspired to paint a broad range of subject matter, drawing upon a number of literary and historical events both in France and abroad.

Delacroix travelled to North Africa for six months and spent time in Tangiers and Morocco, where he filled notebooks with drawings and watercolour sketches. Although his art is strongly underpinned by classicism, there's a powerful sense of drama reinforced by lively gestures and energetic movement. Above all, Delacroix's strong, vibrant colour and distinctive broken brushwork, in part inspired by Constable's experiments in juxtaposing pure or divided colour, have a profound emotional charge.

▶ THE MADWOMAN, *c1821–24*
THÉODORE GÉRICAULT

After a trip to London in 1820, Géricault started to paint a series of portraits of the insane, with each subject exhibiting a different affliction. Set against a dark background and with a white bonnet framing the face, Géricault forces us to confront the psychological discomfort etched into the face of this particular individual.

▶ THE WOMEN OF ALGIERS, *1834*
EUGÈNE DELACROIX

Delacroix travelled to Spain and North Africa in 1832 where he managed to sketch these women – concubines in a harem – secretly in Algeria. In the 19th century, such a sensual image was seen as acceptable because it derived from the exotic East – a practice known as Orientalism that has since acquired negative connotations.

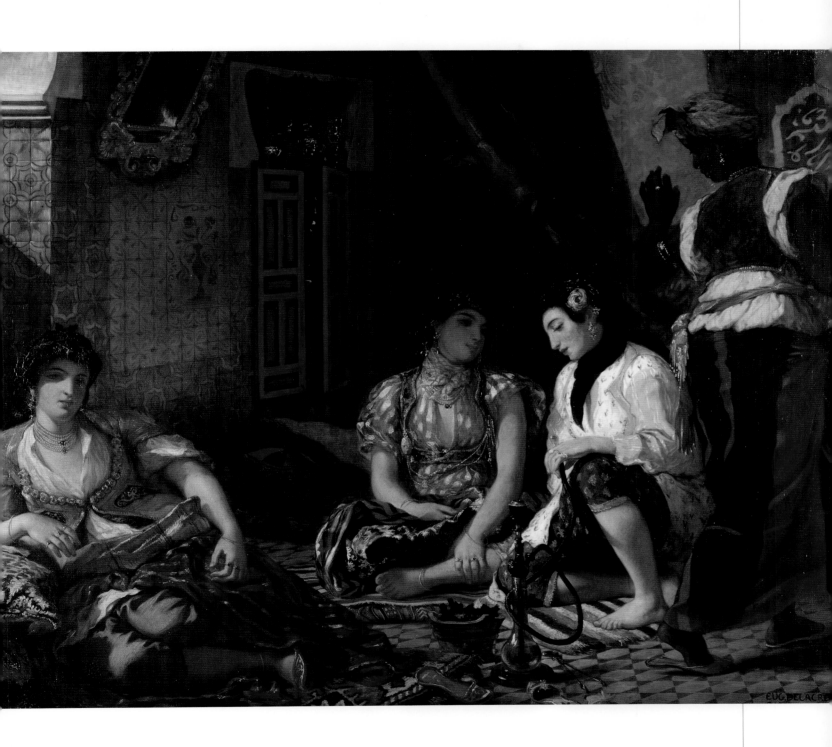

DIRECT FROM NATURE

IN 19TH-CENTURY FRANCE, when both Neo-Classicism and Romanticism had asserted very different influences over painting, there were artists whose work did not belong to either tradition.

Jean-Baptiste-Camille Corot (1796–1875) specialized in landscapes that looked, at first sight, as if they belonged to the classical tradition. Corot trained in the classical landscape genre, making paintings of idealized views set in an ancient world inspired by the 17th-century paintings of Poussin and Claude Lorrain. However, his bold and direct style also borrowed elements, such as the rich tones, from Romanticism.

Corot first visited Rome in 1825 and returned to Italy several times throughout his career. He also made lengthy sketching trips round Europe where he followed the advice of his early tutor, Michallon, who told him to reproduce what he saw in front of him as closely as possible. Corot made sketches direct from nature, using these as the basis for larger compositions that he would work up in his Paris studio.

From about the 1850s onwards, his landscape work underwent a profound change, using closely related tones together, a technique which gave his woodland and waterside scenes a soft and silvery appearance. Corot looked closely at the way that light interacts with nature; the overall effect gives his landscapes a diffuse haziness, suggestive of ephemerality. The sketches he made are remarkably fresh, although Corot never regarded them as anything other than studies to be used as reference material. He also displayed a very modern interest in photography. Later in his career he turned to portraits and these – in particular his studies of women – are much admired.

Eugène Boudin (1824–1898) is an important painter, not least because his work provides a link between his friend Corot and other French artists of that generation, including the Impressionists. Boudin also painted outside in the open air and, in particular, focused on visitors gathered at the resorts of Trouville and Deauville on the Normandy coast. Boudin painted a great number of seascapes and beach scenes at many different times of year and in all weather conditions. His fascination with light and his loose, spontaneous brushwork were an inspiration to the Impressionists, in particular Claude Monet.

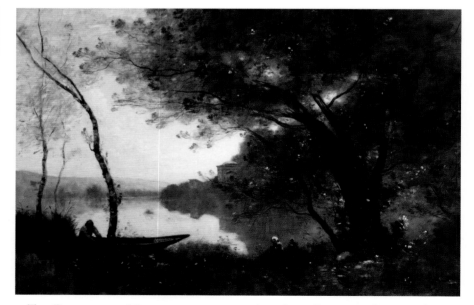

▲ THE BOATMAN OF MORTEFONTAINE, c1865-70 JEAN-BAPTISTE-CAMILLE COROT
This late work provides a lyrical and hazy evocation of the ponds of Mortefontaine, near Senlis in France. It is a timeless vision created out of a restricted palette of pale blues and greens and dark vegetation. Corot may have been influenced by the blur of early landscape photographs, which he avidly collected.

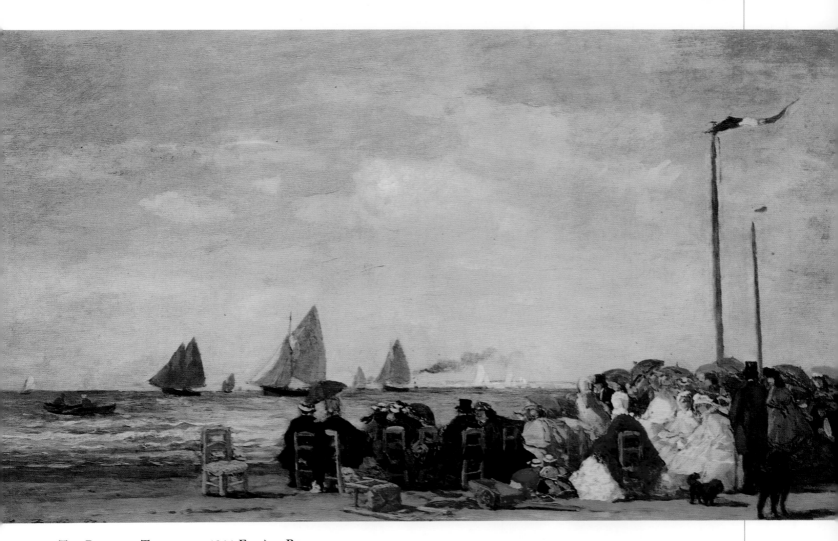

▲ THE BEACH AT TROUVILLE, *1864* EUGÈNE BOUDIN

Boudin painted several versions of the beach at Trouville, a lively 19th-century seaside resort in Normandy. This atmospheric painting records a number of fashionable visitors gathered to look out at the choppy sea on a grey and windswept day.

NEW REALISM

IN REJECTING THE IDEALS OF BOTH the Neo-Classical and Romantic schools, Gustave Courbet (1819–1877) created a new revolutionary style known as Realism. Courbet saw his work as being diametrically opposed to everything that the French Academy stood for; in turn, the Academy disliked the Realists for their spontaneity and lack of control. Courbet's defiant stance stemmed in part from his socialist politics; above all, he regarded his art as being part of a revolutionary struggle, designed to expose all pretentiousness and reveal harsh truths about the society he lived in.

Gustave Courbet was born in Ornans in France, near the Swiss border, the son of a prosperous farmer. He came to Paris in 1839 and, instead of a conventional art training, copied old masters such as Caravaggio, Velásquez and Zurbarán in the Louvre. Courbet's belief in the importance of truth meant that he immediately wanted to distance himself from Romanticism, which he saw as individualistic, decadent and exotic. He felt it was more important to concentrate on the commonality of experience. However, his first major work, *Burial at Ornans,* caused a sensation when it was exhibited at the Paris Salon in 1850, on the grounds that it idealized the peasants it portrayed, while subjecting the clergy to savage criticism.

Courbet followed this work with a succession of paintings featuring a disparate range of subject matter, including landscapes, nudes and large genre scenes. All were again criticized for their heavy realism, although after 1855 the tone of his work became less dogmatic. While Courbet's gritty approach undoubtedly sent shockwaves through the art establishment of his day, his paintings remain no less impressive for the skill with which he handled chiaroscuro, impasto and rich colouring. Courbet had an enormous influence on the development of art in the 19th century.

Jean-François Millet (1814–1875) was born in Gruchy, a rural community in northern France, which inspired his simple, realistic paintings showing the dignity of men and women at work on the land, apparently at peace with their rural surroundings.

In 1849 he moved to Barbizon, a move which gave rise to the mid-19th-century Barbizon School of painters who lived and worked there, painting undramatic scenes of peasant life.

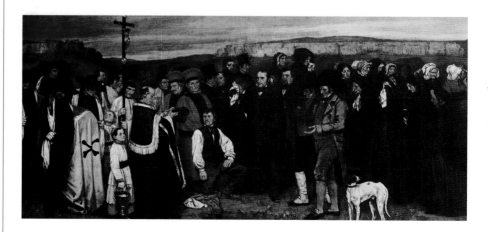

◀ A BURIAL AT ORNANS, *1849–1850*
GUSTAVE COURBET
When the Paris Salon exhibited this 20-foot-long painting there was uproar. It is hard to see now why the dark, frieze-like portrayal of worthy middle-class citizens at a graveside caused such a stir, but its realism was deemed vulgar and ugly, the very antithesis of what a painting should be!

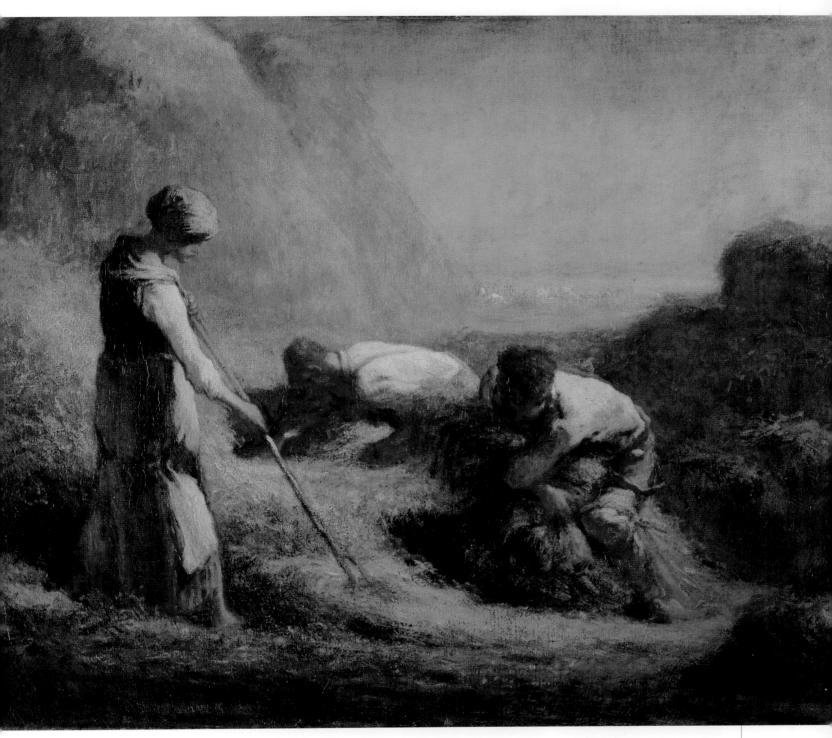

▲ HAY HARVEST, *1850* JEAN-FRANÇOIS MILLET

Jean-François Millet made many paintings of rural labourers and the land they worked.
Set amid a poetic landscape comprised of mounds of soft hay, the real purpose of this picture
seems to be to suggest how man is at one with his tranquil rural surroundings.

THE PRE-RAPHAELITES

THE PRE-RAPHAELITE BROTHERHOOD, a group of seven young artists, came together in 1848 with the aim of reviving in British painting the purity and sincerity that they felt existed in art before the great Renaissance master, Raphael. One way they felt they could achieve this was to concentrate on 'realism' in their painting and to focus on poetic, moral or religious subject matter.

Altogether, out of the original group of seven, only three – Dante Gabriel Rossetti (1828–1882), John Everett Millais (1829-1896) and William Holman Hunt (1827–1910) – continued to make paintings of any distinction. Another painter, Ford Madox Brown (1821–1893), was closely involved with the group but never became an official member. The movement also had a literary aspect to it; Rossetti was a poet and a painter and the critic, John Ruskin, was one of their staunchest defenders.

One of their original aims and intentions was to be faithful to nature and characteristic Pre-Raphaelite paintings show extraordinary attention to detail. The light in the paintings of Millais, Madox Brown and Holman Hunt is astonishingly clear; the figures and the landscapes have a super-bright intensity that helps to convey the emotional clarity of the scene. They achieved this luminosity by painting pure colours on to a canvas prepared with a white ground, which gave their hues added brilliance. The Pre-Raphaelites saw themselves as upholding a principled seriousness and their work often made use of biblical or allegorical scenes to demonstrate their sincere and high-minded beliefs.

The Pre-Raphaelite Brotherhood only lasted eight years, partly as a result of persistent criticism but also because its members went off to pursue their separate interests. In 1896, John Everett Millais, undoubtedly the most successful painter, became, ironically, President of the Royal Academy, the very institution which the Pre-Raphaelites had set out to oppose. Equally, a movement that started as a rebellion against sentimentality and pretentiousness ended up being characterized for its romantic escapism.

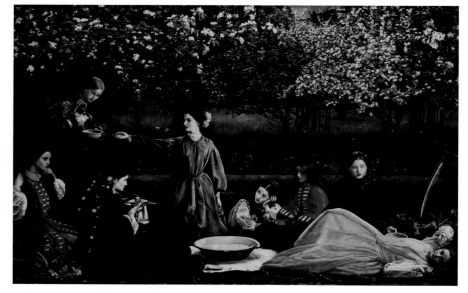

▲ APPLE BLOSSOMS – SPRING, *1856–59* JOHN EVERETT MILLAIS

In this picnic under apple trees, young girls are shown tasting a sweet dish. The underlying message of the painting suggests that youth is transient and, like the blossoms and wild flowers, it will not last for ever. Contemplative works of this kind were intended, said Millais, to evoke deep 'religious reflection'.

▶ VENUS VERTICORDIA, *1864–68* DANTE GABRIEL ROSSETTI

To paint this image of Venus, Rossetti painted from two models: a cook discovered by Rossetti and a friend and model known as Alexa Wilding. Rossetti wrote a poem to go with the painting, which reveals the negative and positive aspects of Venus holding both Cupid's dart and the golden apple of discord.

IMPRESSIONISM AND POST-IMPRESSIONISM
c1860–1900

In the 1860s in Paris, a loose movement of artists came together to share common themes and ideas. This new grouping did not have a clear structure or programme, but its members were generally opposed to the Academy style that dominated the French art scene in the middle of the 19th century. The Academy upheld traditional values and dictated that historical subjects, religious themes and portraits were of value, whereas landscape and still life were not. It also favoured images that were smooth, highly finished and naturalistic.

The Salon des Refusés (Salon of the Rejected) was set up in 1863 after the official Academy and its Paris Salon refused to accept a number of works, including those by Manet, Cézanne and Whistler. Although regarded with disdain by the establishment and art critics, the new Salon drew record crowds and inspired artists to develop their own salons. In 1874, a group consisting of Monet, Renoir, Pissarro, Sisley, Cézanne, Morisot and Degas organized their own exhibition at a photographer's studio. Impressionism was first used as a derogatory term by journalist Louis Leroy; in a satirical magazine he derided one of Monet's works as 'an impression of nature, nothing more'.

The Impressionists were always a diverse group. The first wave consisted of Monet, Renoir and Sisley, who established friendships with Pissarro, Cézanne and Morisot and were later joined by Degas and Manet. The Impressionists wanted to get away from the twin strictures of Realism and the idealized and highly subjective, emotional art of the Romantics. Above all, this new wave of artists wanted to get out into the open air and paint what lay before them. They wanted to convey the freshness and spontaneity of nature by capturing the transient effects of each passing moment.

This manifested itself, too, in a preoccupation with the surface of the painting, including the texture and physical nature of the paint and the way it is applied. Impressionist paintings typically display short, thick

1860	1861	1864	1867	1879
The US Secret Service founded to protect the President	The American Civil War kicked off with the bombardment of Fort Sumter	The Geneva Convention met for the first time to formulate rules for prisoners of war	The US bought Alaska from Russia for two cents an acre; Karl Marx published Das Kapital	Thomas Edison perfected his light bulb, which could burn for over 13 hours

brushstrokes and colours are applied next to each other with little mixing on the canvas. Pure black paint is avoided and wet paint is applied on to wet paint, producing softer edges and a gradual fusing of colour. The Impressionists learned much from the work of Corot and Boudin, who had painted direct from nature. Other painters who paved the way stylistically for Impressionism include Delacroix, Rubens and Turner.

Another major influence was the unconventional compositions found in popular Japanese art prints; Edgar Degas was an avid collector of these. He was also a keen photographer and the Impressionists experimented with the new possibilities opened up by the development of the portable camera.

The French public was slow to accept Impressionism. Individual artists saw few financial rewards from the Impressionist exhibitions, but their work gradually gained acceptance once art dealer Paul Durand-Ruel had taken up their cause, arranging shows in London and New York. Impressionism was popular in America; Whistler, Eakins and Homer were among the American artists who travelled to Europe to study.

Napoleon III became Emperor of France in 1851 and set about making Paris the new centre of Europe. He employed architect Baron Haussmann to remodel the centre of the capital; his new design featured tree-lined boulevards. New squares, parks and civic buildings helped to create a fashionable café society among artists and writers. French poet Charles Baudelaire and novelist Émile Zola were friends and contemporaries of the Impressionists.

Post-Impressionism is the term applied to another loose grouping of artists that followed the Impressionists from 1886 to 1910. Post-Impressionists were even more diverse than the Impressionists. The work of the Post-Impressionists displays a new subjectivity, expressed by artists as different as Van Gogh, Seurat, Munch, Gauguin, Klimt, Toulouse-Lautrec, Vuillard and Bonnard. Cézanne was key to Post-Impressionism and to understanding the art of the 20th century. He was preoccupied with the underlying structure of things and his work features the struggle between the principles of reality and abstraction that was to set the mood for the dawning of a new era.

1885	1888	1889	1895	1898	1899
The world's first skyscraper was built in Chicago	The Jack the Ripper murders took place in London's East End	The Eiffel Tower was built for the Great Exhibition in Paris	X-rays discovered by Wilhelm Roentgen; Louis Lumière showed the first moving pictures	China leased Hong Kong to Britain for 99 years	The Boer War began between the British Empire and Dutch settlers

THE FREE HANDLING OF PAINT

ALTHOUGH RESPECTED AND admired by the younger Impressionists, such as Monet, Renoir and Sisley, Edouard Manet (1832–1883) never actually exhibited with them, setting his sights on recognition from the established Salon. Manet is, however, related to the Impressionists because of the originality of his subject matter and the free way he handled paint.

Manet came from a solidly bourgeois Parisian family and, despite his family's opposition, trained to be a painter, mainly by studying paintings in the Louvre. Velásquez and Goya were important early influences, along with the Realist works of Gustave Courbet. Manet started off by painting the social milieu with which he was familiar, although his work with its strong tonal contrasts, bold colour and unorthodox compositions always revealed a rebellious spirit.

Déjeuner sur l'Herbe (1861–3), featuring a naked woman picnicking with clothed men, was rejected by the Salon and seen as shocking – not so much because of its nudity, but because of its refusal to place the work in a classical setting. Manet followed this with another reinterpretation of a classical work, *Olympia* (1861–3), which again caused controversy due to the overt sexuality and confrontational gaze of his model.

Manet was more of a Realist than an Impressionist in many ways, but the opposite in nature to the passionate, coarse Courbet, being more of a *flâneur*, the term used to describe an 'idle man about town'. Part of the Monmartre café society, Manet was friends with many other artists and writers, in particular Baudelaire, and followed his advice to paint modern life, sketching constantly in the boulevards and the cafés of Paris.

Working at Argenteuil in the 1870s, Manet had more contact with the Impressionists, but continued to paint mainly from models in his studio. He was interested in depicting figures such as singers and waitresses and their relationship to the cities they inhabited. Manet's still lifes are some of his most beautiful works; these acute studies of everyday objects are extraordinarily physical, being modelled from vital broken brushstrokes and full of gleaming light.

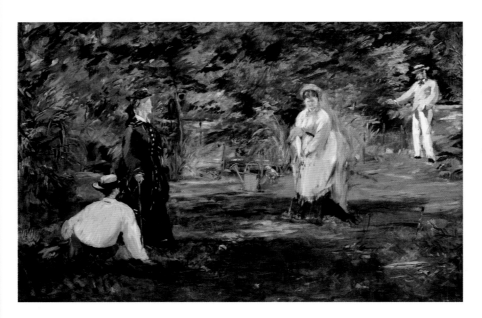

◀ THE CROQUET GAME, *1873*
EDOUARD MANET
In 1873, croquet was a popular activity for both men and women. This game is taking place in the garden of Belgian artist Alfred Stevens, allowing Manet, seen to the far right, to swap mallet for paintbrush and experiment with painting outdoors. Paint is applied informally and freely, anticipating Impressionism.

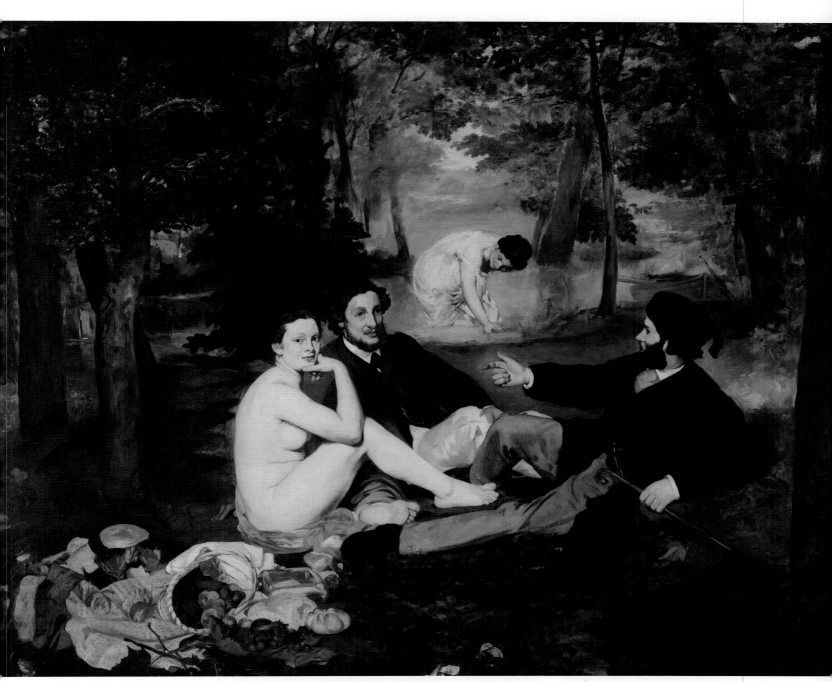

▲ LUNCHEON ON THE GRASS (DÉJEUNER SUR L'HERBE), *1863* EDOUARD MANET

This controversial image of a naked woman sharing a picnic with two clothed men was painted on a large canvas, of the kind usually reserved for grander subjects. Manet breaks with convention in other ways – the harsh light and the broad handling give the work spontaneity and an unfinished feel.

THE PLAY OF LIGHT

IMPRESSIONISM OFFICIALLY DATES from 1874 when Monet, Renoir, Pissarro, Sisley, Cézanne, Morisot and Degas organized their own exhibition in an empty photographer's studio. A journalist accidentally gave the group its name, after launching a savage attack on Monet's painting, *Impression Sunrise,* arguing that 'wallpaper in its embryonic state is more finished'.

Claude Monet (1840–1926) is the archetypal Impressionist. His work is characterized by the fact that he applied pure pigment directly on to a canvas prepared with white paint. Painting outdoors, Monet used his luminous colour to capture the play of light across the natural landscape, eliminating unnecessary detail and using rapid, sketchy brushstrokes to record the constantly changing conditions.

Monet was born in Paris but educated in Le Havre, where he met Boudin who encouraged him to paint directly from nature. Monet met Pissarro, Renoir, Sisley and Bazille while studying in Paris and painted with them at Chailly near Fontainebleau, forming an embryonic Impressionist group. During the 1860s, Renoir and Monet produced the first pure Impressionist paintings, in which they started breaking up colour to create dappled and glittering light effects.

Monet took part in five of the eight Impressionist exhibitions. His work continued to receive unfavourable reviews and, like other Impressionists, he experienced poverty until the timely intervention of dealer Paul Durand-Ruel ensured that their work was brought to the attention of a wider and more discerning audience. Monet remained dedicated to the study of light and its transforming impact on nature and, in 1876, he started to paint a series of works based on an individual motif. *Gare St-Lazare, Haystacks* and *Rouen Cathedral* are some of his best-known works and richly demonstrate the acute tonal sense that Cézanne famously described as 'only an eye, but my God, what an eye'.

In 1883 Monet settled at Giverny and built an extraordinary water garden. Here, with his eyesight failing, he created expansive canvases of waterlilies which surround and engulf the viewer and, as fields of pure, broken colour, do much to anticipate Abstract Expressionism.

▶ GARE ST-LAZARE, *1877*
CLAUDE MONET

This railway station was a recurring motif for Monet, although only four of his seven versions of the interior of this station have survived. In this unusual view, the smoke from the engines billows round the cavernous station, the loose, sketchy marks creating a sense of urgency and immediacy.

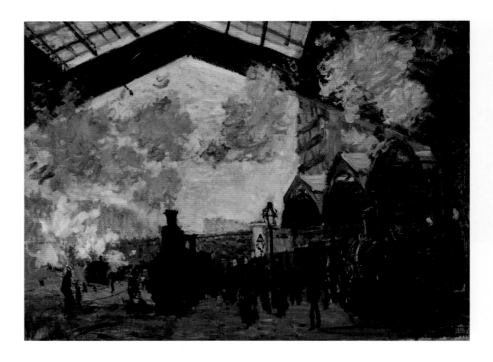

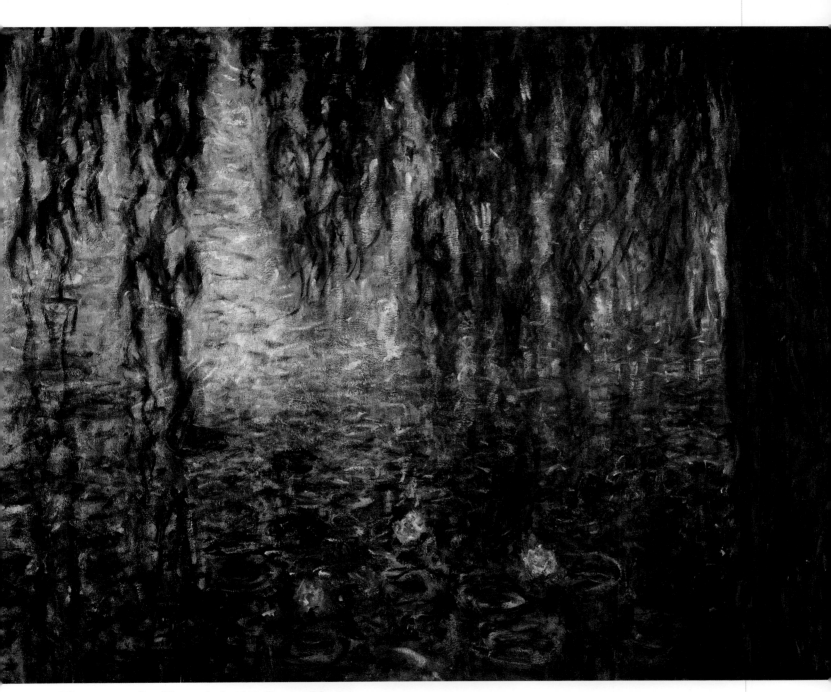

▲ WATER LILIES (LES NYMPHÉAS), *1905* CLAUDE MONET

In 1883, Monet moved from the North-west of Paris to Giverny where he created a water garden with an arched, Japanese-style bridge. He made a series of huge canvases of the pond, showing the water lilies in differing light conditions, as well as producing many similar works which feature a close-up of the surface in a near-abstract design.

CAPTURING THE MOMENT

FRENCH IMPRESSIONIST AUGUSTE RENOIR (1841–1919) became best known for the joy that he saw in the charming children, gay crowds, social celebrations and, above all, the pretty women that he painted. His work does not have the intellectual rigour of Monet's, instead it has a sweetness that is best expressed in Renior's own words: 'Why shouldn't art be pretty? There are enough unpleasant things in the world.'

Renoir was born into a relatively poor family in Limoges, moving to Paris in 1845 where he trained and worked as a portrait painter. He met Monet in 1862 and exhibited in four out of the eight Impressionist exhibitions. Between 1867 and 1870, Monet and Renoir worked outdoors side by side, painting subjects such as poppy fields and river scenes; both were keen to capture the transient effect of light. Renoir's was an innovatory palette that made use of bright, sparkling colour, but not black; his darkest hues were mixed from burnt umber and ultramarine and his feathery brushstrokes also contribute to a uniquely soft and flexible sense of form.

Renoir gradually distanced himself from the Impressionist movement – he never lost affection for old masters such as Rubens and Boucher – and his later work showed an altogether more classical sensibility.

Edgar Degas (1834–1917) came from a more prosperous background, attending the Academy School in Paris before studying Renaissance works in Naples and Rome. He began by painting portraits in a severely classical manner, but abandoned these for compositions drawn from contemporary life, such as the ballet, theatre, circus and the races.

Degas never fully subscribed to the theories behind Impressionism although he was part of the wider circle from 1861, and exhibited with them until 1866. Degas was fascinated by the possibilities of the camera and also by his own private collection of Japanese prints. Unusual angles, figures cut by the frame and an off-centre focal point were, subsequently, all dramatic features of his compositions, many of which were executed rapidly in pastels as well as in oil.

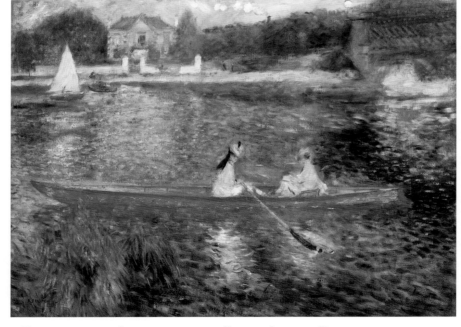

▲ BOATING ON THE SEINE, c1879–1880 PIERRE-AUGUSTE RENOIR
Renoir painted outdoors to capture the immediacy and freshness of what he saw before him. Here, the painting is as much about the shimmering effect of light on the broken surface of the water as it is about the two young girls whiling away a lazy day on the river.

▶ JOCKEYS BEFORE THE RACE, c1878–79
EDGAR DEGAS
This racing scene focuses on the tense moments before the race as three jockeys prepare for the off on a bleak wintry day. The unusual, asymmetrical composition – with the starting post cutting across the riders – was quite possibly the result of Degas's keen exploration of Japanese prints.

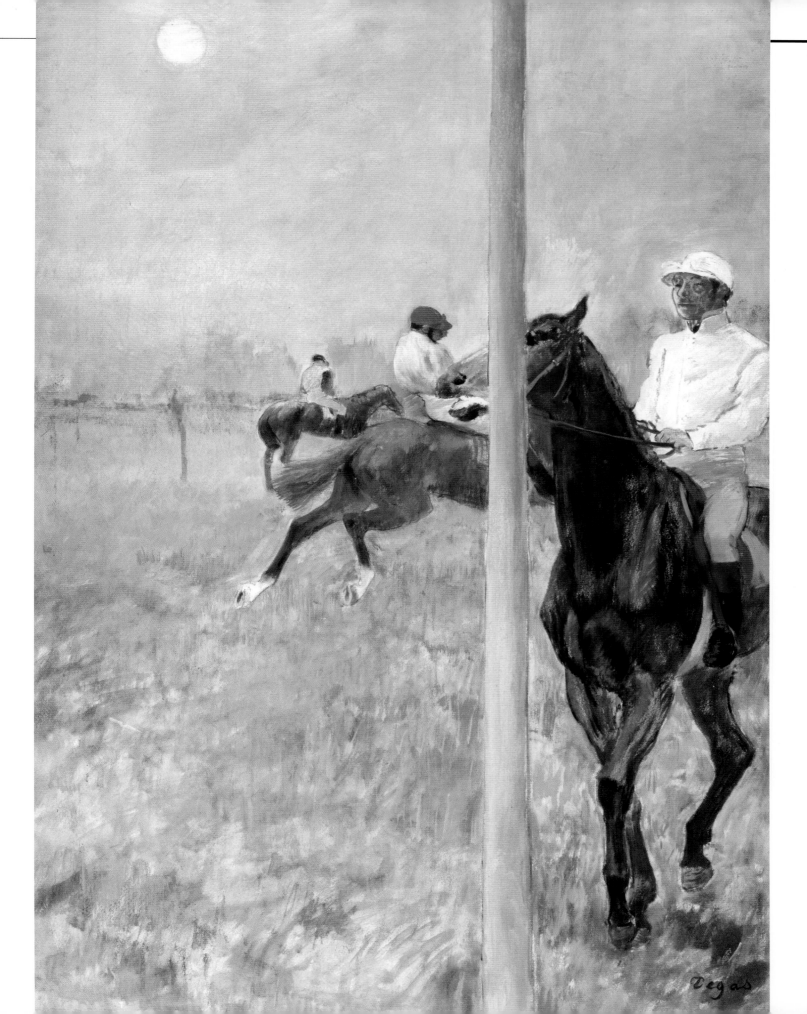

THE FEMALE GAZE

THE IMPRESSIONIST CIRCLE embraced Mary Cassatt (1844–1926) and Berthe Morisot (1841–1895), two important women artists who studied, worked and exhibited with their male counterparts, including Degas, Manet, Monet and Pissarro. The subject matter available to women artists of this period was limited – this was a time when even being alone in a room with a man was considered inappropriate. Women Impressionists used women and children as models, partly out of necessity but also because the female gaze, and femininity in general, was so under-represented in art that they were able to offer a unique and singular contribution.

Mary Cassatt was born in Pittsburgh, USA, but yearned for the challenges and adventures that Europe had to offer and pleaded with her father to let her travel. She studied in Spain, Italy and the Netherlands, before settling in Paris where she met Degas, who became a lifelong friend and mentor. Cassatt exhibited with the Impressionists between 1877 and 1881. Like Degas, Cassatt made many pastel studies, as well as lithographs and etchings, revealing the influence of Japanese prints from the *ukiyo-e* tradition. Her studies of women and children, in particular the work that is generically referred to as her 'Mother and Child' portrayals, are tender without being mawkish. Degas described her art as being preoccupied with the study of 'reflections and shadows on skin and costumes for which she has the greatest feeling and understanding'.

Berthe Morisot came from an aristocratic French family and was the great-granddaughter of Fragonard, and sister-in-law and pupil of Edouard Manet. In 1868, she posed for Manet's *The Balcony*, with her mother in attendance for the sake of propriety. She studied under Corot and took part in seven of the eight Impressionist exhibitions. Limitations placed on female artists of the time meant her paintings frequently included members of her own family, or featured simple, domestic scenes observed from her own life. Morisot's many charming and intimate portrayals of girls and young women provide an unsentimental record of the transition from girlhood to womanhood. Interestingly, during her lifetime Morisot outsold Monet, Renoir and Sisley.

▶ MOTHER'S KISS, *1890–91* MARY CASSATT

This coloured print features a mother and children a theme to which Cassatt returned many times. Although herself unmarried, she spent time with friends and family who had children and enjoyed representing them in her work. The slight awkwardness of the child prevents this image from being unduly sentimental.

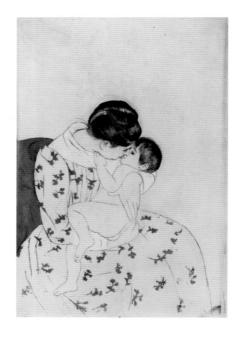

▶ THE CHERRY TREE, *1891* BERTHE MORISOT

Two young girls pick cherries from a tree: in this work, as in most of her paintings, Morisot focuses on the things she knew well. She made several sketches before beginning this painting as, in a late work like this, she rarely relied on direct observation from nature.

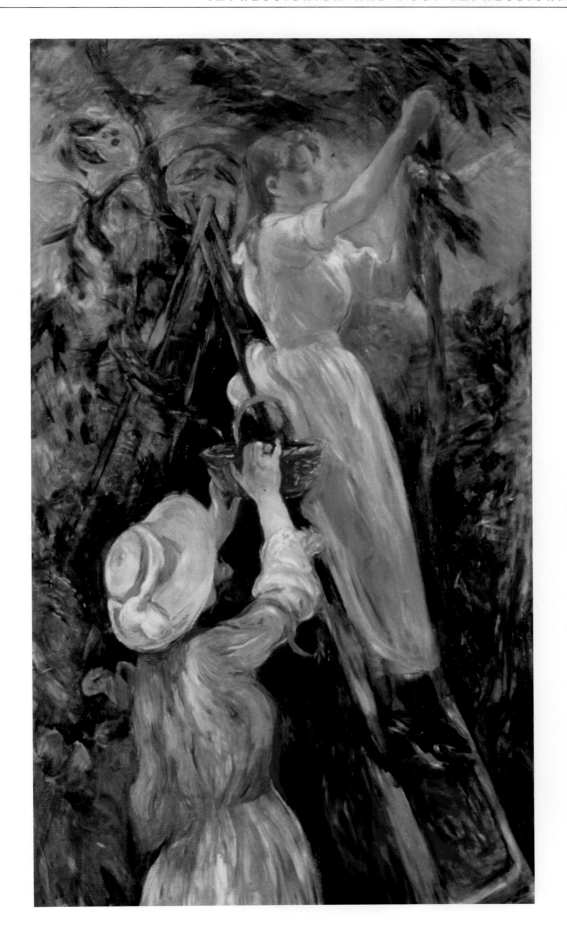

COLOUR AS FORM

IMPRESSIONISM IN ITS PUREST FORM was concerned with the quality of light and the changing shadows across a landscape. Camille Pissarro (1830–1903) and Alfred Sisley (1839–1899) remained true to the original aims of Impressionism, painting landscapes in the open air, building up form from dabs and flecks of pure, brilliant colour. Both artists preferred to live outside Paris in the countryside where they could focus on painting rural scenes. Of all the Impressionists, Sisley remained most true to the movement's principles, never developing beyond them. Georges Seurat (1859–1891) was a Post-Impressionist, a younger artist who expressed a keen and scientific interest in Impressionist theories of colour. Seurat developed a new method known as Pointillism in which dots of pure colour, laid side by side on the canvas, blended in the viewer's eye rather than on the artist's brush.

Camille Pissarro initially worked under Corot in Paris who advised him to make small sketches working directly in the landscape 'to study light and tonal values'. A senior figure to the other Impressionists, Pissarro was 44 by the time of the first Impressionist exhibition and he was the only member to show in all eight. His remarkably consistent vision focuses on direct observations of light and atmospheric conditions as well as the human figure, showing something of Millet and Daumier's concern for the plight of the working man. In the 1880s, Pissarro also became interested in optics and exhibited some Pointillist work with Seurat.

Alfred Sisley had English parents, but met Monet and Renoir while studying in Paris in 1862. He became a central figure of the Impressionist group and exhibited with them four times. His loosely worked landscapes are freshly painted in clear colour and subtly evoke atmosphere. Sisley's many views of the French countryside – of meadows, floods and fields covered in snow – are perhaps the most lyrical of all Impressionist works.

Post-Impressionist Georges Seurat is significant not only because of his scientific approach to colour, but because of the geometric precision with which he arranged his subject matter. Although, like the Impressionists before him, Seurat worked on studies in the open air. He then worked up his precise, classical, uncluttered compositions in the studio.

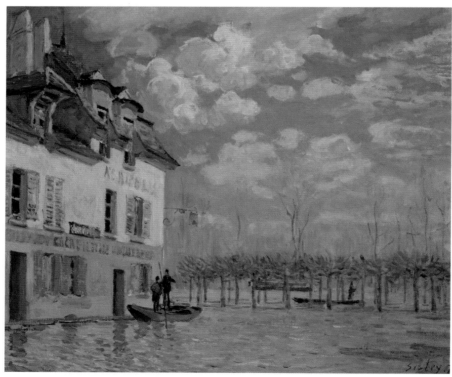

▲ BOAT DURING THE FLOOD OF PORT-MARLY, 1876 ALFRED SISLEY
In February 1876, severe floods at Port-Marly on the left bank of the Seine inspired Sisley to produce seven different paintings of the scene. This one is a quiet, lyrical painting largely composed of water and sky, in which the upright poles and trees add depth to the composition.

▲ THE RED ROOFS, *c1877* CAMILLE PISSARRO

This rural scene showing a corner of a village in winter is from the first period of time that
Pissarro spent with the Impressionists. The painting fulfils the essential aim of Impressionism
in making the spectator feel that he is actually present in the landscape through an objective
recording of the transient effects of light and colour.

SUBTLE TONES

Amerian James Abbott McNeill Whistler (1834–1903) left the US for Paris in 1855. Whistler trained under Charles Gleyre, a realist painter, and was at first influenced by Gustave Courbet. After meeting Manet and Degas, Whistler's style changed, but although his paintings in the 1860s came close to Impressionism, he was never a fully associated member of the movement. A dandy and a wit, Whistler moved to London in 1859 where he mixed in elevated circles, fraternizing with Oscar Wilde and Dante Gabriel Rossetti among others. The poet Baudelaire was also an acquaintance. Whistler firmly believed in the idea of art for art's sake and expounded this idea in a lecture first delivered in 1855.

Whistler loved Japanese art and appropriated some of its basic principles into his own work, juxtaposing areas of colour and tone on what was a flat, decorative surface. He gave his elegant, stylized arrangements musical titles which help to reinforce the idea of the paintings as harmonious compositions and subtle evocations of mood.

British painter Gwen John (1876–1939) studied at the Slade School of Art with her brother Augustus. She went to live in Paris in 1903, where she was taught by Whistler, who inspired her use of subtle, delicate, greyish tones. John lived in France most of her life but, after an unhappy affair with sculptor Auguste Rodin, became something of a recluse.

She painted her attic room several times, although the image she portrayed was one of a quiet introspection, not the one of neurosis or angst that might be expected through her self-imposed isolation. In 1913 she became a Catholic, announcing: 'My religion and my art, these are my life.' John's paintings include several self-portraits, a series of nuns and some individual women and young girls; these are restrained, muted studies of exquisite sensitivity, using a cool, subtle palette.

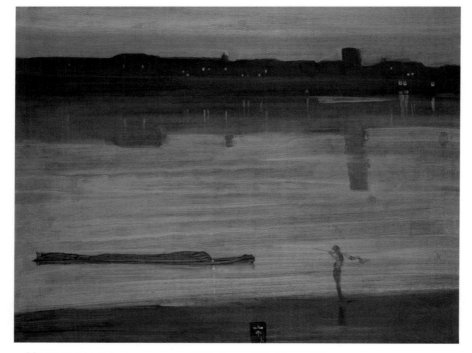

▲ NOCTURNE, BLUE AND SILVER, *1871* JAMES McNEILL WHISTLER
This is the first of Whistler's series of Nocturnes – *namely paintings of the river Thames at night – through which the artist wished to convey a sense of beauty. It has an almost abstract quality and lyricism that comes close to pure sensation. This view looks out from Battersea Bridge towards Chelsea, with a man on the foreshore, just visible in front of a low barge.*

▶ MÈRE POUSSEPIN SEATED AT A TABLE, *c1913–20* GWEN JOHN
After converting to Catholicism in 1913, Gwen John was commissioned by a Dominican order of nuns to paint a portrait of their founder, Mère Marie Poussepin (1653–1744). John's wistful painting was based on a prayer-card image of Mère Poussepin. Between 1913 and 1920, John worked on at least six versions of this portrait.

MUSCULAR REALISM

IMPRESSIONISM BECAME A TRULY international movement and its influence was felt in countries as far apart as Japan and America. Along with James Whistler, American artists Winslow Homer (1836–1910) and Thomas Eakins (1844–1916) were drawn to Europe to study. America was undergoing a period of great change. It was the time of the American Civil War (1861–1865), when the federal government came into conflict with the southern states over the issue of slavery.

Winslow Homer was born in Boston, Massachusetts and started his working life as a lithographer. In 1859 he moved to New York where he worked as a freelance illustrator. When the Civil War broke out, Homer was sent by the magazine, *Harper's Weekly,* to cover the fighting. He observed the battle of Bull Run and accompanied the Union army during its Peninsula Campaign. Homer developed a reputation for realism, his lively figure groupings making use of dramatic contrasts of light and dark.

After a visit to Paris in 1873, he began to work in watercolour. He travelled to England where he spent two years in the north-east fishing village of Cullercoats, producing watercolours based on fishing and life at sea. His style loosened up considerably and his brushstrokes became freer and more spontaneous. He returned to the United States in 1883 and settled at Prouts Neck on the coast of Maine, where he concentrated on seascapes. These marine paintings – in which man is often shown as overwhelmed by the vastness and sheer force of the ocean – are regarded as his most important work.

Painter and photographer Thomas Eakins studied at the École des Beaux Arts in Paris where he was influenced by Manet. A trip to Spain in 1870 enabled him to study Velásquez and Ribera at first hand; both had an influence on his particular style of scientific and exact realism. A born controversialist, his brutally realistic portrayal of surgeons caused uproar among a rather squeamish public. Alongside his uncompromising portraits – including one of Walt Whitman which delighted the poet – many of Eakins' paintings reveal his love of sports, featuring men engaged in boxing, baseball and rowing.

▲ THE LIFE LINE, *1884* WINSLOW HOMER
A dramatic scene in which a shipwreck victim attached to a line dangles precariously above stormy waters. A red cloth flaps like a flag signalling the appalling weather conditions. The sea and acts of heroism in which man fights to master the forces of nature was a subject that Homer returned to many times.

▶ BETWEEN ROUNDS, *1899*
THOMAS EAKINS
The boxers pause between rounds and we can see prizefighter Billy Smith getting treatment for his cuts in a fight that actually took place in Philadelphia. Eakins' portrayal of athletes was informed by his growing interest in photography.

ANGUISHED VISION

POST-IMPRESSIONISM IS THE name given to the group of painters working at the end of the 19th century and the start of the 20th century.

Along with Cézanne and Gauguin, Vincent van Gogh (1853–1890) was the greatest of the Post-Impressionists. There is no one style that characterizes the group although, of all of them, Van Gogh's paintings with their violent swirls are perhaps the most instantly recognizable.

Van Gogh was a maverick, a zealous man who threw himself wholeheartedly into whatever he did. Initially it was as a preacher to the miners in the Borinage, Belgium, but he was rejected by the church and turned to art. In 1881, living again with his parents in Etten, Van

Gogh started to make graphic studies and sombre paintings of peasants and neighbours he saw working around their homes and on the land.

In 1886 Van Gogh left Holland for Paris where he lived with his brother Theo, an art dealer. His move to Arles, in the South of France, resulted in a radical change of palette, but his idea of founding a community for artists came to nothing – the only painter who joined him was Gauguin in 1888.

They quarrelled violently; Van Gogh cut off part of his ear. After a period in an asylum, Van Gogh had a massive creative surge of energy, producing seventy-six paintings in total. Two days later, he shot himself.

In his short life, Van Gogh had sufficient contact with other painters to

absorb some of the main influences of his day, such as the lines and patterns of Japanese prints. He was introduced to many of the Impressionists although he used colour very differently from them, primarily to express his feelings. He painted in a frenzied manner, his passion serving to convey a sense of real excitement in his work.

In the last ten years of his life, he produced over 2,000 works, working faster and faster as his suicide neared. Characteristically, his dramatic and vibrant colours were applied thickly with short, broad strokes, side by side, with no blending. He exaggerated and changed things to suit his intense vision; his interest lay in expressing the wildness of nature, or the feelings that a field of corn or a starry night sky could evoke.

▲ WHEAT FIELD WITH CROWS, *1890* VINCENT VAN GOGH
Van Gogh committed suicide in the same month that he painted this picture. The most common interpretation of the work suggests that the dark, turbulent sky, the confused pathway and the black crows reveal his fraught state of mind at the time and in some way anticipate his death.

▲ THE BEDROOM, *1889* VINCENT VAN GOGH

Van Gogh painted two versions of his bedroom: the first in Arles in October 1888; the second
was painted from memory in September 1889, while he was in the asylum at St Rémy.
As he explained in a letter to Gauguin, 'It amused me enormously to paint the bare, Seurat-
like simplicity of such an interior … I wanted to suggest absolute repose, you see.'

EXOTIC PRIMITIVISM

LIKE CÉZANNE AND VAN GOGH, Paul Gauguin (1848–1903) was influenced by some aspects of Impressionism, but felt his art demanded a different approach. Gauguin came to painting after being in the merchant navy and working as a stockbroker when he was a young man. He showed work in the last few Impressionist exhibitions and, in 1876, had a painting accepted by the Paris Salon. In 1886, he abandoned his wife and children, rejecting a stable bourgeois family life in favour of becoming a full-time artist.

From 1896, Gauguin spent four years in Brittany where he was the central figure in a group of artists attracted by his attempts to formulate a new aesthetic which he called Synthetism. By this, Gauguin meant that the forms in his compositions were not derived from empirical or objective methods of looking, rather they were constructed from symbolic patterns of line and colour. This primitive, non-naturalistic style, partly inspired by medieval stained glass and folk art, made use of bold colour and decorative elements which

Gauguin admired in Japanese prints. He also made woodcuts which have an abstract, rhythmic quality to them, and produced lithographs, carvings, watercolours and ceramics.

In 1891, Gauguin left for Tahiti where he spent much of the rest of his life, living in a remote part of the island and painting the Polynesian people in their daily lives. His art records his attempt to become one with the people of the island; the figures become more simplified, the outlines clearer and the colour bolder and more dramatic. He was one of the first artists to find inspiration in the art of primitive cultures. However, Gauguin's sojourn in a tropical paradise was to bring about his untimely demise as he finally succumbed to syphilis and died in poverty in 1903.

Greatly admired by the German Expressionists, Gauguin became a leading figure in what became known as the Symbolist movement and is now seen as one of the key exponents of non-naturalistic art in the 20th century.

▲ AREAREA (JOYOUSNESS), *1892* PAUL GAUGUIN

Paul Gauguin was drawn to the Polynesian islands in search of the exotic, and this is celebrated in this depiction of a couple of young women under a tree, one playing a flute. Flat areas of colour and clear outlines reveal the influence of Japanese prints.

▶ ANNA FROM JAVA, *c1890*
PAUL GAUGUIN

Gauguin painted this image of an Indonesian woman after he had abandoned his family to live among the native people in Tahiti. The high-key colour makes this a typical work. The red monkey at Anna's feet probably represents the warding off of evil.

OFF CENTRE

PHYSICALLY DISABLED FROM both a genetic condition and childhood accidents, Henri de Toulouse-Lautrec (1864–1901) turned to art during a period of convalescence. He was born into an aristocratic family, but after studying art in Paris, Toulouse-Lautrec became part of a circle of artists that frequented the seedy nightclub quarter of Montmartre. Here, he painted scenes from the theatres, café-bars, brothels and music halls, in particular the Moulin Rouge, home of the can-can.

Toulouse-Lautrec became a central figure of the *fin-de-siècle* world that he depicted. He taught painting to the model and society beauty, Suzanne Valadon (1865-1938), who became his mistress. Toulouse-Lautrec introduced her to Degas and she became a successful painter of figures, portraits and still lifes.

Toulouse-Lautrec's off-centre compositions reveal a strong Japanese influence; he was also inspired by Gauguin's use of outline and rhythmic patterns. The simplicity of line, bold colour and flat shapes meant that his art was well suited to graphic design and he became known as a master of both the poster and the lithograph.

English painter Walter Sickert (1860–1942) was born in Munich. Despite the fact that both his grandfather and his father were painters, Sickert initially pursued a career as an actor. In 1868, he moved to London and studied at the Slade School of Art where he took lessons from Whistler. He later went to Paris and met Edgas Degas, whose drawing and creative use of pictorial space made a deep impression.

Like Toulouse-Lautrec, Sickert turned to the theatre and the music hall for his subjects, painting portraits and low-life genre subjects, often depicted from ambiguous points of view. The theme of confused or failed communication between people became a regular feature of his art. Sickert also painted intimate domestic scenes emphasizing the wallpaper patterns and other banal features, as well as creating abstract decorative shapes and flattening the sense of space.

▲ AT THE SALON, RUE DES MOULINS, *1894* HENRI DE TOULOUSE-LAUTREC
Toulouse-Lautrec used to visit brothels, in particular the one in the rue des Moulins, since observing prostitutes inspired him to paint a number of works. These are, however, not voyeuristic or judgemental. Here, bored prostitutes are seated on plush velvet sofas; the women's isolation and loneliness seem to be what interests Lautrec.

▶ ENNUI (BOREDOM) C*1914*
WALTER SICKERT
Sickert's paintings present a sometimes disturbing view of sexuality in which unusual vantage points create a complex and intense sense of space. Here, a couple's troubled relationship is brilliantly suggested in a bleak portrait which was the inspiration for a story by Virginia Woolf.

RAW ANGST

IN THE PAINTINGS OF NORWEGIAN artist Edvard Munch (1863–1944), there is a great affinity with the Symbolist work of Paul Gauguin whom he met in Paris in 1908.

The intense colour and visionary decorative qualities are, however, allied in Munch's work to a deep emotional anguish that came from the need to express his innermost feelings.

Munch, along with Van Gogh, was a forerunner of Expressionism; this was one of the greatest movements at the start of the 20th century, which abandoned the idea of art being faithful to nature in favour of making work that expressed emotions residing deep within the artist

Munch's mother died when he was five and his sister when he was 16: both experiences affected him deeply and, as an adult, he suffered bouts of mental illness and was subjected to electric shock therapy. Munch studied art in Christiania (now Oslo) and travelled in Germany, Italy and France, before settling in Oslo. During his visits to Paris between 1889 and 1892, he became familiar with Van Gogh and the work of Gauguin and other Symbolists, including Odilon Redon.

Munch formulated his own personal art in which the swirling lines and strident colours both contain and surround strange, dreamlike images. Revealingly he said: 'Art is the opposite of Nature. A work of art can only come from inside a person.'

In the 1890s, he worked on *The Frieze of Life* cycle of paintings, which include *The Scream* and which reveal the artist's preoccupation with themes of alienation, neurosis and morbidity – subjects that continue to concern artists in the 21st century. Unsurprisingly perhaps, Munch had a troubled relationship with women, whom he portrayed as powerful, enigmatic creatures. He allowed his own feelings of sexual inadequacy, jealousy and unease to eat away beneath the surface of the works.

Munch lived a dissolute life – drinking and womanizing – and the unhappier he was, the more autobiographical his work became, revealing his state of mind through increasingly unnerving imagery and contorted forms.

He did, however, achieve success in his lifetime, exhibiting worldwide and winning awards. He also produced etchings, lithographs and woodcut engravings that greatly influenced the development of the German Expressionist art movement, *Die Brücke*.

▸ THE SCREAM, *1893* EDVARD MUNCH
The best-known of all Munch's work, there are several versions of this painting, which is part of a series entitled The Frieze of Life, *exploring themes of life, love, fear, death and melancholy. Describing his inspiration for the work, Munch talked about sensing 'an infinite scream passing through nature'.*

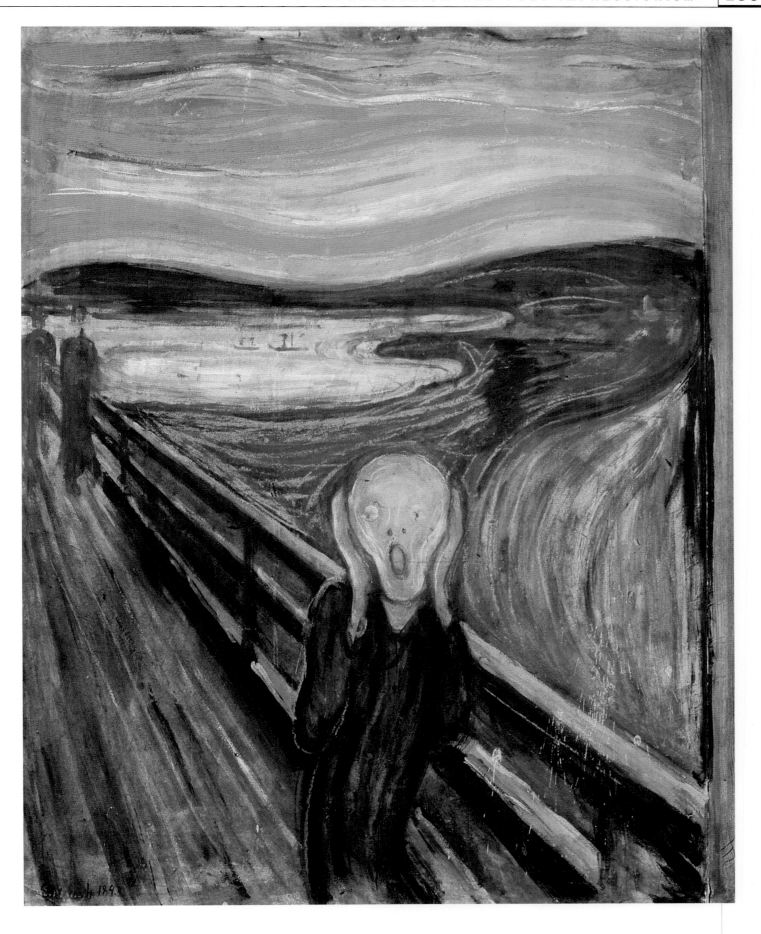

EXPLICITLY EROTIC

IN AUSTRIA, the highly ornamental work of Gustave Klimt (1862–1918) contained elements of Symbolism, but was also part of the new decorative art movement known as Art Nouveau. Developed in the 1890s, this movement was inspired by organic, natural forms and expressed itself in various media – sculpture, jewellery, ceramics and posters. An international style, Art Nouveau was known in Austria as *Sezessionstil*. Klimt was one of the founding members of the Viennese Secession in Vienna, a group of forward-looking artists and designers that formed in 1897 and who broke away from the mainstream salon exhibitions to explore the possibilities for art outside the confines of academic tradition.

Gustav Klimt trained as an architectural decorator and began his career painting interior murals in large public buildings. His career came to an abrupt end when three of his paintings were criticized and destroyed for their overt eroticism. Klimt's work is characterized by a decorative layer composed of elegant gold, or brightly coloured shapes that conceal or distract from the erotic positions adopted by many of the models. Klimt's distinctive style is inspired by an eclectic range of influences, including Egyptian and Byzantine art, the engravings of Albrecht Dürer and Japanese *ukiyo-e*. His many candid portraits of women, often renowned femmes fatales, feature archetypal images of feminine beauty and sexuality.

Fellow Austrian, Egon Schiele (1890–1918), met Gustav Klimt at the Viennese Academy in 1907. Klimt recognized Schiele's talent and, in 1909, invited Schiele to exhibit with him; here he came across the work of Munch and Van Gogh, among others. Disillusioned with the academic style, Schiele began to make explicitly sexual work that many found deeply shocking. He also made a series of self-portraits which, with their exaggerated gestures, arresting colour combinations and jagged contours, showed the influence of Expressionism.

Schiele is best known for his drawings and watercolours in which writhing, naked and often emaciated bodies express a range of intense emotions, from passion to desolation. The nervy quality of his line, combined with his complex, tortured personality, help contribute to an anxious and, at times, disturbing vision.

▶ NUDE, *1917* EGON SCHIELE
With its tense line and strange pose of a woman bent backwards, this study of a nude looks like a typical Schiele composition. In April 1912, he was arrested for seducing a young girl below the age of consent, and at the same time police seized more than a hundred drawings which they considered to be pornographic.

▶ THE VIRGIN, *1912* GUSTAV KLIMT
This brilliantly decorative work is distinguished by the jewel-like colours and the swirling ornate patterns of the many covers on the bed. In a break with naturalism, Klimt uses symbolic elements drawn from an eclectic range of influences which emphasizes how different his work is from traditional fine art.

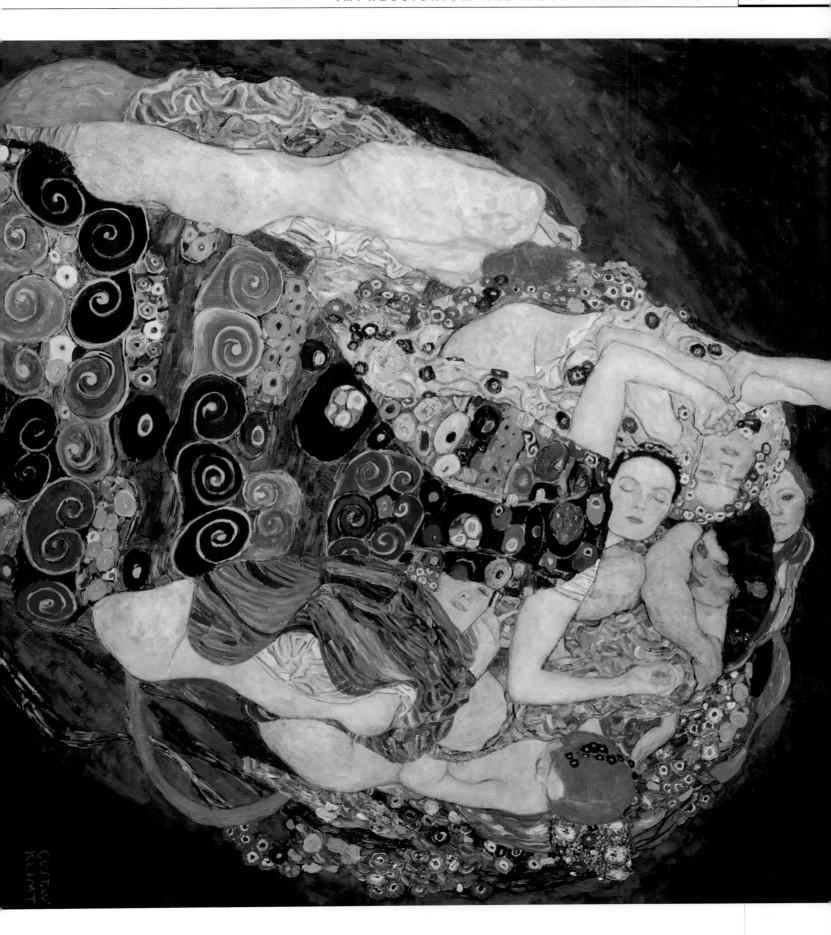

INTIMATE INTERIORS

BETWEEN THE POST-IMPRESSIONISTS and artists of the modern era stands a small group of French artists known as the Nabis (the Hebrew word for prophets). United by a love of Gauguin, these artists met at the Académie Julien in Paris in the 1890s.

The Nabis rejected the naturalism of Impressionism and admired the simplification of form and the spirituality that they found in Gauguin and Japanese art. Pierre Bonnard and Édouard Vuillard, who initially shared a studio in Paris, were the most important

Nabis. Both artists focused on painting quiet, introspective scenes of domestic life, termed *Intimiste*.

Known as the Japanese Nabi, Pierre Bonnard (1867–1947) had an instinctive feel for design which expressed itself through his love of Japanese woodcuts. Bonnard simplified the shapes and patterns of his compositions and made use of light, not as the Impressionists had done, but as an intrinsic part of his rhythmic, colourful compositions.

He painted intimate interiors which emphasized everyday objects, and the members of families gathering round the

table or going about their daily routines. Bonnard's models reveal little of their personality. From 1926, he worked in Le Cannet where he often used his wife Marthe as his model, as well as painting flowers, interior views and landscapes. He was a great colourist whose conventional works radiate a sense of wellbeing along with their prismatic light effects.

Édouard Vuillard (1868–1940) spent practically all his life in Paris. When his father died, his mother turned to dressmaking to support her family and Vuillard was surrounded by fabric and lengths of cloth. This early exposure to patterned cloth is reflected in the wallpapered intimate interiors of his paintings in which people, mainly women, are shown carrying out everyday tasks. The muted, delicate colours, small brushstrokes and broken surface contribute to a rich textural sense.

Like fellow Nabi, Bonnard, Vuillard's early work was hugely influenced by Japanese drawings. Vuillard constantly sketched people in public places.

His modest paintings reflect a love of the ordinary, but there is also an intriguing ambiguity of form that creates a subtle tension. His later works were larger and more naturalistic due to reliance on photographs

▲ THE DRESS WITH FOLIAGE *(detail)*, *1891* ÉDOUARD VUILLARD
Vuillard's early exposure to rolls of decorative fabric – his mother was a dressmaker – is revealed through the squiggly-patterned dress of the standing figure. This crowded, intimate scene, with the women bent over their sewing, also reflects his love of the simple shapes that he found in Japanese prints.

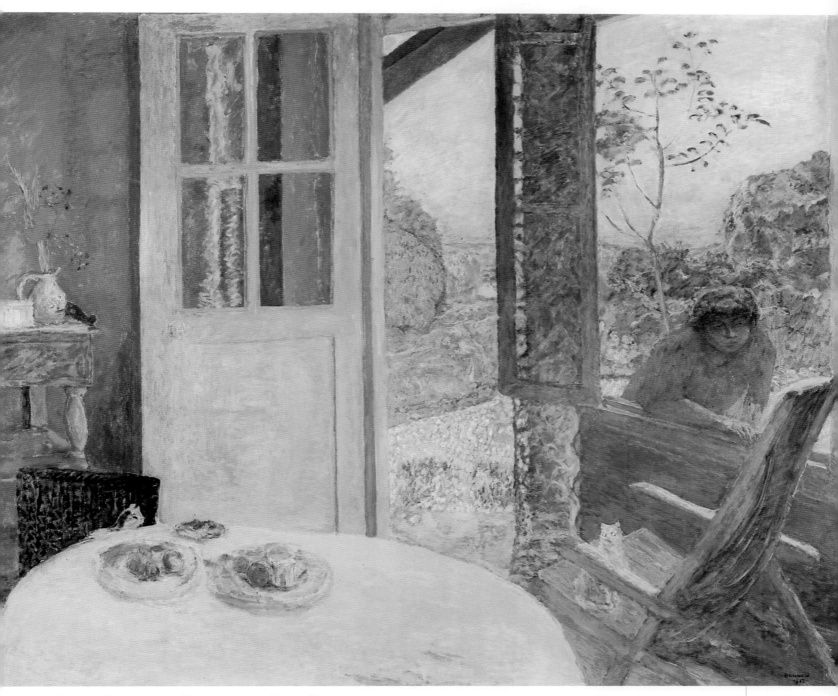

▲ DINING ROOM IN THE COUNTRY, *1913* PIERRE BONNARD

When Bonnard moved from Paris to the South of France, his use of colour brightened in response to the Mediterranean sunlight. The contrast between the dominant elements of the composition – the strong vertical lines and the circular table – and the little details of the interior, such as the cats on the chairs, enhances the feeling of tranquil domestic intimacy.

BREAKING THE BOUNDARIES
c1900–1950

The first half of the 20th century saw people's lives change in extraordinary ways that we can hardly imagine. Those who might have been relying on the hansom cab to go about their daily business now had the automobile. Telephones and other technological developments eased the process of communication. Scientific and medical advances improved the lives of many, and even saved the lives of those who might have succumbed to a previously incurable illness or disease.

However, two world wars took their toll on the population, with many artists getting caught up in the struggles, or having to flee their country in order to survive; the mounting pressures of living at a time of upheaval undeniably took their toll. As the century progressed, the pace stepped up and the old certainties disappeared, never to be replaced. Artists, like everyone else, had to come to terms with this transformation by trying to make some sense of the flux.

This notion of the 20th century as a time of momentous change is mirrored by the fact that there were many emerging art movements and styles. These were often short-lived; at the start of the century no sooner had a new style made its mark, than it disappeared or reformed round a different grouping of artists.

Modernism is the broad and lasting term that overarches the art made at the beginning of the 20th century. A description that is applied across all the arts – namely fine art, applied art, architecture, literature and music before 1914 – modernism rejected the stuffy, traditional art of the previous century and wholeheartedly welcomed everything that was fresh and progressive in the modern era.

During the 20th century, photography became accepted as a fine art medium in its own right. This new method of recording the world had clear implications for the practice of painting, bringing its very purpose into question. Suddenly, what was in front of you could be rendered far more quickly and easily with a camera than with a paintbrush. Artists were forced to engage with this idea and redirect their work methods.

Cézanne is regarded as the linchpin of modern painting and crucial to the artistic developments of the

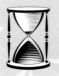

1900
Freud's Interpretation of Dreams *published*

1901
Queen Victoria died and the first wireless communication between Britain and the USA took place

1903
The first powered, heavier-than-air flight made by the Wright brothers

1908
Ford introduced the Model T, the prototype 'motorcar for the multitudes'

1914
The assassination of Archduke Franz Ferdinand sparked events leading to the First World War

20th century. Cézanne didn't paint a realistic likeness of the arranged apples and the landscapes in his compositions; instead he examined them intently to see how they fitted together formally, in terms of structure, tone and colour, applying the principles that he had gleaned from his research.

The result was paintings that commented on the physical world, but above all possessed their own sense of space. After Cézanne, paintings, whether figurative or abstract, convey more of an alternative pictorial reality. For the first time, painting was articulating its own language. This meant that Matisse, the Fauves, the Expressionists and all the artists that were to follow in the 20th century had to determine exactly how this language should best be constructed.

This opened up the whole question of what was fit and proper to paint. As painters began to look wherever they chose for inspiration, what made 20th century art so exciting and radical was that no one, single trend or course was followed. Rather, the 20th century is a story of disparate movements and artists who, collectively and individually, approached their subject matter in a new spirit of freedom and autonomy; exploration and innovation are the key words here. Some painters focused on their own private struggle, picking up where Van Gogh had left off and looking deep within themselves to explore their innermost feelings. German Expressionists like Emil Nolde and Max Beckmann are examples of this tendency (as are later American Abstract Expressionists like Jackson Pollock and Willem de Kooning).

Others, such as Kasimir Malevich and Piet Mondrian, adopted a more intellectual approach, referring to the political or psychological theories of the day, or, like Wassily Kandinsky, used other art forms such as writing or music as a starting point. The revolutionary approach developed by Picasso's Cubist experiments, the absorption of Freud's theories of the unconscious into the surreal world of Salvador Dali, or the fascinating and insightful self-portraits of Frida Kahlo can not be fitted neatly into any category. This is the point. In the 20th century, painting is less easy to pigeon-hole; it is characterized by being highly subjective and broadly diverse.

1922	1926	1928	1939	1946	1947
Two masterpieces were published: James Joyce's Ulysses and TS Eliot's The Wasteland	John Logie Baird transmitted moving images of the human face for the first time	Women in the UK got equal voting rights. Penicillin was discovered	Germany invaded Poland, making the Second World War inevitable	Churchill made his famous 'Iron Curtain' speech. The UN opened for business in New York	The Marshall Plan brought aid to bankrupt Europe. Mao Zedong declared China a republic

PAVING THE WAY

L IKE TITIAN AND MANET before him, Paul Cézanne (1839–1906) is a hugely significant artist whose life straddled two major periods of change. Cézanne's paintings reflect the division; he is the last and most significant of the Post-Impressionists of the 19th century. Even though he died only six years into the 20th century, his work has had an enormous and lasting impact on the modern era. Cézanne's groundbreaking experiments with form and structure have led him to be considered as important an artist as Leonardo and Rembrandt.

Cézanne came from a relatively wealthy background and an allowance from his father meant that he could travel from his birthplace in Aix-en-Provence to Paris. Here, he became friends with Camille Pissarro and got involved in the anti-establishment moves against the Academy. He was involved in the first Impressionist exhibition of 1874. Throughout his life, however, Cézanne continued to submit work to the official Paris Salon. Although he met Manet and Degas through his friend Pissarro, Cézanne was never part of any group or movement. He preferred to pursue his own experimental approach to composition and form through research into other artists, as well as by experimentation in the studio.

Much of Cézanne's early work is quite dark and heavily worked, often with the help of a palette knife; a new freedom and lightness appears in his work after contact with the Impressionists in the 1870s. After the death of his father in 1886, Cézanne moved back to Aix. Here he began an intense period of work in the studio during which he was preoccupied with the question of solidity and form. Whether he was painting apples and oranges on a table cloth, the Provençal hills or working from a nude model, he sought to convey a sense of the underlying structure of what lay before him. He made repeated studies of tone, looking carefully at the way this affected form, which meant that many of his paintings offered a fundamental re-evaluation of the picture plane. In demonstrating how it was possible to recreate the dimensions of space within the frame, Cézanne prefigured Cubism and paved the way for painting in the 20th century.

▲ STILL LIFE WITH APPLES, *1893-94* PAUL CÉZANNE

In his search to express three-dimensional form more effectively on the two-dimensional plane of his canvas, Cézanne often appears to shift his viewpoint. You can see this if you compare the shape of the ellipses at the top of the two vases in this still life – the ellipse of the vase on the right appears to be tilted towards us.

▲ CHESTNUT ALLEY, JAS DE BOUFFAN, *1871* PAUL CÉZANNE

*In 1859, Cézanne's father bought an estate on the outskirts of Aix-en-Provence. The large
house and grounds, with chestnut trees and views of Mont Sainte-Victoire, inspired Cézanne.
He painted this particular avenue several times, using a palette knife to model the vegetation.*

RIOTOUS COLOUR

ALTHOUGH SHORT-LIVED, Fauvism was one of the first major new movements in western art in the 20th century and arose out of the friendships formed in Paris between the artists André Derain (1880–1954), Maurice de Vlaminck (1876–1958), Raoul Dufy (1877–1953), Georges Rouault (1871–1958) and Henri Matisse (1869–1954).

The Fauves first exhibited together at the Salon d'Automne in 1905, and their name came from the critic Vauxcelles who, in reference to a Donatello statue exhibited in the same room, exclaimed: *'Donatello au milieu des fauves!'* ('Donatello among the wild beasts!')

Fauvism refers to paintings that are intensely bright and which make use of an artificial colour scheme in which many of the colours clash violently – pinks on reds, or oranges on reds, for example. This was revolutionary in that it broke with the tradition of trying to match colours to those that existed in the natural world. Here, vivid colour was used more for dramatic and decorative effect.

André Derain was perhaps the most typical and certainly one of the most important of the Fauves. In his Fauvist phase, Derain painted landscapes that were notable for their scorching colour as well as for the broken, mosaic-style

brushwork. From about 1919 onwards, Derain's style became more markedly eclectic. Maurice de Vlaminck initially also made use of wild colour contrasts, inspired in part by the Van Gogh exhibition in Paris in 1901.

Like Derain, he painted mainly primitive landscapes and in later years reverted to a more sober style. A graphic artist and textile designer, Raoul Dufy was inspired to join the Fauves because of his association with Matisse.

Dufy's trademark style of drawing – rapid calligraphic marks over bright colour washes – developed after his period with the Fauves. Georges Rouault, although a close associate of the Fauves, was the odd one out. Rouault's vision was altogether darker; he painted a series of figures on the outside of society such as clowns and prostitutes, expressing his hatred of all things inhumane and corrupt.

▲ LONDON BRIDGE, *1906* ANDRÉ DERAIN
Derain came to London in 1906 to produce a series of works to rival Claude Monet's London views, exhibited to great acclaim in 1904. Derain made paintings of bridges and barges along the river Thames in which the scenes are transformed by the vivid, intense colour.

▶ OPEN WINDOW, NICE, *1928*
RAOUL DUFY
Dufy uses bold colour and pattern to depict this interior of a hotel room overlooking the French Riviera. The open window reveals an inviting and vibrant view that is full of light. This joyful scene has flat areas of colour in contrast to the ornate patterns and swirling, expressive calligraphic lines.

COLOUR, LINE AND PATTERN

ONE OF THE GREATEST ARTISTS of the 20th century, Henri Matisse (1869–1954) used pictorial space primarily to convey the emotive power of pure colour.

He was not interested in convincing the viewer of the reality of the space within the frame, rather his paintings are meaningful because of the brilliance of his colour, line and overall sense of design. Matisse gave up his original training as a lawyer to be a painter and studied under Gustave Moreau, the leader of the Symbolist movement. In 1904, Matisse joined forces with the Fauves.

Other influences played a part in

Matisse's subsequent development including a visit to North Africa in 1906 and an Islamic exhibition in Munich in 1910. Here, he was greatly impressed by the richness of the oriental textiles and patterns, the influence of which can be seen particularly in his *Odalisque* series of 1920–25.

The great ballet impresario, Diaghilev, and his Russian troupe were in Paris in 1909 and this was another source of inspiration, leading to two great works featuring a circle of dancing figures known as *The Dance* and *Music*. Matisse was drawn, in particular, to studies of the figure, commenting: '[it is] through the human figure that I best succeed in

expressing the almost religious feeling I have towards life'.

From 1917 Matisse lived mainly in Nice on the Côte d'Azur, producing paintings that celebrated the strong sunlight and the textures and patterns he found in interior studies as well as in the views around him. When cancer confined him to a wheelchair, Matisse evolved a new working method, cutting out simple shapes in brightly coloured paper and arranging them into large abstract collages. Towards the end of his life, Matisse worked on the Chapel of the Rosary at Vence, creating murals, stained-glass windows and even a new design for the priests' robes.

▶ THE DANCE, *1909* HENRI MATISSE
Matisse was commissioned by a Russian merchant in 1909 to produce The Dance *and* Music, *two large decorative panels for a palace in Moscow. Dance was popular at the time because Diaghilev and his* Ballets Russes *had just visited Paris. Speaking of* The Dance, *Matisse once said that it evoked 'life and rhythm'.*

DEEP EMOTIONS

WHILE GEORGES ROUAULT, the unlikely member of the Fauves, was painting his dark, tortured visions of vice and cruelty in Paris, artists in Germany were starting to develop a new style of painting which was to be a vehicle for equally strong emotions. Just as the Fauves had run riot with their palette in Paris, the German artists involved with the new movement made use of bright colour. Here, however, the mood was more menacing, sombre and bleak.

In Dresden in 1905, Ernst Ludwig Kirchner (1880–1938), Erich Heckel (1883–1970), Karl Schmidt-Rottluff (1884–1976) and Emil Nolde (1867–1956) formed *Die Brücke*, meaning 'the bridge', a name chosen because the artists in the group wanted to be seen as projecting forward into the future. *Die Brücke* was the first of two major Expressionist movements in Germany. The group had no clear manifesto, although most of its members expressed an interest in primitive art,

something that was reflected in the naïve style in which they approached their figures, landscapes and scenes derived from modern urban living. They showed an array of influences, including the Fauves, the Nabis, Van Gogh, Gauguin, African art and Munch.

Once the group had dissolved in 1913, Nolde continued to be inspired by his travels, painting simplified but intensely emotional and energetic landscapes in rich, vivid colour. A deeply religious artist, he was also very solitary and evolved his particular brand of emotional expressionism at a distance from the group. Kirchner went on to create a series of Berlin street scenes which gave powerful expression to the alienation and frenzy of modern city life.

Not aligned with the group but precursive of *Die Brücke's* ideas, the work of Paula Modersohn-Becker (1876–1907) – in particular the insightful portraits focusing on the worn faces of peasants – reveals her to be one of the most important harbingers of the German Expressionist movement.

▲ TROPICAL HEAT, *1915* EMIL NOLDE

Nolde travelled the South Seas between 1913 and 1914 – from China, Japan and South-east Asia to the west coast of Africa. These tropical journeys provided great inspiration and he went on to produce many intensely coloured, expressive works that leaned towards primitivism.

▶ OLD PEASANT WOMAN, *c1905–1907*
PAULA MODERSOHN-BECKER

Modersohn-Becker spent time in the artist's colony of Worpswede where she made poetic work inspired by nature. From 1905, after seeing paintings by Cézanne and Gauguin, her work took a new direction. From this point, she uses stronger colour and there is a new simplicity and decisiveness.

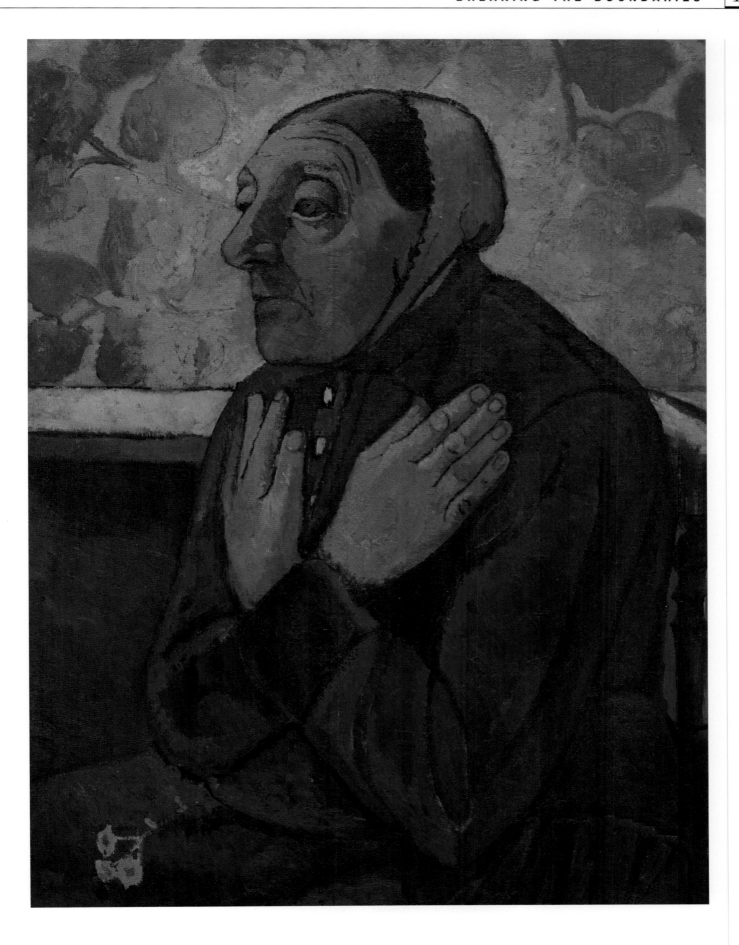

PLAYING THE HARLEQUIN

WITH A VAST AND DIVERSE body of work and a life that spanned over ninety years, Pablo Picasso (1881–1973) dominated the 20th century like no other artist. Picasso was an endlessly imaginative artist and constantly reinvented his art, employing a variety of different media – paintings, drawings, collages, etchings, sculptures and ceramics – to make his mark. Picasso himself said that he used these different means of expression not for their own sake, but because the subjects that he wanted to express demanded it of him.

Born in Malaga in southern Spain,

Picasso was the son of an art professor. From 1901 to 1906, Picasso travelled between Barcelona and Paris, working on a series of melancholy portraits depicting the misery and poverty experienced by those who lived on the streets. This became known as his Blue Period and was swiftly followed by the Rose Period, which featured paintings of circus performers which were less severe and warmer in tone. His seminal painting, *Les Demoiselles d'Avignon,* begun in 1906, was a turning point. It marked the beginning of Cubism and was an attempt to break down the picture plane into a series of geometric shapes. Picasso

became a close friend of Georges Braque and together they developed works which allowed the viewer to experience several different views of an object at the same time. In a further development known as Synthetic Cubism, the pair collaged bus tickets, torn-up newspapers and stencilled letters into their paintings.

From 1914 onwards, Picasso ceaselessly pushed his work in all sorts of new directions. He looked to classical mythology, bullfights and war for inspiration and was fascinated by politics; his infamous *Guernica* painting of 1937 eloquently expresses his repugnance at the futility of war. He also made several paintings that referred to other artists' work, most notably a series based on *Las Meninas* by his fellow Spaniard, Velásquez. He was nothing if not prolific.

Other paintings simply sprang from imaginative journeys that Picasso allowed himself to undertake, deploying a range of unconscious and conscious imagery and showing the artist as a kind of shaman figure, capable of all kinds of sorcery and trickery.

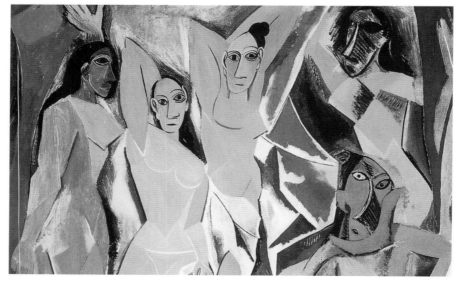

▲ LES DEMOISELLES D'AVIGNON *(detail),* **1907** PABLO PICASSO

In painting Les Demoiselles, *Picasso not only broke many of the centuries-old conventions belonging to western art, but he also introduced influences from other cultures – for example, the heads of the two women on the right and the woman on the extreme left are derived from African masks.*

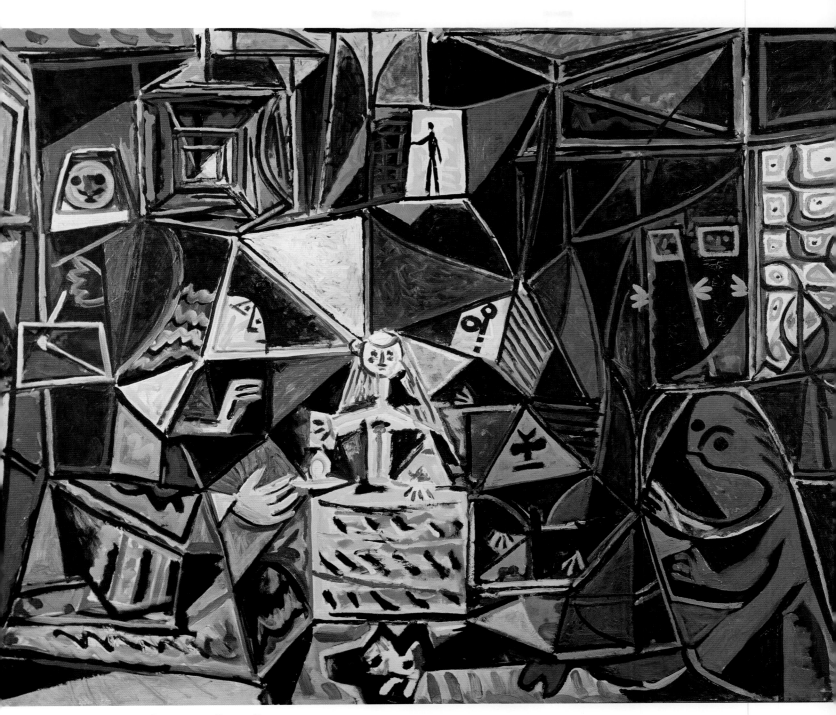

▲ LAS MENINAS, NO 31, *1957* PABLO PICASSO

Intended by Picasso to be a homage to Velázquez, Picasso spent five months in 1957 working
on his own interpretations of the great Spanish masterpiece. Toying with themes of reflection
and trompe l'oeil, Picasso kept experimenting with different versions of the grand interior
court scene, which resulted in 58 new oil paintings.

IN THREE DIMENSIONS

CUBISM DATES FROM 1907 and specifically from *Les Demoiselles d'Avignon,* Picasso's complete reappraisal of form. The right-hand side of the painting, with its flattened shapes and simplified mask-like heads that Picasso had discovered in African art, shows a radical new approach to pictorial space and marks the beginning of an attempt to represent the multi-dimensional nature of solid things.

Picasso and Georges Braque (1882–1963) began to work together after discovering they enjoyed a mutual interest in African sculpture and the later work of Cézanne.

Both artists were interested in discovering a method of representation that went beyond the conventional ways of conveying space; they aimed to transcend the rules of perspective and modelling using light and dark. They wanted to pursue their own idea of realism and present objects seen from all angles, a truer reflection of how the human eye perceives reality.

The first phase of this new movement was known as Analytical Cubism. These paintings are generally more monochromatic and starker than the paintings of Synthetic Cubism.

As Cubism moved into this phase, other artists such as Juan Gris (1887–1927) and Fernand Léger (1881–1955) also became part of the movement. Although Picasso and Braque's initial partnership was broken up by the First World War, Georges Braque continued to make Cubist-inspired works, while allowing for a range of painterly marks and earthy colour to come to the fore. Spanish artist Juan Gris developed a sober, intellectual approach to his paintings of everyday items in which he often collaged materials that stood as a reminder of their original function.

Architectural student Léger became part of the Cubist circle in Paris in 1910. Typically, his early paintings were inspired by machinery and construction and showed a preoccupation with volume and solidity that led to the nickname 'tubist'. Amedeo Modigliani (1884–1920), an Italian painter and sculptor, moved to Paris in 1906. Although he did not become part of the Cubist group, the flattened and simplified forms in his work show the influence of both Cubism and African sculpture.

▶ LANDSCAPE, *1908* GEORGES BRAQUE

Belonging to the analytical period of Cubism, this work does not refer directly to the landscape that inspired it, but rather offers an interpretation in which space is explored from all angles. Typically, Braque uses a narrow range of muted and earthy tones here.

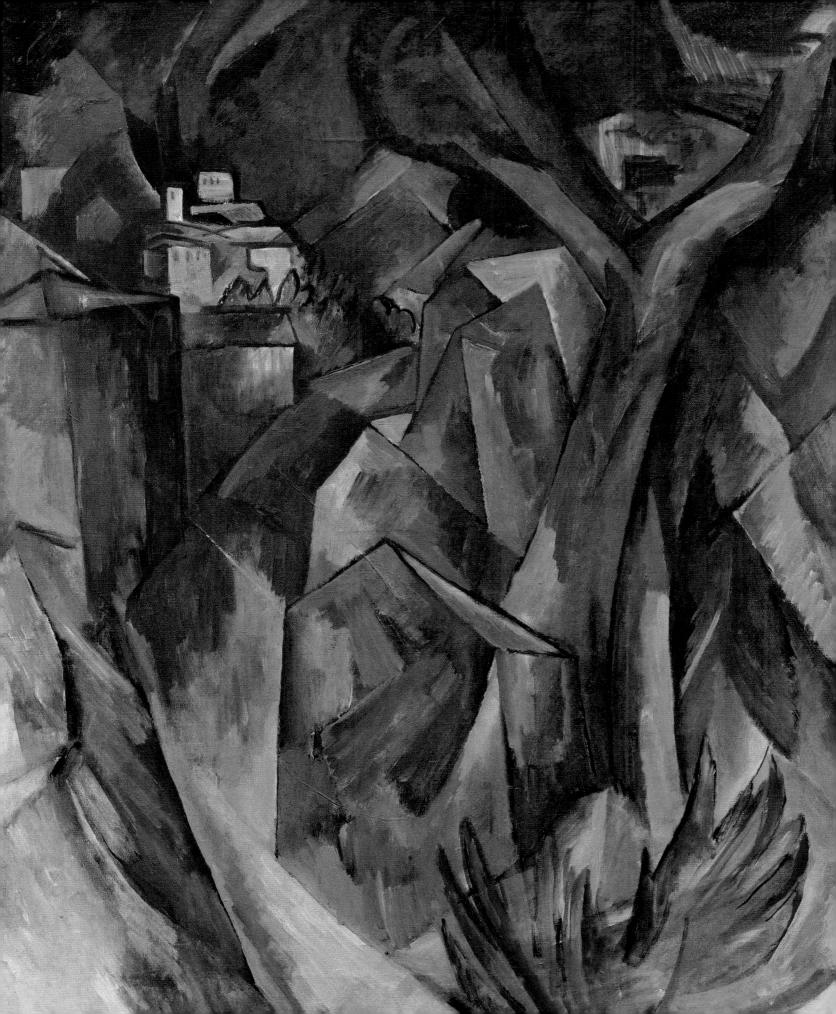

FROM ORPHISM TO LYRICISM

ORPHISM, A VARIETY of Cubism, evolved around 1910 amongst the second wave of Cubist artists. Robert Delaunay (1885–1941) was the central figure of the group who wanted to make Cubism a more poetic experience; it was felt that the introduction of pure prismatic colour into the fractured structure of the picture plane was the best way to achieve this.

The name Orphism came from Orpheus, the singer and poet of Greek mythology, a figure who, these artists believed, represented the supremacy of the unconscious spirit over rationalism.

Robert Delaunay started his investigations into colour in 1908. He began by making paintings that featured churches and buildings in Paris, revealing the dynamism and poetry that he saw in the architecture. Declaring that 'colour is form and subject', his paintings uncovered a new, lyrical side to Cubism, creating movement and depth through contrasting blocks of colour and fragmented form.

Delaunay's work became increasingly abstract, relying on a purely prismatic surface to convey the poetical experience of reality that he referred to as the 'heartbeat of man himself'. Delaunay's wife, Ukraine-born Sonia Terk Delaunay (1885–1979), was a notable artist also associated with the development of Orphism.

Orphism had a luminosity and ethereal quality which in turn was well suited to the work of Marc Chagall (1887–1985). Chagall was born into a poor Jewish family in Belarus, studied in St Petersburg and then went to Paris in 1910 where he came into contact with the Cubists. Although early works show a marked Cubist influence, he was principally interested in finding a way of conveying memories of his early life in Russia and its rich folk-art tradition.

Chagall combined an unreal colour sense with dream-like images drawn with a child-like simplicity. In his lyrical scenes, figures and images freely float across the picture plane, with a dislocated sense of size and scale.

Like Chagall, Chaïm Soutine (1893–1943) was a Russian Jewish émigré. He settled in Paris in 1913 where his wild visions of landscape and of dead animals, in which the paint was thickly applied, were out of step with most of the developments in Paris at that time, having more in common with the Expressionist movement in Germany.

▶ THE POET RECLINING, *1915* MARC CHAGALL

In this tranquil rural scene, Chagall is believed to be remembering the place in the Russian countryside where he and his first wife, Bella, spent their honeymoon. It is an intensely lyrical work in which the rose-coloured sky captures the nostalgic mood of the artist's reverie.

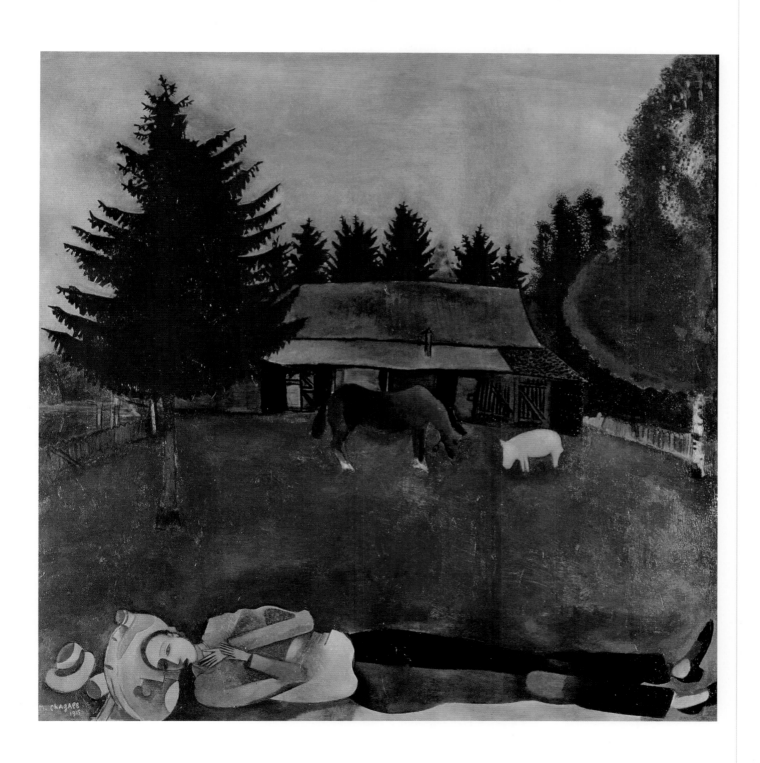

A New Dynamic

The Futurist Manifesto was signed in 1910 and Italian artists, Umberto Boccioni (1882–1916), Carlo Carrà (1881–1966), Giacomo Balla (1871–1958) and Gino Severini (1883–1966) were among the signatories. The movement originated as a result of the growing technological and scientific advances of the 20th century, in particular because of the importance of speed and movement to modern life. In much the same way that the Cubists had concluded that the conventional way of representing space with perspective no longer adequately represented their vision, the Futurists wanted to find a different pictorial reality to convey the sensation of movement.

Early Futurist work relied upon the divisionist theories of unmixed colour that the Impressionists had chosen to employ when depicting thronging crowds on the Parisian boulevards. Balla had visited Paris in 1910 and he passed his knowledge of divisionist colour theory on to Boccioni and Severini.

In his earliest Futurist works, Boccioni painted a crowd of tiny figures as little more than dots hurtling forward in diagonal streams. Later paintings made use of the discoveries of Cubism, such as the dissection of the picture plane into many fragments and the simultaneous viewpoint, to communicate the feeling of movement.

In several of his paintings, Giacomo Balla attempted to show motion by superimposing several images on top of each other. Balla was not as interested in conveying speed as some of the other Futurists and the result was paintings with a charm of their own.

His later works became increasingly abstract. Carlo Carrà started out as a Futurist, making work that fused dynamism with a Cubist fragmentation of form, but from about 1918, he became increasingly influenced by the enigmatic, metaphysical paintings of Giorgio de Chirico.

Severini made several paintings in the Futurist idiom, in particular conveying the dance rhythms of the music hall, but he too moved away after a short while.

Futurism as a movement came to an end in 1914, although its influence was far-reaching. It had an impact on Cubism and on the artists of the *Blaue Reiter*. It also paved the way for the socially critical work in Germany of George Grosz and Otto Dix in the 1930s.

▶ Dynamism of a Dog on a Leash, *1912* Giacomo Balla
In his desire to find a way of depicting light, movement and speed, Balla superimposed images on top of each other. In this unusual composition, the dog's dark body runs parallel with the hem of his mistress's black skirt, with the lead also shown in a repeated sequence.

MYSTICAL EXPRESSIONISM

Der Blaue Reiter ('The Blue Rider') was formed in 1911, preceding the dissolution of *Die Brücke* in 1913. This second wave of Expressionism was led by the artists Wassily Kandinsky (1866–1944), Franz Marc (1880–1916) and Auguste Macke (1887–1914). Paul Klee (1879–1940) was another prominent member and the painters Gabriele Münter (1877–1962) and Alexei von Jawlensky (1864–1941) were also closely involved. The ideas that gave rise to the *Blaue Reiter* were chiefly romantic, resting on a vision of man as part of a whole. To varying degrees the artists involved gave this spiritual belief expression, while exploring the symbolic qualities of colour and form.

After visiting Delaunay in Paris in 1912 with Macke, Marc became preoccupied with colour. He mainly painted animals, placing these in an all-encompassing natural environment using flat planes of colour, to show how all living things are in harmony. Macke was a German painter who studied at the Düsseldorf Academy. He visited Tunisia in 1914 where he made many bright watercolours, going on to adopt the prismatic colour method favoured by the Orphists. Macke and Marc were killed in action during the First World War.

Swiss-born Paul Klee settled in Munich in 1906 where he made contact with the other *Blaue Reiter* artists. He, too, absorbed a number of different influences to produce a series of translucent watercolours. Klee developed his own personal meditative brand of mystical expressionism. He moved freely between figuration and abstraction, his often witty paintings drawing upon his love of primitive and folk art.

Before founding the *Blaue Reiter*, Russian-born Wassily Kandinsky strove for a harmony between colour and music, or 'the purposeful stirring of the soul' as he put it. Improvisation was a key note in his compositions, which blended fluid shapes and calligraphic lines. Kandinsky is generally considered to be the pioneer of abstract painting.

▲ WALLFLOWER, *1922* PAUL KLEE

Paul Klee often combined different media – oil paint, watercolour, ink, etc – in one work. Wallflower *typically has a delicate, child-like quality and contains spidery, hieroglyph-like symbols which Klee used to refer to the unconscious world inspired by poetry, music and dreams.*

▶ ACCENT IN PINK, *1926*
WASSILY KANDINSKY

In this colourful, later work, Kandinsky creates a dynamic surface in which the geometric forms move in and out of our field of vision. Circles played a dominant role in many later works.

TOWARDS ABSTRACTION

THE IMPORTANCE OF PIET MONDRIAN (1872–1944) lies in his development of 'pure' abstraction. His evolution from landscape painting to abstraction was a complex process and encompassed an early struggle with the mystical principles of theosophy, which claimed an intuitive understanding of divine nature. Born in Holland, Mondrian studied at the Amsterdam Academy and his Dutch background meant that landscape was all-important.

Initially, he focused on painting moody, tonal landscapes and buildings reflected in water; he became particularly interested in trees and how their branches and foliage interlace. Some landscapes from the period 1907 to 1910, with their brilliant colour, showed the influence of the Fauves and Van

Gogh. Other early landscapes revealed the flat sea under a weighty horizon, with vast expanses of open plain that progressively became more abstract.

After Mondrian got involved with the Cubists in Paris, his work began to change. He returned to Holland in 1914 and founded the *De Stijl* periodical, setting out some of his new thinking which he named Neo-Plasticism and which referred to a systematic, abstract style of painting based on restricted colours and rectangular forms.

In 1919, Mondrian started to work on his first Neo-Plastic composition, experimenting first with coloured pieces of paper on his studio wall and declaring that he wished to eliminate the object from the painting.

Many of his compositions explore his abstract principles – limited to primary

colours and black, white and grey, the works present a series of weights and counterbalances that are neither rigid nor symmetrical, but which hold the overall composition together. Mondrian was fascinated by the dynamic relationship that existed within his paintings, commenting on how 'a balanced relation can exist with discords'.

By the 1930s, colour had just about vanished from Mondrian's work to be replaced by white planes and black bands of differing widths. In 1938 he travelled to the UK and New York, continuing to make abstract, autonomous works of great rhythm and movement. He spent the last few years of his life in New York producing a series of austere and pure paintings in which he continue to strive to achieve 'the equilibrium of the universal and the particular'.

▶ COMPOSITION WITH RED, BLUE, BLACK, YELLOW AND GREY, *1921* PIET MONDRIAN OIL ON CANVAS, 39.5 X 35CM

Mondrian first began working on these abstract, grid-style compositions in 1920. Thick black lines separate the rectangular forms, in which colour is used sparingly, with many left white. In the 1921 paintings, many of the black lines stop short at an arbitrary distance from the edge of the canvas.

PURE GEOMETRY

AT MUCH THE SAME TIME that Mondrian was developing Neo-Plasticism, a new movement known as Suprematism was starting to develop in Russia. Kasimir Malevich (1878–1935), a Ukrainian painter born in Kiev who trained in Moscow, was initially influenced by Post-Impressionist artists such as Cézanne and Van Gogh, as well as Matisse and Picasso. Malevich took part in the first Knave of Diamonds exhibition. This was organised by Larionov, a Russian painter who, in protest against the Moscow Art School, was drawn to the art that was popular in Paris and staged an exhibition of like-minded painters.

After seeing the work of Cubist painters in Paris in 1912, Malevich became convinced, like Mondrian, of the need to free painting from being representational. He developed his theories, abstracting them into a purer form of Cubism known as Suprematism. Malevich worked on designs for the scenery of a St Petersburg theatrical production which included a backdrop comprised of a stark black-and-white square. This led, in 1915, to an exhibition of 36 abstract works which included a painting of a black square on a white ground. Although he moved on from this stark approach and introduced more colour and depth into his cool, geometric work, the logic of this strict rationality led, in 1918, to the ultra-minimalist painting of a white square on a white ground. At this point, Malevich practically gave up painting but continued to lecture and to write.

Russian painter Liubov Popova (1889–1924) was one of Malevich's followers and a fellow contributor to the Knave of Diamonds exhibitions. After 1916, she produced several abstract compositions that showed the influence of both Malevich and Vladimir Tatlin. Tatlin was inspired primarily by Picasso to make three-dimensional reliefs in a variety of materials – wood, plaster and tin, for example – developing a new strain of geometric art around 1913 known as Constructivism. Painter and graphic artist El Lissitzky (1890–1941) met Malevich in 1919. He went on to produce architecturally inspired abstract paintings which fuse elements from both Suprematism and Constructivism.

▲ PAINTERLY ARCHITECTONIC, *c1916–17* LIUBOV POPOVA

Popova made a series of Constructivist compositions which she entitled Painterly Architectonics. *In these, she is concerned with the overlapping arrangement of planes on the surface. At first, these were quite static, but as they developed they became increasingly dynamic, with tilting and intersecting planes.*

▶ SUPREMATIST COMPOSITION, *1915* KASIMIR MALEVICH

Stating that he wished to free art from the 'tyranny of the object', Malevich developed a series of Suprematist works that relied on a severe arrangement of geometric shapes on a flat ground. He developed his own aesthetic theory of Suprematism which he communicated in the 1920s through writing and teaching.

ANOTHER REALITY

THE ADVENT OF CUBISM had a far-reaching effect on painting, subjecting the picture plane to intense analysis and leading it away from the casual representation of objects or things. Frenchman Henri Rousseau (1844–1910) was an amateur painter who quite happily remained outside the main artistic developments of his day, choosing to follow a highly personal approach to picture making.

Known as *Le Douanier* after working as a customs officer, Rousseau had also served in the army and only started to paint full time in the 1880s when he was in his forties. Despite his lack of training and his outsider position, Rousseau was extraordinarily confident in his own abilities and pursued his painting with single-minded dedication. From 1886, he exhibited most years at the Salon des Indépendants, as this meant that his work was not subject to any rigorous selection procedure.

Rousseau's paintings show a naïve simplicity of form, with clear outlines and bright, flat areas of colour. The scenes he chose to depict have a firm basis in reality, although he often imbued his subjects with a quality reminiscent of dreams, or some other, unconscious reality. To imagine they were produced in a childlike, spontaneous manner would be misleading, however. These were carefully planned paintings based on preparatory work that involved sketches, studies and even measuring the proportions of his sitters. Both Delaunay, and Picasso, whom he met around 1906, were fans – the latter throwing a banquet in his honour, which, while half in jest, was an indication of the esteem in which Rousseau was held by his more knowing contemporaries.

Rousseau is nowadays best known for his jungle paintings, works that arose out of visits to the Jardin des Plantes in Paris, where he made careful studies of the hot-house plants and greenery. Although he never travelled out of France, exotic plant life and animals inspired him to create.

In his best work, Rousseau managed to capture a mysterious, secretive atmosphere that continues to haunt the viewer long after the image has disappeared. It is this quality of 'magical realism', applied to Rousseau by Kandinsky, that helped him to transcend the label of 'primitive artist'.

▶ TIGER IN A TROPICAL STORM (SURPRISED!), *1891* HENRI ROUSSEAU
First exhibited at the Salon des Indépendants in Paris in 1891, Rousseau later explained that he saw the tiger as the hunter rather than the hunted, hence the 'Surprised!' in the title. Rousseau's detailed knowledge of exotic flora and fauna was probably inspired by his frequent trips to the botanical gardens in Paris.

METAPHYSICAL PAINTING

FOLLOWING THE First World War, artists in Italy displayed a new mood of introspection. They found their own way of expressing what they saw as the mysteries of existence, away from the influence of other persuasive European movements. *Pittura Metafisica* (Metaphysical Painting) was a movement that arose in Italy after Giorgio de Chirico (1888–1978) and his fellow Italian, Carlo Carrà (1881–1966), met while recovering in a military hospital in Ferrara, Italy in 1915. Carrà had been a signatory with Balla of the Futurist Manifesto of 1910 and his early work displayed the Futurists' preoccupation with movement.

De Chirico made Metaphysical paintings that combined everyday deserted street scenes with antique statues and relics, producing the disquieting sense of a dream; his work had great impact on the Surrealists. In taking Giotto, Masaccio and Piero della Francesca as influences, the Metaphysical painters acknowledged the importance of space and light and a desire to penetrate below the surface of things to what they perceived to be their essence.

From 1920, both Carrà and de Chirico moved towards a much quieter meditative style. Giorgio Morandi (1890–1964) led an even more insular life, never actually leaving Italy. Born in Bologna, he flirted briefly with the Futurists before showing the surreal influence of de Chirico in work that he exhibited in 1918. Morandi painted still life almost exclusively. His work was dedicated to a melancholy and elegiac contemplation of everyday things, such as simple arrangements of bowls, bottles and vases. Morandi used restrained colour and the formal, spatial relationships between objects to discover the poetry and grandeur in the everyday. His particular form of cool classicism finds echoes in Piero della Francesca, Chardin and Cézanne.

▲ STILL LIFE, *1950* GIORGIO MORANDI
Between 1950 and 1960, Morandi made a number of contemplative still lifes featuring everyday objects. In these sparse, orderly, obsessive arrangements, there's a poetic sensibility to be found in the distance between objects, the subtle lighting and the restrained colour.

▶ MELANCHOLY AND MYSTERY OF A STREET, *c 1914* GIORGIO DE CHIRICO
Moving to Paris in 1911, De Chirico began work on a series of deserted city spaces with ominous overtones where time is suspended. In this empty neighbourhood, the brooding, oppressive architecture and sinister shadows cast by unseen objects threaten to overpower the occasional isolated figure or statue.

DREAMS AND CHANCE EVENTS

SURREALISM WAS A MOVEMENT in art and literature which started in Paris in 1924 as a result of the manifesto written by André Breton (1896–1966). The manifesto talked about 'pure automatism', namely how suspension of the conscious mind could allow the free expression of uncensored thoughts. Although there was no dominant Surrealist style, this emphasis on allowing dreams and chance events free rein encouraged writers and artists to make work featuring the absurd, the irrational and the incongruous.

Salvador Dali (1904–1989) came to Paris from Spain in 1929, where he first made Surrealist films with Luis Buñuel. Dali described his paintings as 'hand-painted dream photographs' and, in early fantastic, hallucinatory works such as *The Persistence of Memory,* he employs a seamless technique to explore the deeper levels of his unconscious. A flamboyant self-publicist, Dali was eventually expelled from the Surrealists when his politics became too conservative.

After serving in the German army, Max Ernst (1891–1976) became the leader of the Dada circle of artists in Cologne, which included Hans Arp. Dadaism with its emphasis on irony and irrationality was a movement which anticipated Surrealism. Ernst used collage and photomontage in his work and was responsible for introducing these Dadaist techniques to Surrealism when he settled in Paris in 1924.

Spanish painter Joan Miró (1893–1983) settled in Paris in 1920, becoming closely associated with the Surrealists and contributing to their major exhibitions. Miró drew upon Breton's notions of automatic writing, inventing a vocabulary of signs and symbols to free the unconscious mind.

René Magritte (1898–1967), along with Dali, was a key member of the Surrealists. Magritte launched Surrealism in Belgium in 1925, before joining other Surrealists in Paris in 1927. Influenced by the work of de Chirico, Magritte quickly developed his own, illusionistic, literal style characterized by bizarre and unnerving juxtapositions which suggest that something startling or disturbing is happening.

▲ THE PERSISTENCE OF MEMORY, *1931* SALAVADOR DALI

This painting introduced Dali's concept of the soft, melting watch in which he explores man's ambiguous relationship with time. In this dream-like vision painted with disturbing clarity, hard objects melt and warp, and ants crawl all over a metal watch. The deformed face across the centre of the painting could be the artist's own in profile.

▶ TIME TRANSFIXED, *1938*
RENÉ MAGRITTE

By placing a familiar object in an unfamiliar setting and introducing a shift in scale, Magritte creates ambiguity and mystery. The tiny engine charges into the stillness of a spotless living room, its smoke echoing the smoke of the coal fire that would normally occupy the fireplace.

THE AFTERMATH OF WAR

BY THE END OF THE First World War in 1918, Germany was isolated and its cultural life had been turned upside down. As a result, the mystical brand of Expressionism that had been developed by the *Blaue Reiter* group around 1911 was replaced by something much harsher, as artists grappled with the horrific reality that many of them had witnessed first hand. After 1920, just as they had done in Italy, artists were looking for a new style to express the terror and pointlessness of war, and came up with a cold, factual, linear style that became known as *Neue Sachlichkeit* (or New Objectivity).

George Grosz (1893–1959), Otto Dix (1891–1969) and Max Beckmann (1884-1950) were the leading exponents of the new style. After being discharged as unfit for service from the German army, George Grosz made many pen and ink drawings satirizing the war effort. In 1917, he helped to found the Dada group in Berlin which produced montages and collages, as well as live performances, as a form of radical protest against the war and all it stood for. The Dada group then went on to become part of the New Objectivity movement, developing work that exposed political corruption and satirized the complacency of the ruling elite.

New Objectivity images were almost hyper-real in their exacting detail. It was a cool, precise style, based on the Old Masters, in which biting, brutal imagery was often subject to expressionistic distortion. Otto Dix, like Grosz, moved from making work that protested against the violence of war to producing paintings that exposed the vice and corruption in post-war Germany. Dix painted a series of incisive portraits of individuals, highlighting the decadence and degeneration that he saw in society.

Having worked as a medical orderly on the front line, Max Beckmann was similarly affected by the visceral horrors of war. He was concerned to develop a style based on objective truth, using scenes from everyday life to comment on the collapse of society and the alienation of man. His claustrophobic, hard-edged narrative paintings, in which there is almost no space or natural light, can be read as allegories, warning against vices such as lust, cruelty and avarice.

▲ UNEMPLOYED, *1934* GEORGE GROSZ

George Grosz was the scathing chronicler of Germany between the wars, producing a brutal rogues gallery of types – corrupt businessmen, prostitutes and their customers, politicians on the make – to outdo any other satirist. In 1932, he moved to the USA and Unemployed, *which is watercolour and ink on paper, shows a softening of attitude from a man bidding for acceptance.*

◀ THE TRAPEZE, *1923* MAX BECKMANN
*In the 1920s, Beckmann used circus and
carnival scenes to allude to the alienation
and disillusionment that the artist felt with
society following the end of the First World
War. In* The Trapeze, *circus players are
crammed together and each one bears a
blank expression, entirely devoid of feeling.*

THE VIEW FROM AMERICA

IN AMERICA, a distinctive new approach to realism started to emerge in the 1920s and 1930s, before the start of the Second World War. Grant Wood (1891–1942) and Andrew Wyeth (1917–) were part of the realist movement known as American Regionalism, in which artists focused on depicting scenes from the American Midwest and the Deep South. Grant Wood lived and worked in Iowa, although he travelled to Europe in the 1920s where he was greatly influenced by both early Netherlands naturalism and New Objectivity in Germany. Wood developed a style of painting that was meticulous and objective, while relying on satire. Andrew Wyeth painted the landscape and inhabitants of his hometown of Chadds Ford, Pennsylvania in a highly detailed, realistic but visionary style, using watercolour or tempera.

Edward Hopper (1882–1967) trained in New York and exhibited there in the Armory Show of 1913 where, for the first time, Americans were exposed to the breadth and range of modern art. Hopper gave up painting after this exhibition, taking it up again in 1923 to paint still, serious scenes often featuring solitary figures in a mood of deep contemplation, poised in an urban setting such as a bar at night, a hotel lobby or an office. Hopper uses harsh contrasts of light and shade, expressing loneliness and alienation in his familiar scenes of city life, although he has said that he does not intend his work to be social commentary, rather 'I'm trying to paint myself.'

Although Georgia O'Keeffe (1887–1986) was not strictly a realist, her paintings of enlarged, exotic flowers, bleached bones and desert landscapes have a clear-cut, almost clinical examination of form which, with their radiance and sensuality, are often described as 'magical realism'. Throughout her career, O'Keeffe moved in and out of abstraction, displaying an obsessive interest with the simplified, sculptural forms that she saw in nature and which she depicted with grace and strength imbued with a strong presence.

▲ MIDNIGHT RIDE OF PAUL REVERE, *1931* GRANT WOOD
In this brightly lit, crisply delineated dream-like image, a lone rider – Paul Revere, a hero of the American Revolution immortalized in Henry Longfellow's poem – circles a New England settlement. The unusual perspective gives the viewer a sense of looking down on a toy town.

▶ COMPARTMENT C, CAR 293, *1938*
EDWARD HOPPER
A lone woman flicks through a magazine in an empty train carriage, her hat pulled down over her eyes. Outside the window lies a dark landscape: she is going somewhere but we have no idea where. Hopper's still but awkward contemplative scene captures feelings of isolation, monotony and unease familiar to us all.

IMAGES OF SELF

FRIDA KAHLO (1907–1954) was a Mexican painter who the Surrealists tried to claim as one of their own – even though Kahlo insisted she was a realist painter, interested only in depicting her own life; this was troubled and eventful.

As a child she suffered from polio; at the age of 18, a trolley-car plunged into the bus in which she was a passenger, leaving her with the horrific injuries which shaped her strongly autobiographical paintings. An active Communist, Kahlo married Mexican muralist, Diego Rivera, in 1929, divorced him after ten years and was reunited with him a year later.

Painted in a primitive, realist style that draws upon Mexican folk art, 55 of her 143 surviving paintings are self-portraits and make literal and symbolic reference to her emotional and physical pain.

These haunting and complex images draw on her personal experiences, including her miscarriages and numerous operations; they are unstinting yet strangely detached in their bleak depiction of suffering.

The self-portrait, *Thinking of Death*, 1943, for example, shows her constant preoccupation with mortality. Kahlo used her broken body not only as a metaphor to examine the role of women within a patriarchal society, but also to pose questions about the nature of the power struggle between Mexico and Europe – she was the daughter of a German immigrant and a Mexican mother.

Self-portraiture allowed Kahlo to penetrate the outer shell of her physical being and examine the depths of her own psychology. Surprisingly, her expression gives little away – it is only the objects and symbols surrounding the artist that give meaning to the work. In many of these brightly coloured self-portraits, Kahlo wears traditional Mexican dress; the peasant skirts and braided hairstyles that she adopted were worn both to conceal her physical ailments and as a political statement in support of her Mexican heritage. She died in Mexico City at the age of 47.

▶ SELF-PORTRAIT WITH MONKEY, *1938* FRIDA KAHLO
The gardens at the Blue House in Coyoacán, where Frida was born and where she lived with Diego Rivera, were home to numerous exotic animals – monkeys, parrots and deer. She included the monkey in this self-portrait because of its playful, uninhibited nature. The calm serenity of this self-portrait is in stark contrast to the paintings in which she expressed her emotional and physical pain.

MAKING WAVES

JUST BEFORE THE OUTBREAK OF THE Second World War, a small Cornish town became a haven for a number of British artists. St Ives had attracted artists since the extension to west Cornwall of the Great Western Railway in 1877, but this new, loose grouping of artists came about after the painter Ben Nicholson (1894–1982) and his wife, sculptor Barbara Hepworth (1903–1975), moved there in 1939.

Nicholson had started painting experimental, Cubist-style pictures after seeing the work of Picasso. In St Ives he was influenced by a local fisherman, Alfred Wallis (1855–1942), whom he discovered painting naïve pictures of the sea and sailing ships on wood or scraps of cardboard.

Wallis had started to paint in 1925 after his wife died and his childlike,

direct style had a huge impact on other St Ives painters. Nicholson began to paint reliefs, building up shallow abstract shapes from the picture plane. Gradually figurative elements from the local environment, such as the shapes of roofs and the distant bay, emerged in his work.

The small Cornish town quickly became a lively artistic community, although it was not a fully fledged movement with any real sense of common purpose. Many of the artists worked with the landscape, some taking inspiration from the quality of the light as well as from the more abstract shapes suggested by the interlocking sea and land.

Younger artists began to gather in St Ives again after the war, including Terry Frost (1915–2003), who was a prisoner of war before going to Camberwell

School of Art in the late 1940s. His work features juxtapositions of bright and sometimes closely related colours, often drawing obliquely on visual elements in the surrounding countryside.

Roger Hilton (1911–1975) was also a prisoner of war until 1945. Initially, Hilton pursued a more sober, semi-abstract style in which, typically, a few sparse charcoal lines would score a thickly impastoed surface. His later work, when sadly he was bedridden, featured colourful, humorous, figurative gouaches.

From 1958, former textile designer and art critic Patrick Heron (1920–1999) worked regularly in Cornwall and was also part of the younger generation of St Ives artists. Influenced by Matisse, his work developed from an early, semi-abstract style through brilliant bands of strong, saturated colour, to later, large, loose compositions filled with a profusion of abstract linear patterns.

▲ 1945 (ST IVES) BEN NICHOLSON
During the 1930s, Nicholson produced abstract works that were characterized by the purity of their simple geometric shapes. After his move to St Ives in 1939, he began to combine abstract shapes with the visually recognizable elements of landscape and still life.

▶ SALTASH, C*1928–30* ALFRED WALLIS
Although Wallis has used linear perspective in the road leading to the river Tamar, he has abandoned it in his two-dimensional rendering of the houses, which seem to tumble down to the water's edge in such a way that their roofs and windows create a lively, almost abstract pattern.

PAINTING NOW
FROM 1960
ONWARDS

As we have seen, at the beginning of the 20th century, a proliferation of dynamic movements in art changed the face of painting forever. The emergence of abstract art signified the development of a new way of thinking which meant that painting was no longer seen purely as a literal, descriptive medium. Painting suddenly found itself in the realm of ideas. Whether or not it was based on figurative or non-figurative elements, painting from this point onwards could be about anything and everything as artists concerned themselves with every aspect of what it means to be alive today.

The period from 1960 to the present is one of the greatest periods for painting although it is also one of the most chaotic and confusing. This is partly because there has been such a great plurality of styles, as well as the fact that painters have increased access to a wealth of cultural material via the exponential growth in new technologies and digital media.

The impact of the Second World War on painting is not perhaps as obvious as the First World War was on artists of the time, many of whom experienced it first hand. However, there was a subtle, post-war shift of focus on to developments in the USA which ensured that the Abstract Expressionist movement emerged victorious; modernism became the dominant way of thinking about painting.

Minimalism in visual art first emerged in New York in the 1960s. Reacting against the crowded canvases of the Abstract Expressionists, the minimalists stated that they wished to get away from the art of self-expression and create a pared-down style that used negligible means and limited references to create an immediate impact. As minimalist painter, Ad Reinhardt, commented: 'The more stuff in it, the busier the work of art, the worse it is. More is less. Less is more.'

During the late 1950s in the UK and the early 1960s in the US, Pop Art provided the first real challenge to modernism with work that was deliberately provocative and challenging to everything that Abstract Expressionism stood for. Pop Art concerned itself with popular taste and kitsch – previously considered outside the limits of fine art – to break down the distinction between high and low culture. Borrowing from

1957
The European Economic Community was established

1959
Castro overthrew the Batista regime in Cuba. The first motorway was built in the UK

1961
The USSR succeeded in the first manned space flight. Back on earth, the Berlin wall was built

1963
John F Kennedy was assassinated in Dallas, Texas

1968
Martin Luther King was shot. The USSR invaded Czechoslovakia

advertising, photography and comic strips for their imagery, pop artists started to used flat, unmixed colour and hard edges in reference to the impersonal process of mass production.

Alongside the Pop Art movement, Op-artists in America and the UK experimented with optical effects to create paintings that dazzled and disoriented the viewer. Generally based on a geometric framework, these paintings were often highly calculated and drew on colour theory and the psychology of perception.

After the cool calculation of minimalism, painting was, inevitably perhaps, going to find its antithesis in a rough and raw style that expressed extremes of violent emotion. Neo-Expressionism developed in the late 1970s and flourished in the 1980s particularly in the USA, Germany and Italy, through artists such as Georg Baselitz, Anselm Kiefer, Julian Schnabel, Phillip Guston and Francesco Clemente.

Meanwhile, in Britain, two of the most important post-war painters, Lucian Freud and Francis Bacon, returned to the body to make expressive paintings that dealt with human existence, identity and sexuality.

Other British artists, including Paula Rego and Howard Hodgkin, took real and imagined stories as their starting points to make narrative paintings which, whether abstract or figurative, explored emotional experiences and specific memories.

As we move further forward into the 21st century, no one style of painting dominates; instead there is a vast array of styles which co-exist. Painting, although often pronounced dead, continues to move viewers as much as it ever did. The postmodernist era has given painters the freedom to determine their choice of subject matter and the manner in which they choose to paint it.

Postmodernism also means that artists borrow wholesale from previous styles, now that the idea of originality and authenticity is moribund; it is precisely such ambiguity and doubt that are recognized as being at the core of things. It seems almost churlish to highlight just a few of the artists currently working, but it is the case that the contemporary artists ending this chapter have created a distinct, new style of painting; its spirit of uncertainty and unease seems to mirror aspects of our insecure times.

1969	1977	1978	1989	2001	2003
Precursor of the internet in the USA, the ARPANet military information network went live	*Two years after Franco's death, the first democratic elections were held in Spain since 1936*	*Louise Brown, the world's first test-tube baby, was born in Oldham, England*	*The fall of the Berlin Wall marked the beginning of the end for the Soviet Empire*	*Terrorists crashed planes into the Twin Towers, plunging the world into a new era of insecurity*	*George Bush ordered the invasion of Iraq with the aim of toppling Saddam Hussein*

MAPPING SPACE

EVEN SINCE THE HUGE Armory Show of 1913 in New York and Chicago, America had become more interested, and involved, in the mainstream of cultural developments in Europe. However, it was not until after the Second World War that a new movement known as Abstract Expressionism began to take root, primarily in the cities of New York and San Francisco.

Abstract Expressionist painters wanted to explore and experiment formally with painting, believing that colour and form in themselves were subject matter enough. They wanted to make work that was full of feeling and expression, while emphasizing the spontaneity of the process by which the paintings were made.

Abstract Expressionists worked on huge canvases and treated the whole of their composition with equal importance. By the end of the 1940s, Jackson Pollock (1912–1956), the leader of the group, was using a method of dripping paint on to canvas laid on the floor, which highlighted the random nature of its creation. The action or the gesture was the important element of the painting for Pollock, whose forceful, expressive work and rebellious character helped to define the anarchic spirit of the movement. Riding roughshod over traditional ideas of composition, Pollock went for a scattergun effect, eschewing identifiable points of emphasis within each work and even trimming and reshaping his canvas to accommodate his freeform splatterings and brushwork.

Abstract Expressionism took many forms and Pollock's dripped paintings are very different from the figurative pictures of Willem de Kooning (1904–1997), who painted in a frenzied, gestural style, acknowledging that Pollock had 'opened the door'. Born in Holland, De Kooning emigrated to the United States in 1926. He became a friend of Arshile Gorky (1904–1948) who was part of the Surrealist circle in New York in the 1940s. Gorky developed another strain of Abstract Expressionism using biomorphic forms that shared a common aesthetic with the work of painter Joan Miró.

By the 1950s, a second wave of Abstract Expressionism was acknowledged, that of the so-called 'colour-fields' of Mark Rothko and Barnett Newman.

▶ WAVING TRACKS, *1947* JACKSON POLLOCK
Pollock's most famous paintings were made by dripping or pouring paint on to a canvas laid flat on the floor. Or as Pollock put it: 'My painting does not come from the easel… On the floor I am more at ease. I feel nearer, more part of the painting, since this way I can walk around it, work from the four sides and literally be in the painting.'

EXPANSES OF COLOUR

THE COLOUR FIELD grouping of painters was held together by the fact that their abstract works generally featured a large expanse of colour. Colour was used by these artists to communicate emotion, the idea being that a particular colour, or combination of colours, was enough to contain meaning without reference to an image or theme.

Robert Motherwell (1915–1991) took up painting in1941 and, initially, was part of a Surrealist circle in New York influenced by automatism, a theory that relied on a free association method that tapped into the workings of the unconscious.

Motherwell also worked as a writer, teacher and lecturer and continued to develop ideas around theories of colour and sensation, alongside his bold abstract paintings composed of large amorphous shapes. From 1958 to 1971 Motherwell was married to Helen Frankenthaler (1928–). She developed an innovative method which involved soaking an unprimed canvas with thin paint, saturating the canvas to ensure that the colour becomes part of the painting rather than sitting on the surface.

Painter Barnett Newman (1905–1970) adopted a stricter approach to his work, rejecting the loose, painterly technique of many of the other Expressionists. In the late 1940s, he began to paint a series of monochromatic canvases which featured a single stripe of a lighter colour on a darker background. Known as 'zips', these bands ran vertically from one edge of the canvas to the other. Newman was an important influence on younger artists such as Larry Poons, Frank Stella and Jasper Johns.

Mark Rothko (1903–1970) was perhaps the most important of all the Colour Field painters. Russian-born Rothko came to the US as a child in 1913. Largely self-taught, from about 1947 he developed his characteristic style of large rectangles of single colours, with blurred edges, floating on grounds and often arranged in parallel.

Rothko's limited palette focused on colours that were near to each to other in the range, such as brown and red, or grey and blue. Overall there is a feeling of calm and meditation in these evocative paintings; later works, however, have a much darker mood, reflecting his depression and eventual suicide.

▲ ELEGY TO THE SPANISH REPUBLIC, *1953* ROBERT MOTHERWELL
One from a series of about 150 works that Motherwell made meditating on the Spanish Civil War. In these rhythmic abstract works, which he described as 'a funeral song for something one cared about', large, black painterly blots punctuate the horizontal white canvas.

▸ UNTITLED, *1967* MARK ROTHKO
By the late 1940s, Rothko had developed a style in which mainly rectangular shapes float on top of one another, their edges softened and blurred. These shapes 'have no direct association with any particular visible experience'. Instead, they provide the viewer with an avenue for contemplation or a screen on to which to project emotion.

ALL OR NOTHING

MINIMALISM DEVELOPED IN America, primarily in New York, in the second half of the 1960s as a reaction to the emotional expressiveness of Abstract Expressionism. The artists involved with the new movement wanted to make work that was devoid of all references, feeling that the work should be complete in itself and not imitate anything else.

Minimal art was therefore composed of very pared-down forms and often relied on simple geometric structures such as the square or the rectangle, and repetition. Many of the minimalist artists (such as Carl Andre, Dan Flavin and Donald Judd) worked in three dimensions and were influenced by the Constructivist artists in their use of light, modern, industrial materials. The action paintings of Lucio Fontana (1899–1968) from the late 1950s – physically slashed

– were another influence, part of a strong overlap between minimalism and conceptual art, where the idea, or rationale, for the work was the primary concern.

Frank Stella (1936–) was one of the first artists specifically associated with minimalism. After graduating in 1958, Stella settled in New York where he painted houses for a living. He particularly admired the hard-edged, geometric grid paintings of Bauhaus painter, Josef Albers, who had moved to America in 1933, and was known for his paintings of squares within squares called *Homage to the Square.*

Stella evolved his own systematic, monochromatic approach to abstract painting, firstly through all-black paintings, then with flat bands of colour. In the 1970s, he also cut out shapes and made boisterously coloured and glittered, three-dimensional relief works.

The work of Robert Ryman (1930–) forms a bridge between Abstract

Expressionism and minimalism. Ryman moved to New York in 1952 where, right from the start, his primary concern was to explore the process of painting, pushing the boundaries and limitations of the medium through combinations of different materials. In the late 1960s, he made predominantly white paintings that focused on light and the surface of the picture plane; white, according to Ryman, 'enables other things to become visible'.

In France in the 1950s, the painter Yves Klein (1928–1962) began to exhibit monochrome canvases covered in a specific shade of intense blue. His performance-exhibitions in Paris, featuring nude models covered in Klein-blue paint, were the subject of outrage when they were first staged. Other painters who made works that featured the blend of order, simplicity and balance favoured by the minimalists include Americans Brice Marden and Ad Reinhardt.

▲ SPATIAL CONCEPT, *1961* LUCIO FONTANA

Fontana began his experiment with making cuts to the canvas in 1959. He saw the dramatic gesture as a way of highlighting the fact that the skin of the surface was two-dimensional and that there was space behind. Fontana claimed this was not an aggressive act, stating, 'I have constructed, not destroyed.'

▶ BLUE SPONGE RELIEF (KLEINE NACHTMUSIK), *1960* YVES KLEIN

Klein's monochrome works were mostly in a deep blue known as 'International Klein Blue'. Klein created this work by covering natural sponges in paint and the secondary title refers to the music he listened to while doing so, as well as to the artist's name.

THE FACTORY LINE

POP ART WAS A NEW VISUAL ART movement that emerged in mid-1950s Britain and late 1950s America. It drew its inspiration from sources in popular culture including pop music, movies, comics, kitsch and advertising. Familiar, everyday objects – such as images derived from cartoons, flags and soup cans – were used as subject matter and sometimes literally incorporated in the work. Making a statement about the need to break down the distinction between high and low culture, Pop Art was seen as a revolt against the orthodox view of fine art represented by modernism.

Jasper Johns (1930–) and Robert Rauschenberg (1925–) were two of the first artists in the US to make the move away from Abstract Expressionism.

Johns was a commercial artist in New York in the 1950s, working on shop-window displays. He made several series of paintings based on motifs such as flags, targets, letters and numbers in which, through repetition, he exploited the banality as well as the beauty of the signs and symbols.

In the mid-1950s, his friend Rauschenberg started to make paintings that combined objects such as Coca-Cola bottles, radios and even a stuffed goat with, and into, the painting. Always alert to the possibilities of different media, Rauschenberg experimented with silkscreen in the 1960s and incorporated photographs from glossy magazines within his collages.

Roy Lichtenstein (1923–1997) was one of the most popular and consistent

of the pop artists – his first one-man show in New York caused a sensation when it opened in 1962. Lichtenstein re-presented comic-strip images, blowing them up to a large scale and then meticulously reproducing all the cheap production values of the original.

Originally a successful commercial artist, Andy Warhol (1928–1987) went on to become the most famous pop artist in America, largely on account of his extraordinary ability to promote himself and the details of his controversial life. Warhol used a silkscreen process to imitate the dehumanizing method of mass production, producing repeated images of Campbell's Soup cans, Coca-Cola and a range of iconic celebrities such as Liz Taylor, Jackie Kennedy and Marilyn Monroe.

▶ LOCK, *1964* ROBERT RAUSCHENSBERG
By 1962, Rauschenberg had started to include found objects as well as found images in his paintings. His collage approach led him to transfer photographs to the canvas by means of the silkscreen process. Commenting on his work, he said, 'I think a painting is more like the real world if it's made out of the real world.'

▶ EARLY COLORED LIZ (TURQUOISE), *1963* ANDY WARHOL
Warhol created this silkscreen painting of the actress and beauty Elizabeth Taylor from a publicity photograph of her taken when she was making the film Cleopatra *in 1963. It is one of 13 made on a variety of coloured backgrounds. Warhol once remarked, 'It would be very glamorous to be reincarnated as a great big ring on Liz Taylor's finger.'*

POPULAR AND PLAYFUL

POP ART DEVELOPED IN Britain in parallel with America. The term, 'Pop Art', was first used by the British critic, Lawrence Alloway, to help define work that drew on imagery from popular culture. Richard Hamilton (1922–), one of the leading British pop artists, went on to describe it as 'popular, transient, expendable, low-cost, mass-produced, young, witty, sexy, gimmicky, glamorous, and Big Business'.

While sharing many common themes and techniques, the emphasis on the playful, whacky side of Pop Art is what distinguishes it from its American counterpart, reflecting, perhaps, the heady consumerism and lightheartedness of the post-war period.

Leading British pop artists include Peter Blake (1932–), Allen Jones (1937–), Patrick Caulfied (1936–2005) and David Hockney (1937–). Coming to prominence in London in the 'Swinging Sixties', Peter Blake made paintings and collages referring to popular stars such as the Beatles and Elvis Presley, often using real emphemera in his painted constructions.

Allen Jones is best known for his paintings and sculptures featuring stylized women in fetishistic clothing such as high stilettos and rubber-wear.

Work by Richard Hamilton in the 1950s and 1960s combined both traditional and mechanically reproduced imagery to produce composite images that explored advertising and aspects of contemporary life. Similarly, the painter Patrick Caulfield used an amalgam of mass-produced and unconventional techniques to comment on the banality of consumer society. The most significant British woman to be recognized on the pop art scene was Pauline Boty (1938–1966), a Royal College of Art graduate, who produced paintings and collages that celebrated her feminity and sexuality, while containing a critique of the male-dominated circle in which she found herself.

For David Hockney, Pop Art was only ever a brief stage in his career. In work made during the Pop Art period, Hockney uses a lightness of touch and an almost jokey mood to convey a range of subjects, largely in a naturalistic manner. In the mid-to-late 1960s, Hockney moved to Los Angles where he made a series of swimming pool paintings that reflected his carefree, Californian lifestyle of the time. He continues to produce a prodigious amount of paintings and drawings, in a range of media, that demonstrate his tremendous skill in capturing a sense of character and place.

▲ SWEET BOWL *1967* PATRICK CAULFIELD
Caulfield's paintings and prints often depict everyday objects placed in an interior. Flat areas of colour are circumscribed by clean black outlines and sometimes, as here, the work is dominated by a single hue. Caulfield's witty and joyous treatment elevates the simple bowl of sweets to iconic status.

▲ SWINGING LONDON, *1968* RICHARD HAMILTON

This late-1960s image plays on the idea of Swinging London, showing rock star Mick Jagger
and Robert Fraser (Hamilton's former gallery owner) handcuffed inside a police van.
Hamilton uses images drawn from popular culture to highlight the relationship between
painting and photography, as well as between representation and reality.

TRICKS OF THE EYE

THE TERM 'OP ART' was first used in 1964 to describe a particular style of abstract painting, in which patterns are used to give the impression that the image is vibrating. The name was intended as a pun on Pop Art but also helped to describe a new style of art that relies on optical effects to dazzle and disorient the viewer. In Germany, Joseph Albers (1888–1976) pioneered the art of optical experiment in his paintings in the 1920s. Albers used a rigid framework of purely geometric forms and drew on colour theory and psychology to create cool, detached compositions that give the illusion of depth.

In the 1960s, Op-artists such as British painter, Bridget Riley (1931–), and the Hungarian-born French artist, Victor Vasarely (1908–1997), started to make abstract works that deliberately set out to explore ideas of illusion, movement, understanding and seeing. Both painters began by making black-and-white paintings and then moved on to explore relationships between different colours, drawing on perceptual and psychological theories. Their aim was to make use of the properties of lines and patterns to create tension and dynamism.

In 1965, the first major international exhibition of Op Art, 'The Responsive Eye', took place at the Museum of Modern Art, New York. Both Riley and Vasarely took part. The pulsating and illusionistic images caught the popular imagination, although some critics were dismissive, declaring Op Art to be little more than empty trickery. Others chose to complain about feelings of dizziness and disorientation when confronted with the works on show.

Although Op Art fell out of favour after the 1960s, both Riley and Vasarely continued to work in the style. Riley travelled to Egypt in 1981, where she was inspired by the colours of Egyptian art as well as by the decorative patterns of hieroglyphics. In 1986, she won the International Prize for Painting at the Venice Biennale. Nowadays she employs studio assistants to make large works that use subtle, repeated bands in an all-over design. Vasarely wrote a number of manifestoes that continue to influence a younger generation of Op-artists, and his fascination with movement led him to experiment with kinetic art. He died in 1997.

▶ CATARACT 3, *1967* BRIDGET RILEY

In this Op Art classic, there is nothing other than repeated, shallow curving lines, and a pairing of complementary colours which shimmer and move depending on the distance from which the spectator observes the work. The title highlights the idea of movement or fluctuation.

A BOUT OF TURBULENCE

NEO-EXPRESSIONISM, with its renewed emphasis on the spontaneous expression of feeling, harks back to the original Expressionist movement in Germany in the early part of the 20th century. As a new force in painting, it came to prominence principally in Germany, USA and Italy in the early 1980s, and was seen as a reaction against the austerity of conceptual art and minimalism.

The key features of Neo-Expressionism are the rough, raw brushwork, a reliance on the human figure (often presented in a distorted and frenzied fashion) and borrowing from all manner of sources, from newspapers to Indian mythology.

Neo-Expressionism first emerged in Germany in the 1960s. Georg Baselitz (1938–), one of the leading figures in the movement, studied painting in East Berlin before moving to West Berlin in 1957. His paintings are roughly drawn, forceful and sometimes disturbing.

He takes human figures, animals and landscape elements and often paints them upside down to empty them of literal meaning and suggest alienation. Other German artists, such as Anselm Kiefer (1945–), allude more directly to the political realities of Germany before Reunification. Born at the end of the Second World War, Kiefer makes huge works that subtly and symbolically refer to his country's past, while revealing a real feeling for landscape and architecture through his choice of materials such as straw, blood and lead.

In Italy, the Neo-Expressionist impulse could be seen in the turbulent brushwork of Sandro Chia (1946–) and Francesco Clemente (1952–) – the latter making nostalgic work that uses primitive or romantic imagery which refers to eastern philosophies and religion. In America, the Neo-Expressionist movement was wildly hyped as the result of an overexcited art market; the monumental, theatrical paintings of Julian Schnabel (1951–), for example – in which he embedded broken crockery over and under layers of thickly applied paint – exchanged hands for record amounts of money.

Up until 1966, American Philip Guston (1913–1980), an older and altogether more serious artist, had worked mainly in an Abstract Expressionist mode. He began to bring figurative elements into his work, drawing on underground comics and popular culture, explaining: 'It [abstraction] is an escape from the "raw" primitive feelings about the world – and us in it. And America.' Guston's subsequent work is typically Neo-Expressionist; there is a fragility, alienation and black humour in his cartoon-style imagery that reflects his view of contemporary urban life.

▶ IN THE STUDIO, *1969* PHILIP GUSTON
In this playful picture, Guston has painted the objects in his studio – the painting on the easel, the clock, light bulb and head – with a cartoon-like simplicity, while arranging them in such a way that they create a sophisticated abstract pattern.

▲ YOUR ASHEN HAIR, SULAMITH, *1970* ANSELM KIEFER

This deeply humane and poignant work was inspired by 'Death Fugue', a poem written in a
German concentration camp by Paul Celan. In this poem, the line, 'Your ashen hair,
Shulamite', refers to the Jewess who is cremated and also to the archetypal Beloved of
The Song of Solomon. *Kiefer sees her spirit in the charred black fields.*

THE BODY MADE FLESH

WHILE ABSTRACT EXPRESSIONISM was taking America by storm, there were artists in Britain who quietly pursued a figurative style of painting. After the Second World War, the sober naturalism of the Euston Road group established a very brief foothold. Of far greater consequence, however, were two artists – Francis Bacon (1909–1992) and Lucian Freud (1922–) – who met in 1945 and first exhibited together at the Hayward Gallery in London in 1976.

Francis Bacon was born in Dublin, moved to London in 1925 and settled permanently there in 1928. He first worked as an interior designer which literally set a stage for later compositions in which the picture plane features as a claustrophobic interior space. In these images, a distorted, isolated figure is often shown – sometimes screaming, seemingly trapped or writhing – creating an emotional response in the viewer which has disturbed and caused controversy in equal measure. Bacon developed an inimitable technique of smudging, smearing and splattering the paint, adding a further layer of risk and uncertainty to his bizarre, nightmarish hybrids.

Fellow painter and friend, Lucian Freud, is the grandson of the German psychoanalyst Sigmund Freud. He initially painted tightly controlled, Surrealist-inspired portraits and still lifes. In the 1960s, he and Bacon went on to develop a reputation as the two most important figurative painters working in Britain. Freud paints mainly nudes in his studio in arresting close-up, declaring that he wants paint 'to work as flesh does'. He has his models pose, often in harsh artificial light, to reveal all their minute imperfections, as well as their emotional reaction to the intense gaze. His luminous still lifes, as well as surrounding objects such as cloths and rags, also have a palpable presence.

Jenny Saville (1970–) continues to work in the British figurative tradition, generally focusing on sculptural and fleshy female nudes of massive proportions, highlighting the disparity between the way women are perceived and the way that they feel about their bodies.

▶ TRIPTYCH, *1974–77* FRANCIS BACON
Bacon revised the central panel of Triptych *in 1977 and removed the reclining figure peering back at the viewer through binoculars. The implications of this can be rather uncomfortable for the viewer. Each of the three panels represents George Dyer, Bacon's lover who died shortly before the painting was completed.*

THE NARRATIVE TRADITION

THERE HAS BEEN A STRONG commitment to narrative in British figurative painting since 1945. Stanley Spencer (1891–1959), with his idiosyncratic biblical vision based on characters from his own village of Cookham, paved the way for storytelling in figurative painting, while he himself was influenced by these tendencies in the 19th century Pre-Raphaelites.

A group of Scottish painters took the narrative tradition in a very different direction in the 1980s; both Peter Howson (1958–) and Steven Campbell (1954–) created scenes of urban deprivation within a social realist tradition, whereas John Bellany (1942–) relied on metaphor and rich poetic language to tell his tales of good and evil.

Portuguese-born Paula Rego (1935–) is perhaps the leading narrative painter working in Britain today. Her figurative paintings draw upon literature, fairytales, myths, religious stories and cartoons to create a series of subversive and often disturbing paintings in which nothing is ever quite as it seems. These curiously amoral, ambiguous and dislocated images mark a return to childhood themes, in part inspired by her own nanny's stories told to her as a child.

By contrast, British artist Howard Hodgkin (1932–) makes abstract paintings; through their specific references to personal encounters, emotional experiences and actual events, these form a rich, dynamic, kaleidoscopic narrative. Hodgkin started painting mainly portraits and interiors in the 1950s and 1960s, adopting a loose, gestural, abstract style in the 1970s when he started to paint on wooden panel. Hodgkin has always used bold, vivid colour as his primary means of expression, building up layers characterized by a vocabulary of brushwork to evoke a particular emotional journey.

Nowadays figurative and narrative painting seem to be enjoying a revival. The tremendous range of images available to the artist – from traditional media such as magazines and books, to electronic and digital – are often shaped by, or allude to, actual or imagined events. In Britain, young artists such as Stella Vine (1969–) and Chantal Joffe (1969–) paint female figures or portraits in a direct, dynamic style, often drawing on the world of contemporary culture such as fashion or celebrity. Edinburgh-born Peter Doig (1959–) uses film stills, real footage and photographs to convey a sense of an imaginary narrative constructed from borrowed memory.

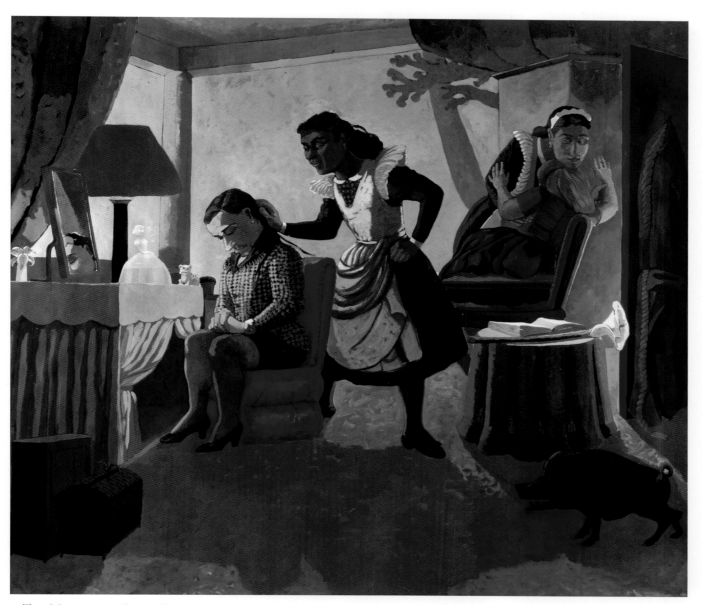

▲ THE MAIDS, *1987* PAULA REGO

Rego based her painting on Jean Genet's play of the same name in which two French sisters
brutally murder the mother and daughter of their male employer. In her depiction of this
troubling tale, Rego focuses on the closeness of the women in a claustrophobic bedroom, in
which even strange shadows could be interpreted as waving for help.

ISSUES OF IDENTITY

POSTMODERNISM IS A TERM that first gained currency in the 1970s when it was applied to everything that modernism was not. Wanting to break free from the modernist belief in autonomy, originality, authorship and its formal aesthetic, critics proposed a new form of representation that had nothing to do with a fixed meaning, but everything to do with the complexities of life and the process of living. Life and art were suddenly back together again. Issues of identity – marginalized under modernism – suddenly became relevant. Deconstruction, diversity and a recycling and/or appropriation of subject matter were hugely encouraged.

Sigmar Polke (1941–) is the consummate postmodernist. He grew up in East Germany but settled in Düssledorf in the West, where he developed his Pop Art-inspired form of painting, appropriating images directly from advertising as well as photography. Polke draws upon a range of different materials within one canvas, combining household paint, screenprint, transparent sheets and found objects to build up a complex, densely layered narrative. Playfulness, parody and pastiche best describe Polke's style, which went through a psychedelic phase in the 1980s, and more recently drew on German history with references to politics and culture as well the process of making an image.

Polke met fellow student Gerhard Richter (1932–) in the 1960s when the pair collaborated on a project about consumerism. Like Polke, Richter has always worked in a variety of styles and across media. In the early 1960s, Richter transferred some disturbing photographs of the Second World War on to canvas which, while neutralizing the horror of the images, also served to question the respective nature and role of painting and photography. Richter continues to work with photography, transforming aerial photographs of cities, as well as producing a series of monumental, visceral, colourful abstract paintings. Other paintings, often made in series and in response to photographs, hover on the borderline between abstraction and figuration, his slightly blurred, seamless style spawning a host of imitators.

Other German artists such as Martin Kippenberger (1953–1997) exemplify the Postmodern tradition in painting. Often using his own body, as well as banal, mundane subjects, Kippenberger's witty works poke fun at the tradition of painting and the various ways in which, over time, it has been repressed and subverted. Polish painter Wilhelm Sasnal (1972–) dismantles notions of high culture and of propagandist imagery by making his own connections to mass-media imagery, using an eclectic range of visual styles and techniques.

▸ S WITH CHILD, *1995* GERHARD RICHTER

In the early 1990s, Gerhard Richter showed a number of recent small-format paintings of his third wife, Sabine Moritz, and their baby son. Entitled S with Child, *the series of images derive from a photographic source, but they are then distorted and distanced by a painting process that relies on blurring and smudging.*

A New Sense of Unease

Now that postmodernism has opened up the practice of painting, there is a remarkable sense of freedom which means that, in terms of subject and style, just about anything goes. Despite such diversity and plurality, some distinct trends can be traced and there are some painters who stand head and shoulders above the rest. While much contemporary work is playful, even tongue in cheek, some recent painting also tackles key themes of life and death, while evincing a disquieting sense of unease.

Marlene Dumas (1953–) is a South African-born painter who lives in Amsterdam. She makes provocative, yet beautiful paintings of women, children, models and celebrities that often challenge the viewer with a direct stare. Drawing inspiration from photos and pictures found in magazines, Dumas works instinctively with a wet-on-wet style, using a mixture of thin washes and thickly applied oil, to create an intimate, yet alienated vision.

Commenting on her own voyeuristic position in regard to her images, Dumas has said: 'The aim is to "reveal", not to "display". It is the discourse of the lover. I am intimately involved with my subject matter.' Confronting personal and political issues like race, religion and prostitution, Dumas opens up a feminist dialogue that does not oversimplify, while allowing for beauty and pleasure in the process.

Belgian-born Luc Tuymans (1958–) is one of the most significant contemporary painters. He began painting in the early 1980s but gave it up for a couple of years to work as a film-maker, after which the use of framing, close-up and cropping became part of his painting process.

Tuymans generally makes small paintings in series. The subject matter can range from intense and harrowing images based on the Nazi gas chambers, to banal and seemingly inconsequential representations of toys or flowers. The images are often abstracted or presented as a disconnected fragment – meaning is only attached once the details are pieced together in the mind of the viewer.

Tuyman uses a pallid, almost sickly colour range which adds a further sense of disquiet to his collapsed forms. Commenting on the unease that lies at the core of his work Tuymans has said: 'There is a sort of indifference in my paintings which makes them more violent, because any objects in them are as if erased, cancelled.'

Rather than this being a statement of finality, his work bears testament to painting which attempts to make tangible and, at the same time, question the very essence of existence.

▶ WITHIN, *2001* LUC TUYMANS
This close-up of part of a bird cage is an arresting and alarming image which, through its emotional intensity, manages to entrap the viewer. Because of their unusual framing and disconnected forms, Tuyman's paintings are often claustrophobic and convey feelings of inadequacy and loss which tap into some universal sense of guilt and shame.

A History of Techniques

If we take *The History of Art* as our timeline, we can see that a wide variety of methods have been employed by artists through the ages to create paintings. The main focus here has been on western art; it is to this strand of picture-making we turn our attention when considering the materials and techniques used.

Although images using graphic tools and pigments have been created since prehistoric times, more formal and complex approaches were being used at the point where we began, in the art of the Middle Ages. Encaustic – pigment mixed with hot wax – had been a painting medium commonly used by portrait artists in ancient Egypt and in the employ of the Roman emperors. Whereas wax was the binding medium (or 'temper') here, egg – and principally the yolk – was the key binding property for later artists working across medieval Europe. The yolk itself is released from the yolk sac and then preserved by the addition of a little vinegar or wine. It is a naturally oily substance and, when mixed with ground pigment and water, it makes for a soluble painting medium which becomes highly durable. Egg tempera was very popular, usually painted on wooden panel which had been prepared with *gesso* – a substance made from white chalk and rabbit skin glue. When smoothed on to a panel and sanded down, *gesso* has an ivory-like, silky surface with the porosity of fine plaster – forming a perfect ground for tempera. As it is water-soluble, egg tempera is fast-drying, allowing for the build-up of layer upon layer of glossy,

semi-transparent paint. Along with gilding – chiefly used in manuscripts and iconic, religious works – tempera is a medium associated with times past, yet it has become increasingly popular with modern and contemporary artists, Joseph Southall, Andrew Wyeth and David Tindle, for example. The craftsmanship required to prepare and execute a tempera painting establishes it firmly as a traditional fine art medium. The result of a relatively delicate process, tempera paintings tended, therefore, to be devotional, small-scale pieces, requiring detailed brushwork and a dedication to carefully cross-hatched detail. Works by Duccio and Raphael, for example, serve to reveal tempera painting at its best, possessing a precious, jewel-like quality.

Egg has also been used as the medium to bind pigment to walls in large-scale mural paintings or frescoes, most prevalent in Roman, late Medieval and Renaissance periods. The patrons of Baroque artists Tiepolo, best known for his work in the Würzburg Residence, and Andrea Pozzo, famous for his frescoes in the church Sant' Ignazio di Loyola a Campo Marzio, favoured high ceilings on which to best exercise their painters' considerable talents for the dramatic perspective of *trompe l'oeil* scenes, breathtaking for their celestial pageantry and ingenious complexity.

When painting fresco on to dry plaster, the term is painting *a secco*. Water-based pigment without a binder can also be painted into wet plaster which is known as *buon fresco*; Michelangelo's Sistine Chapel ceiling was painted in this way during the

High Renaissance. The process necessitated small sections of wet plaster being laid down, in a piecemeal fashion, over initial drawings or *sinopia*, made on the rough underlayer. Each section, or *intonaco*, was then painted upon before it dried. The work that could be accomplished in one day – roughly the time it would take for the plaster to dry – was known as the *giornata*. This was a painstaking activity, favoured for such monumental projects because of its durability; the painting fused with and therefore became part of the building. The fact that many frescoes still survive today, centuries later, is a testament to the steadfastness of the medium. Frescoes are best sustained by drier climates; Southern Europe, particularly the Italian cities of Rome and Mantua – home to Andrea Mantegna's magnificent *Camera degli Sposi* paintings – are perfect locations for such projects. In Venice, wall-frescoes were not so successful due to the inevitable dampness and a non-water-soluble medium – oil painting – was therefore key to establishing the city's reputation as an artistic centre for Renaissance greats such as the Bellini brothers, Titian and Tintoretto.

Although seed and nut oils have been used to bind pigments since the 11th century, pure oil painting did not come into its own as a popular medium until the 16th century – a development credited to Early Netherlandish painter, Jan van Eyck. His altarpiece for the cathedral in Ghent (1432) and *The Arnolfini Marriage* (1434) exemplify his

complete mastery of the medium. Oil paint dries by oxidation rather than evaporation and this process is slow. As such, it allows for greater freedom in the manipulation of artistic ideas, capacity for blending, changing and building tone; its translucency makes for expressive paintings of depth and warmth. Historically, artists who have most popularly exploited oil's properties to interpret the human spirit include Leonardo da Vinci, Rembrandt and Rubens; they remain largely unsurpassed in their achievements. Francis Bacon and Lucian Freud are, perhaps, two modern masters who have come close.

The process of painting dictates a picture's longevity. With oil pigment that has been heavily thinned with white spirit, an artist would traditionally lay down initial ideas on the painting's ground (canvas, linen, vellum or panel), prepared with primer – a water-based barrier between the ground and the oil paint. These thinly painted sketches would be very fast-drying. As the whole composition develops, however, subsequent layers use more and more oil (most popularly linseed) in proportion to spirit. This process is often referred to as working 'fat over lean'. In this way, the paint layers dry in the order they were laid down and are less likely to deteriorate and become brittle and crack as the painting ages. Additions to the medium like bitumen (famously favoured by Joshua Reynolds) can also cause conservation problems over time. Just as watercolour paintings fade in the light, oil paintings tend to darken in the dark and, in any event, may yellow

or eventually become transparent, depending on the process and ingredients used. Tempera, fresco and acrylic – developed relatively recently around the 1950s – are more stable and generally stand the test of time more predictably than oil. Whereas oil paint originated from natural materials, with the pure pigments obtained from powdered, precious minerals such as lapis lazuli (a deep blue), verdigris (rich green) and cinnabar (vibrant orange-red), acrylic is a synthetic, matt medium, highly favoured because of its water-solubility and quick drying time.

From the middle of the 19th century, oil paint became transportable in tubes and its properties began to be exploited for their own ends, rather than to mimic nature or reality. The Impressionists, painted *alla prima* (directly on to the ground), putting down a thick layer of paint in one brushstroke, rather than building up layers of coloured glazes. They also tended not to blend pigments on the canvas, allowing the viewer's eye to do so – a technique taken to mathematical extremes by Pointillist artist, Seurat. The development of photography dictated that painting had a different role to play in commenting on life as it was lived. Painters showed us we were looking at an arrangement of pigments on a flat surface; these could be lush and expressive in their own right, rather than acting as a mirror of the world. Great swathes of buttery impasto and wildly coloured palettes captured the inherent magic of the quality of oil; a chief exponent of such an approach was Post-Impressionist Van Gogh, followed

by the Expressionists, using the medium to convey high emotion. With Cubism, painting techniques extended to incorporate text and collage, a move which served to fix pieces of the real world literally within the painting and, conversely, thereby establishing painting as a vital element of contemporary culture. Such ideas were recalled by American Pop Artists Jasper Johns and Robert Rauschenberg, to the extent that paint became only a part of conveying a creative idea.

Similarly, contemporary artists incorporate painting alongside all manner of media – Jessica Stockholder, Angela Cruz and Damien Hirst, for example, use painting as one of various means of expression including installation and sculptural elements.

Following postmodernism, many artists have made painting about painting itself; Fiona Rae is known for using numerous different styles of painting in one work, including Abstract Expressionism and cartoon-inspired imagery, while Glenn Brown and John Currin play with the concepts of pastiche and irony in the context of painting, painters and painting techniques.

Despite major advances in the development of artistic materials and the ongoing debate about what constitute these, artists continue to work with relish in paint today. As a singular medium in its own right, painting remains a steadfast staple in contemporary practice. Long may it continue to do so.

Libby Anson, London 2007

INDEX *Paintings are in italics*